TRACTION

Published by Sternberg Press

Editor: Matthew Poole
Copyeditor: Marnie Slater
Proofreading: Mark Soo
Design: Aude Lehmann
Printing: druckhaus köthen

ISBN 978-3-95679-203-8

Sternberg Press
Caroline Schneider
Karl-Marx-Allee 78
D-10243 Berlin
www.sternberg-press.com

TIRDAD ZOLGHADR

TRACTION

An Applied and
Polemical Attempt to Locate
Contemporary Art

Sternberg Press

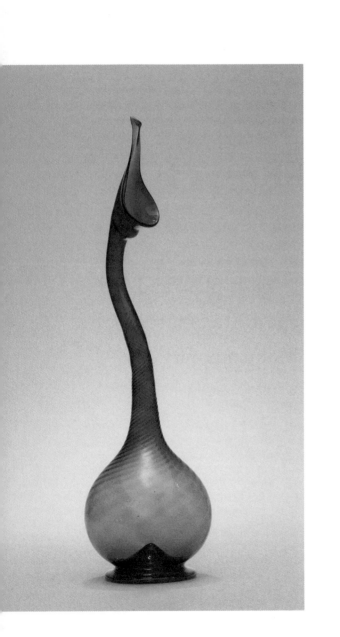

TABLE OF
CONTENTS

-8-

BODIES IN SPACE:
PLOTTING THE
EXHIBITION EXPERIENCE

-9-

SCHOOLING

- 10 -

CONCLUSION

- PREAMBLE -

SUCH IS
MONARCHY

The Working Example
of the Tehran Museum of
Contemporary Art

Contemporary art is always looking for the hole in the fence. For a way beyond categories, stereotypes, institutions, schoolmasters, and the corridors of power. Whether in the shape of hermeneutic limbo, a contemplative daydream, a radical gesture, or a kaleidoscopic show. Art is currently so very invested in this line of flight that it takes its actual, physical locations for granted. In an intuitive sense, art fancies itself an innocent, peripheral, beleaguered kind of place. A bit like a chicken house made by foxes. If it is prime real estate,

that is only because it is located right by that fence, the one with the secret hole in it.

The Tehran Museum of Contemporary Art does not care much for chicken-coop fantasies. It is the kind of overdetermined institution that embodies an entire microcosm of its own, even encapsulating an entire era in its own right. A buckled space-time warp of high-modernism, neo-Islamism, Persianist nostalgia, and postmodern statecraft. In some ways, admittedly, the museum, or *muzeh*, as it is widely called, is just another sleepy public venue, its promise hampered by sluggish management, like hundreds of government-run museums across the globe.[1] But although the muzeh does its best to decontextualize and neutralize art, it does so only to immediately embed it within a heady matrix of political conflict, urban legend, and architectural eccentricity; a framework so dense that you end up reading every show as yet another baffling muzeh occurrence in its own right.

The muzeh is often referred to as a museum of "modern" art, and, to be fair, that is what it is most famously: a prominent collection of modern masterpieces, encased within striking modernist architecture. But, as the institutional epithet makes clear, this place is devoted to the contemporary. In terms of its use in the international artscape, in that chicken house over by

1 At the time of writing, rumor has it that the Ministry of Culture and Islamic Guidance is about to announce the privatization of the muzeh.

the fence with the hole in it, the "contemporary" is defined by a highly effective form of indeterminacy that allows it to travel far and wide as a concept, or as a cultural currency. Channeled largely, though not exclusively, by the laws of capital. And the muzeh reflects a definition of the contemporary that strays from that particular transcontinental consensus. It is not that the muzeh is uninterested in a transcontinental conversation, but it is in no hurry to get there.

This slow-burn attitude could arguably be referred to as a "postcolonial" one. But this would be a postcolonialism rather unlike the one we are accustomed to in art, transcontinentally speaking. The muzeh has nothing in common with a documenta workshop in Kabul, or Okwui Enwezor pitching "off-center" curating in Venice, not to mention a Zolghadr criticizing Tehran museums in a Sternberg book. In the eyes of people who use "postcolonial" in the way I do, the muzeh is a corrupt, frustrating, and self-provincializing stick-in-the-mud; a form of nonheroic refusal, at best. To be sure, the art world routinely celebrates refusals of all kinds, as a more edgy, sustainable form of business as usual, but the refusals of the muzeh are too unwieldy to fit into an agenda of that kind.

It was the early 1970s when Queen Farah Diba took a serious interest in contemporary art. Taking advantage of a slump in art-market prices, she swiftly invested sums that saved a cluster of weathered American galleries from bankruptcy, and her collection quickly included a spectacular range of western *Meisterwerke*, which in

2007 was already worth nearly four billion USD.[2] The budget was derived from the National Iranian Oil Company and the advisory team included David Galloway, who was appointed chief curator, Karimpasha Bahadori, who was chief of staff for the Shah's cabinet, and the heads of Christie's, Sotheby's, and Beyeler. Kamran Diba, for his part, multitasked as architect, director, and cousin to the queen.

As the venue assembled its new collection, despite the widespread coverage of systematic human rights abuses in Iran, you would be hard pressed to find anyone in the field of visual art who had any qualms about being in the service of the monarchy. I did hear a rumor about Lawrence Weiner refusing his invitation, and hastened to ask if this was true.[3] Weiner testily replied that he was "seventy years old," and did not have "time to stand around and congratulate himself for his political credentials." I take that to be a "yes."

The five-thousand-square-meter museum was inaugurated in the summer of 1977, with a solo show by David Hockney. It featured a bewildering poly-circular trajectory that wound its way through generous hallways, as well as small, quirky chambers, and back again, sometimes leading underground, sometimes offering delightful views of a seven-thousand-square-meter park. In a style characteristic of the time, the edifice combined stark modernism with regionalist elements, most con-

2 Robert Tait, "The Art No One Sees: A Basement That Symbolises Cultural Isolation," *Guardian*, October 28, 2007, http://www.theguardian.com/world/2007/oct/29/artnews.iran.
3 This was on the occasion of an Art Basel after-party in 2008.

spicuously in the form of turrets suggesting traditional wind funnels. To say the least, the muzeh does not exactly offer prime conditions for exhibiting art, in the white cube sense, but given the building's sheer elegance it is hard to hold that against it.[4]

Today, the museum park is a setting for stores, playgrounds, teahouses, outdoor fitness equipment, junkies, horny teenage couples, and a sculpture garden. With the latter featuring a gaggle of Giacomettis being eaten away by acid rain and looking more measly and miserable than ever. The park also features a stunning carpet museum, designed by Farah Diba herself. In the city at large, it is arguably this park that the muzeh is associated with primarily. Only within the art field does the venue itself overweigh. Not least because of the resources: major art funding, local or international, is all channeled through the muzeh.

It is now a conversational cliché to say the muzeh is a "mirror of Iran." A discreet homage to the onetime glory of the Shah. Or populist architecture masking a brutalist top-down temperament. Or a political kaleidoscope that can be as paranoid and controlling as it can be bafflingly open-minded. In other words, whether as a national emblem, a social space, a collection of art, a didactic experience, or a funding body, the muzeh man-

4 The muzeh was inaugurated concurrently to the Pompidou, another venue at the heart of a capital city, equally saddled with national ambition. What set the Pompidou apart from the muzeh was the multidisciplinary temperament, the bare-bones style—meant to promote an atmosphere of "transparency"—and the polemical tenor of the programming.

ages to tick all the usual museal boxes. And few muse-
ums will impress themselves upon you with such vigor.

In terms of exhibitions, you will see anything from
collection displays to traveling international shows (even
the YBAs were here), to calligraphy and local land-
scapes, and so on. You will also see curatorial scandals
at every turn. Clunky glass walls separate you from the
art, which is bathed in a soundtrack of classical concer-
tos, and misspellings mark the wall labels, while some
harsh juxtapositions force unlucky artworks into pretty
jarring dialogues. Not to forget the crooked Donald Judd.
The scandals also include financial mischief. On one
occasion, artists were summoned as court witnesses to
help assess how much public funding was disappearing
into muzeh pockets.

Such colorful cases of mismanagement have many
onlookers worried about the famous collection. Ru-
mors abound. Stories of cobwebs, dust, de-acquisition,
and theft. As far as I can see, no material damage has
been detected thus far, and there has been only one of-
ficial case of de-acquisition. In 1994, the museum ex-
changed Willem de Kooning's *Woman III* (1953), for a
five-hundred-year-old volume of the *Shahnameh* epic.[5]
The book was worth six million dollars, but *Woman III*
was eventually sold for 110 million.[6] According to the
award-winning Swiss journalist Serge Michel, the collec-

5 From American art collector Arthur Houghton.
6 Allegations fly especially thick and fast when it comes to
Jackson Pollock's *Mural on Indian Red Ground* (1950). Panic en-
sued in 2012, when the painting was loaned to Tokyo's National
Museum of Modern Art, and confiscated by Iranian customs
upon its return. The confiscation was a ransom demand: customs

tion also includes Adolf Hitler watercolors, which were presented to the public at a 2001 press conference. They were unveiled with a vague air of embarrassment, then lugged back to the cellar without a word of explanation.

Permanently installed in the atrium is a 1977 rendition of Hiroki Haraguchi's *Matter & Mind*, a tub filled with oil, into which, according to urban legend, the Shah dipped his little finger at the opening, as he was chatting to Nelson Rockefeller.[7] Up until recently, Shahryar Ahmadi's *Spider's Web* (2001) was spanning the atrium; an example of institutional critique that was a hallmark of "Conceptual Art" (2001)—a show that was in some ways burlesque, but a decisive moment within a collective learning process. Appointments to public museum directorships are politicized in Iran; every presidential transition brings a new director, along with a new team, burdened with brand-new suspicions and insecurities. Gradually, every team becomes professionalized over time. Until a new president is elected, and the whole damn thing begins all over again.

Alireza Sami Azar marked the reformist era of 1997 to 2005. A man with hardheaded opinions, a winning

—— were demanding the settlement of debts owed on behalf of the Iranian Ministry of Culture.

7 Another iconic addition is Alexander Calder's mobile *Orange Fish* (1946), which permanently frames the portraits of Ayatollahs Khomeini and Khamenei in the atrium. Calder's role of Cold War pawn is a story well told by artist Alessandro Balteo Yazbeck and art historian Media Farzin, by means of their research and exhibition project "Cultural Diplomacy: An Art We Neglect" (2009–ongoing). See also Yazbeck and Farzin's contribution to the "Artists' Inserts" section in: *Dissonant Archives*, ed. Anthony Downey (London: I. B. Tauris, 2015).

smile, and a PhD in architecture. After submitting to the collective learning process, Sami Azar did more for the Tehran art field than any museum director before him, or since. It was also Sami Azar who was reckless enough to grant me my first shot at curating in 2000.

"Groupproject" was a weeklong exhibition-in-progress featuring five artists from Geneva. The five of them pursued all manner of impromptu collaborations with Tehran-based practitioners. Though it had its moments, it was a bit of a (semi-intentional) mess, and was utterly trashed by *Hamshahri*, the most prestigious Tehran daily at the time. The reporter did not care for the install, let alone the experiment in progress. She actually showed up outside opening hours, to describe us as "European brats visiting the third world to effectively do whatever they like."

She had a point, at least as far as my own role was concerned. My research was naught, my communication skills pathetic, my installation skills nonexistent. I can remember a telling conversation with Patricia Nydegger, one of the artists, as if it were yesterday: "T'sais, Tirdad, le boulot que t'es en train de faire, là, c'est ce qu'on appele le boulot d'un curateur."[8]

"Curateur?"

"Cu-ra-teur. *Curating*."

"Huh."

Such ignorance would be unthinkable nowadays. If you do not know the term by your late teens, you are not fit to compete.

8 "You know, Tirdad, the work you're doing right now, it's what they call 'curating.'"

Sami Azar ended his tenure in 2005 by exhibiting the collection in one fell swoop, under the terse title "The Modern Art Movement," to extensive coverage world-wide. Some of which sneeringly painted a picture of famished Iranians gorging themselves on Picasso. (Most of them falsely claiming it was the first time the collection had been seen since the revolution.)

In 2011 I asked Sami Azar what advice he would offer his successors, and he coyly suggested they all step down. "It's become a battle that can only be lost." Only hours after that conversation, I had the privilege of meeting one of Sami Azar's unfortunate heirs, Ehsan Aghaii, a soft-spoken man my age, ostensibly an appointee of then-President Ahmadinejad. He was friendly and forth-coming, proudly pointing to an upcoming survey of Günther Uecker, as well as the muzeh's Paris residencies, and the support it lends the Iranian Pavilion in Venice. Aghaii took issue with Sami Azar not along ideological lines, but for his management style, suggesting he ran the museum according to personal whim; a case of "charismatic leadership." Aghaii claimed he had finally introduced a board, to which he and others would be accountable. But Aghaii has long been replaced by a string of directors since, and, to my knowledge, no board is operative to date.

Plus ça change. When it comes to public account-ability, little has changed since the days of the empress. I am often reminded of the documentary *The Queen and I* (2008), a portrait of Queen Farah Diba by one-time Marxist revolutionary Nahid Sarvestani. At the emotional climax of the otherwise cumbersome movie,

Sarvestani confronts Diba describing how she grew up in misery under her reign, and finally exclaims, "Don't you understand why we hated you?" The queen's answer is fabulous. "You made one mistake," she gently explains, "you should have written me a letter."

Such is monarchy. A temperament not unknown in contemporary art. Forget the checks and balances. If the king is good, well, that is great. You can write a letter. If the king is not so good, well you will have to wait.

I was commissioned to present my (still ongoing) research on the muzeh at the 2012 International Committee for Museums and Collections of Modern Art (CIMAM) convention in Istanbul. In a tone of great urgency, the conference called for building a new "future for museums," by expanding our modes of "access [to] a global heritage that we all share," and for "different cultural and epistemological traditions to be reconciled." CIMAM is hardly alone in this. If there is anything uniting museums today, it is a passion for accessibility across the board. Across traditions, cultures, disciplines, professions, markets, borders, generations. Even across any measures of willingness and unwillingness to engage with art.

And it is safe to say that every single curator visiting Tehran, including myself, really does fantasize about interconnecting. Our gut reaction is invariably to open up, wake up, shake up, speed it all up. Do the Iranians a favor and globalize. Somebody call Hans Ulrich Obrist. The very idea of competence in art, the sonics of intelligence, if you will, is directly linked to this notion of

Access Undeniable. Of porousness in terms of hermeneutics and politics alike.

Once empowered by a socialist sense of purpose, the latter-day internationalism of contemporary art is a wanderlust empowered by a voracious ideology of indeterminacy.[9] That is what "cultural and epistemological reconciliation" looks like these days. And as long as it is the best we have to offer, maybe the muzeh can afford to take its time.

To be clear, I am not inclined to scoff at CIMAM. The aim of this book, rather, is to prove that all-inclusive, universalizing tenets are surprisingly typical of our field at large. The book further insists on the question of who is benefiting from all the "cultural and epistemological reconciliation" booming and blooming around us. But also suggests other working tenets in the process. It is in this sense that the muzeh offers a helpfully skewed perspective. After all, the "Contemporary" in the "Tehran Museum of Contemporary Art" marks a clear contrast to the "contemporary" in contemporary art at large.

The first step in the reformist exercise I am aiming for is to clearly circumscribe an object whose forte,

9 "Indeterminacy" is a term with a colorful track record not only in Euro-American art (John Cage most famously) but throughout the history of European philosophy; my own take on the term is indebted primarily to Andrea Phillips and Suhail Malik's usage in: "The Wrong of Contemporary Art: Aesthetics and Political Indeterminacy," in *Reading Rancière: Critical Dissensus*, ed. Paul Bowman and Richard Stamp (London: Continuum, 2011); see also Malik's lecture series "On the Necessity of Art's Exit from Contemporary Art" (Artists Space, New York, May 3–June 14, 2013), available at: http://artistsspace.org/programs /on-the-necessity-of-arts-exit-from-contemporary-art.

precisely, is to deny that it has any contours whatsoever. (There is an outside, and it is not all that mysterious.) To then be able to identify, in turn, any given ongoing artistic, curatorial, and art-institutional practices as "noncontemporary," is not an imperialist or condescending gesture, but, to the contrary, a matter of putting contemporary art back in its place.

Over time, it did become clear that the two institutions, the Tehran Museum and the prevailing superstructures of contemporary art at large, did have a few things in common. Both are comfortably suspended in a vague sense of historical exceptionalism, and oblivious to the actual potential they hold. The former is beholden to a regime that considers itself inherently "revolutionary," and does not care to really make its mind up on art (nor on very much else, for that matter). This also holds for contemporary art, which is just as convinced of its own "revolutionarism" in that it purportedly embodies a degree of complexity that is as unprecedented as it is incommensurable. The two regimes are both fundamentally aestheticized spaces of exception, accountable to no one, and brimming with squandered possibility. Such, in any case, is what I will be arguing during the course of this publication.

Beyond the claim itself, I will be insisting on the way in which I eventually, slowly, stumbled onto that claim to begin with, almost by accident. But at the outset of my practice as a curator, the muzeh was a hands-on training ground, a hard-hitting political lesson, and a didactic "theoretical picture" (W. J. T. Mitchell) all in one. Ever since that first gig at the muzeh, my exhibi-

tion making, my writing, my postcolonial instincts, and my institutional fixations have all been bleeding quite liberally into one another. It is this type of practice-based abstraction that drives this book, an approach I will be pitching as a curatorial one specifically. It is a mentality marked by the productive paranoia of critical theory, but also by the bluster of cultural journalism, and the mundane anxieties of the technocrat. More anon.

-1-

A MORAL
ECONOMY

Looking Forward

"Looking forward to reading your book! Contemporary art sucks, we all know that." A colleague's e-mail strikes a nerve. Talk about a complete cliché. Imagine setting out to prove that "politics sucks." Or accounting. Not exactly groundbreaking stuff. They say even gravity sucks, which makes it a default condition. Surely enough, for most of my own fifteen-year itinerary as a writer, curator, and educator, I have been a pitch-perfect example of the very things I am attacking in these pages.

As the preamble explains, I stumbled into the field of contemporary art almost by accident. It was only slowly that I woke up to the stakes at hand, and noticed that only few things hold as much potential as our tentacular milieu, but also that few things are quite as hampered by our own escapism. Today, I am increasingly bored to tears by contemporary art, but I still have more faith in its potentials than anyone I know. As contradictory, and as embarrassing, as that may sound. Ultimately, the idea of this book is not to spit in the soup, but to clearly define the field as the formidable, creepy machine that it is. Replicating itself internationally with breathtaking precision, precisely because it successfully claims to be a harmless, level playing field of indefinite postpone-ment, a chronopolitical *Wunderkammer.* Becoming-as-telos. Beyond analyzing contemporary art's refusal to identify with power, the aim is not to lessen the power effects, but to actually heighten them. The idea here is to maximize art's muscle.

My vantage point being that of a curator first, and that of an educator and art writer second. And one of the main things to set curators apart from most other profes-sions is a nagging notion of being neither-nor. Neither-creatives-nor-clerks, neither-artists-nor-academics. Thus we make a virtue out of necessity, by celebrating the "in-between." Sometimes, we raise the flag of mercurial me-diation with pride, sometimes with blushing apologetics. Either way, it is a flag that has undeniable advantages.

As Søren Andreasen and Lars Bang Larsen posit in *The Critical Mass of Mediation,* something of a bril-liantly argued manifesto for curators-as-mediators, the

figure's historical precursor is the medieval merchant on the edge of town. This tradesperson "breaks off relations between producer and consumer, eventually becoming the only one who knows the market conditions at both ends." An activity that is "opaque" in that it escapes the regulations, and the transparency, of the elementary marketplace.[10]

Opacity not only offers a strategic market advantage. It is much more attractive as a mysterious and seditious idea, than the prim pedantry of criteria, positioning, and transparency, which are the "Good Objects" of my own book. Within contemporary art, the forte of mediation-as-telos is a magical ability to appear subversive even when perfectly orthodox. It is always nice to agree on something that is canonical anyway, but it is even more exciting to bond over something canonical as if it were totally crazy.

One might argue that there is hardly a job profile out there that does not amount to mediation of some form or other. Even a butcher is a mediator between a cow and a steak. But a butcher would never consider some "in-between state" to be the splendid telos of her everyday actions. While a diplomat, by contrast, is far more likely to sympathize. "It must be the very aim of a mediator to make himself superfluous precisely," as Roland Büchel, vice president of the Swiss Foreign Relations Committee, once said.[11] It seems that whether

10 Søren Andreasen and Lars Bang Larsen, *The Critical Mass of Mediation* (Copenhagen: Internationalistisk Ideale, 2012), 21.
11 "Ziel eines Vermittlers muss es ja gerade sein, sich selbst überflüssig zu machen." Roland Büchel, in "Wir gehen besser

in an exhibition or a parliamentary committee, selfless-
ness is rarely proportionate to the degree in which it is
publicly insisted upon.[12]

For a time, I considered the curatorial fetish for the
in-between to be something very 1990s, very postmod-
ern. But at second glance, much of the prose from that
particular decade suggests that a curator is more of a
"director," a "psychotherapist," or a "caretaker" (this in
keeping with the etymological root of the term). All pro-
fessions with more clear-cut, unilateral mandates than
smugglers, translators, or negotiators.

Many colleagues will be put off by the brash choice
of words, and the broad brushstrokes of my "art-per-se"
attitude. Am I really comparing the comparable here?
Remember the range of contemporary art prototypes
at our disposal, even among curators alone. The art-
historical-nerd curator, the conscientious-activist cu-
rator, the happy-clappy-let's-be-friends curator, the
investment-portfolio curator, the new-institutionalist
curator, the XXL-museum curator. It is particularly the
latter who stands out as a breed of their own. I will
never forget the man who showed up late from a power
lunch to meet my students in his Manhattan office, and
proceeded to drunkenly mock the tourists queuing for

—— einen Schritt zu weit," interview by Raphaela Birrer, *Tages Anzeiger*,
January 24, 2014 (my translation).

12 For a textbook example, see: *The Goodness Regime* (online
publication, forthcoming), which presents the research of artists
Jumana Manna and Sille Storihle on the role of the Norwegian
government within the Oslo Accords. Ramallah, where much of
this book was penned, is where the results of Oslo's selfless me-
diatory efforts are glaringly, painfully palpable.

his own show. "Performance? Oh me too. I can play the saxophone and piss my pants." Hard to imagine Hans Ulrich Obrist putting things that way.

It is not a matter of personal style, so much as a colossal difference in infrastructure that is speaking here. Generally, the differences between freelancers and employees—between "prophets" and "priests," as Beatrice von Bismarck elegantly puts it—are due to the respective structures that define the speaking position a curator can afford to inhabit. Both must learn to exploit a distinct set of tactical advantages. In *The Murmuring of the Artistic Multitude*, Pascal Gielen describes how your typical curatorial *Gastarbeiter*, who is only around for a project or two, is rarely dependent on local networks, and only engages in fleeting interpersonal negotiations that barely scratch the surfaces.[13] Surfaces that are patiently mined by in-house curators, over endless meetings with politicians, patrons, fellow directors, local reporters, and fickle audiences.

Moreover, even the very motivations informing contemporary art are becoming evermore diverse. These days, the field offers much more than art alone: jobs, urban renewal, quick returns on investments, private backing, public subsidies, geopolitical prestige—even nation-building is on offer here. Curator Maria Lind likes to say that the term "art" no longer sticks.[14] It has been used so widely, at this point, that some of the stuff

13 Pascal Gielen, *The Murmuring of the Artistic Multitude: Global Art, Memory and Post-Fordism* (Amsterdam: Valiz, 2010), esp. 138–41.
14 Lind is a personal friend who accepts my frequent challenges to her practice with serene Nordic cool.

is actually closer to Hollywood productions than to the traditional artscape. We should perhaps introduce "Contemporary Mart" and "Shmart" to distinguish matters more clearly. I am being glib, but nominalism does play a role. The only way to make room for other shades of art is to accept and circumscribe the specificities of contemporary art itself. There is no reason to take "contemporary art" at face value, and assume it is as indefinable, porous, and thereby all-encompassing as it claims.

This is why this publication will be a doggedly ontological affair, essentializing the profession with rude partiality—well beyond flattering notions of in-betweenness. It argues that the above diversity in motives, infrastructures, styles, and methodologies only render the commonalities all the more striking. For when it comes to the political upshot, and the subjectivities produced, both within the field and among its audience, the distinctions are minute. Contemporary art is intrinsically, globally defined by a moral economy that leaves curators and artists unaccountable, and their audiences unaccounted for. Whether it is a populist blockbuster, a zero-budget artist-run experiment, or a meandering "project exhibition," the differences are minimized and domesticated by the broader, socio-epistemic brushstrokes. To be sure, no working ideology is universally decisive. To generalize in this fashion is not to claim that all production and theorization is always and everywhere conducted along the very same lines. But that there is a hegemonic pattern at play.[15]

15 For the cooks among you, indeterminacy is that one batch of tomatoes too many. Tomatoes are innocuous enough, but pos-

The idea of an overarching "moral economy" is borrowed from sociologist Didier Fassin: "The production, dissemination, circulation and use of emotions and values, norms and obligations in the social space [which] characterize a particular historical moment and in some cases a specific group."[16] Moral economies, Fassin further suggests, "are about the production but also the dissemination and consumption of sensibilities."[17] Contemporary art is an economy not only in a monetary sense, but also in that it supplies and demands, distributes and redistributes—more equally to some than to others. It loudly circulates and quietly obstructs, it empowers and disempowers. Actions that are dissimulated by a persistent disidentification with power, and a pervasive sense of "critical virtue" (Suhail Malik).

If no system, however totalizing, is genuinely total, when it comes to the moral economy in question, the most visible and bracing exceptions to the rule are those subscribing to an overtly activist agenda. But even here, whether we are talking the iconic Hans Haacke, the many American practitioners vivaciously promoted by curator Nato Thompson, or examples I have personally

sess the magical capacity to transform any cuisine, no matter how replete with herbs and spices, fruits and berries, into tomato ragout. You can tell your guests it took the whole day to make, and they will sympathize, but they will still go home with a memory of ragout.

16 Didier Fassin, "A Contribution to the Critique of Moral Reason," *Anthropological Theory* 11, no. 4 (2011): 481–91. Fassin's idea of a moral economy is also put to brilliant use in: Neve Gordon and Nicola Perugini, *The Human Right to Dominate* (Oxford: Oxford University Press, 2015).

17 Fassin, "A Contribution," 487.

encountered in Taipei, Tehran, and Jakarta, supporters of direct action impatiently harrumph at attempts to pin down the operational logic at play. If anything, the abstractions of an ontological approach are dismissed all the more militantly, as moral failures in and of themselves. The irony being that the intuitive identification of art as a subversive force, a vector of critical virtue, is the art-world code of conduct par excellence.

Take an example of curatorial prose that is as refreshingly lucid, and ambitious, as Thompson's 2015 book *Seeing Power*. Thompson is the most prominent American curator to be invested in that contentious intersection between art and activism, and he does acknowledge straightforwardly didactic methods beyond the open-endedness of indeterminacy. But in the end, even here, it is the value of the "ambiguous" that wins out. The best-case scenario is still that which "accommodates both play and flexibility"[18] and refuses to be pinned down.[19] Concepts and terminologies aside, even when direct action on behalf of artists is effective—and it often is, to a surprising extent (see further, particularly "Boycotts," chapter 6)—the efficacy pales in comparison to the impact of our latter-day art apparatus as a whole. It is the latter's efficacy that needs to be the object here.

18 Nato Thompson, *Seeing Power: Art and Activism in the 21st Century* (New York: Melville House Books, 2015), 54.
19 Ibid., 126.

Chapter Overview

This book draws heavily on my experience of teaching graduate students at the Center for Curatorial Studies (CCS), Bard College, New York, between 2008 and 2013. My first two years were spent teaching part-time. I was commuting transatlantic, working absurd hours as a freelance writer/curator, secretly impressed by my own jet-lag bravado, and thereby perfecting—not to mention teaching, and enthusiastically replicating—the very formulae so loudly critiqued in these pages.

In the summer of 2010, I finally decided to accept a full-time position, and moved to upstate New York. The move from Mitte in Berlin, a bastion of the cognitive precariat, to the upstate woodlands, surrounded only by squirrels and curators, was quite a shift. Going from international zippadeedooda to being part of the furniture was not easy. Once the dust settled, I was lucky to be joined by Suhail Malik, of Goldsmiths, University of London, a visiting professor who became an important partner in conversation. Malik himself was at the beginning of a long-term project tracing an ide-

ology of indeterminacy he saw as defining contemporary art. My personal volte-face, that eventually led to this publication, is much indebted to Malik's input, but also to the comparative upstate calm which allowed for that kind of conversation in the first place. As stated over and over throughout the course of this book, it is surprising what deceleration can do.

As of August 2013, I was no longer teaching at CCS, but at Al-Quds Bard College, near Jerusalem, and at the International Academy of Art Palestine, Ramallah, where I eventually laid the curatorial foundations for the 5th Riwaq Biennale (see chapter 5). From that particular neighborhood, you could plainly see a rash of art-institutional flora bedecking the Middle East at breathtaking speed. From project spaces in Tehran, Cairo, and Dubai, to art schools in Ramallah and Beirut, to the raging ambitions of massive new venues in Istanbul, Abu Dhabi, Doha, and elsewhere. And the moral economy of contemporary art is still replicating itself across these settings with eerie precision. Even political upheavals and economic downturns seem to produce very little, in this regard, other than a change of pace (if that). The ultimate question is whether new horizons are a realistic possibility here, or whether we will just be replicating the same old clichés as everyone else.

Contrary to Malik, who insists on the aristocratic prerogatives of a theorist pure and simple, I consider it part of my professional laundry list to transfigure theoretical proposals into tangible preoccupations that are curatorial and aesthetic, even administrative in spirit. Which is why this publication is peppered with

concrete cases in point ("Working Examples") along-
side numerous unsolicited suggestions and personal
resolutions ("Notes"). Malik's impact is hard to overes-
timate, particularly the impact of the initial essays which
kick-started his own research—"Ape Says No" and
"Educations Sentimental and Unsentimental" (both
published in the *Red Hook Journal* in 2012). But it is
equally important to emphasize the influence of my col-
laboration in 2006 with the inimitable Anton Vidokle,
within the framework of unitednationsplaza, Berlin,
along with multiple joint ventures with the brilliant
Lind. But also conversations with my ever-patient part-
ner Oraib Toukan. What is more, our move to Palestine
in 2013, and the political lessons learned, had an im-
mense impact on my curating and writing.

I should also mention a bracing intellectual atmo-
sphere from within which this publication is emerging
internationally. In various ways, what I have been call-
ing the moral economy of contemporary art has, along
a variety of lines, become the object of polemical scorn
among a good range of writers and artists; all of them
proposing new parameters that will inevitably leave
deep traces over the years and decades to come. Malik
aside, among them are Armen Avanessian, Bassam El
Baroni, Diann Bauer, Amanda Beech, Robin Mackay,
Andrea Phillips, and Mo Salemy, but also my patient
editor Matthew Poole, to name but the few who are
most important to me personally.[20]

20 Other references include: Ray Brassier, Reza Negarestani,
Luke Pendrell, Keith Tilford, et al.

There is another reason for all the hands-on, concrete suggestions in my book. My tone as a writer can be so dismissive that even the most prescriptive, pragmatic essay is widely read as some kind of negational hissy fit. "Nice work Tirdad, but it's always easier to *DECON-STRUCT*—I'd love to hear some of your OWN suggestions for once?!!?" Hence, again, the many unsolicited suggestions and practical resolutions, and so on.

Following the negational fit that constitutes this very first chapter, I will be proposing three sets of discursive samples that are meant to illustrate and exemplify the object of critique that defines this book.

This critique is expanded upon throughout chapter 2, in terms of the disidentification with power that is a hallmark of contemporary art. A chapter that also attempts to situate the above discussion within the context of institutional critique, and the historical backdrop of post-structuralist theory. The latter, in turn, allows for some brief comparisons to the field of human rights, via the work of Thomas Keenan of Bard College.

Chapter 3 traces the effects of indeterminacy on artists specifically, and includes the first of several unsolicited to-do lists. In some ways, these five suggestions, though explicitly addressed to artists, are underhandedly addressing my curatorial colleagues in equal measure.

A second barrage of unsolicited propositions is what constitutes the bulk of chapter 4. All of these suggestions plead, in various ways, for "transparency" as an operational category. A manner of marking a deliberate contrast to the sense of entitlement to "opacity" that

engulfs our field at present. The plea for transparency is also a push to "depersonalize," as far as humanly possible, our respective practices.

Chapter 5 more or less self-critically introduces three conspicuous examples from my own curatorial practice, drawn from three very different biennial settings; Sharjah (2005), Taipei (2010), and Riwaq (2015). Working examples that together set the stage for the discussion of "location" that is to follow.

Chapter 6 attempts to translate the discursive polarity of "transparency" versus "opacity" into spatial terms: specific "locations" as opposed to an all-pervasive "periphery." Self-marginalization, the chapter argues, is key to contemporary art's notion of critical virtue. Contemporary art is always in need of an institutional Other, so as to position itself somewhere outside its corridors of power. Which is why the section suggests a more prescriptive sense of location, also by means of cross-comparisons to "universalism" and "site," and to international boycott movements within the arts.

Chapter 7 reframes the above locational query of "here and there" into a matter of "above or below." We are still talking locations, but less in terms of peripheral self-images, and more in terms of glass floors and middle-class entitlements. What role does art play in terms of elite formation? In which ways does the moral economy of indeterminacy consolidate the art world's class biases as they presently exist, and how does it preclude possibilities of reimagining the field differently?

Chapter 8 also follows in the above topographic footsteps, but leads in very different directions. This is

a section that addresses the curatorial prerogative of moving bodies through space. Among other things, it polemically addresses the format of the thematic group show, and includes, as a self-reflexive working example, the UAE Pavilion at the 53rd Venice Biennale in 2009 alongside the "Monogamy" exhibition held at CCS in 2013.

The penultimate chapter addresses formal and informal sectors of art education, tracing the pedagogical effects of indeterminacy paradigms in general, and of latter-day "disruption" narratives in particular. It ends with a vindication of the student show as format, and a study of unitednationsplaza, Berlin (2006–7), as one last working example.

The conclusion, finally, features ur-curator Dominique de Vivant Denon who presides, in all his ur-imperial grandeur, over a recap of the stakes defining this book.

The scope of these chapters clearly prioritizes the last decade, from 2006 to 2015, primarily, though not exclusively, as seen from Tehran, upstate New York, and Berlin. Moreover, many of the key references stem from *Red Hook*, the online journal of CCS, of which I was editor between 2011 and 2013. The editing of catalogues and websites comprises a facet of curating that is somewhat under-historicized, and that is not addressed much in this book. Suffice to say that *Red Hook* was a mixture of voices and positions successfully mirroring the complexity of CCS itself. And yet, cutting through the pluralism, you could still discern a stubborn editorial tenor. A commissioning process just overdetermined enough

to feed into the specific queries of this long-term book project. A little creepy, perhaps. But very helpful.

Caveat on
Curatorial Writing

Before we cut to the chase at last, I will allow myself a quick word on the soul-crushing idea of yet another book on the market penned by a curator. As a longtime CCS faculty member, I know writing of this type is rarely, if ever, referenced by students, nor even by curatorial colleagues. Except, perhaps, as token straw man, upon which people can build their own arguments. Exhibition histories are much preferred, as they avoid the diplomatic abstractions curatorial discourse is rightfully associated with. The diplomacy of curatorial writing, the unwillingness to abandon an evasive language of intellectualized innuendo, is due to a number of factors—among which three stand out.

Firstly, there is the moral economy, which represents the core concern of this book. And which makes for bloody awful prose. What already sounds tired in a PowerPoint presentation will look patently bankrupt in an essay. And in a vicious cycle, the porous prose only serves to reinforce the spongy dialectics in turn.

In his 2012 text for the *Red Hook Journal,* "Writing and Indifference," curator Dieter Roelstraete puts it rather well. The prevailing art-editorial guideline seems to be: "Please feel free to write anything you want, as long you refrain from writing 'about' the work. Indeed, the author is expressly asked, sometimes almost implored, to write 'beside the point': often a mere literary *Spielerei* will do, [sometimes] a dialogue or play may be considered fit, sometimes a broadly art-historical framing. Anything but a piece that seeks to engage, in varying degrees of directness—this in particular being the great new taboo—the work or the practice itself."[21] It is hard for me to argue with his delightfully angry paragraph. I myself have too often engaged in such *Spielereien.* The one footnote I would add is that the trend Roelstraete is lamenting transcends the acceptability of fiction-as-art-writing or poetry-as-criticism: the elusiveness of the "about" is pointing to a much broader crisis here.

The second factor dovetails neatly with the first, and is both symptom and catalyst thereof: an oversaturated job market that discourages polemical positions.[22] The field is large enough to be ferociously

21 Dieter Roelstraete, "On Writing: Writing and Indifference," *Red Hook Journal* (June 2012), http://www.bard.edu/ccs/redhook /writing-and-indifference/.

22 On the rare occasions when frank criticism is uttered in public, it tends to escalate to mythical proportions, e.g., on the occasion of the 52nd Venice Biennale (2007). In *Artforum* (Fall 2007), Robert Storr responded to critiques of his biennial, and of his African Pavilion in particular. It was Okwui Enwezor who insisted on pursuing a screaming escalation with Storr, covering everything from colonialism to careerism to generational divides. I was reminded of *Au séminaire* (1969), where Roland Barthes

competitive, but small enough to be strangely intimate. Compare the film industry, where I can critique a Steven Spielberg movie all I want, for it is unlikely he will ever care. It is another matter to critique someone who is liable to be standing next to you at an opening. Or who may be on that grant committee, that recruitment panel, that jury, or that one advisory board you were firmly counting on. There are all manner of complex personal friendships and fiendships that will come to haunt you sooner or later.

In order to move on to a third and final factor defining curatorial prose, I will draw on my practice as a novelist. Working on a third novel alongside this book has been a dicey parallel experience that clarified how much easier it is, in fiction, to allow for overarching political concerns to permeate the work. In an all-out, full-frontal manner. As a novelist, I am of course accountable for the representations I spew into the world. But I write alone, and my novels will circulate as commodities, somewhere out there in the Amazon. Which means my responsibilities have little to do with moving bodies through a given space. Nor do I directly define working conditions for others. Nor do I enjoy any unmediated gatekeeping prerogatives. Labor, institutions, bodies in space: three classic biopolitical concerns that are as removed from the idiosyncratic act of writing as they are essential to the curatorial everyday. I am not

suggests that discord produces *sychomythia* (the predictability of a script). But Barthes was proven wrong: the *Artforum* shit fest was a rare, captivating moment well beyond the sychomythia that the art limelight usually produces.

saying writing requires a bubble. But it does rely on high-intensity conjectural, physiological, and neurological activities that are as distinct to curating as they are to mud wrestling, or ikebana.

Whatever the setting, moreover, putting words on digital paper requires more than lyrical flair. Writing relies on a modicum of consistent practice, which in turn relies on a modicum of support. Which is increasingly hard to come by. If people whose prime vocation is writing are having a hard time focusing, how can we expect artists and curators to do a decent job on the fly? Even among those who take writing seriously, few can afford to give it the sustained focus it requires. In the end, most will outsource as much writing as possible. These days, curators in particular look upon the little prose they produce with such pride, and relief, that they become ferociously uninterested in critical feedback. Speaking from personal experience, when it comes to trimming a text, however meekly, curators are tough to contend with. Pity the editor of any curatorial manuscript.

Working Example:
Curatorial Discourse

Having addressed the writing, allow me to get to the language overall. Art is a glossocentric operation in more ways than one. Audience reception aside, consider the studio visits and public presentations, the catalogue essays and press statements, the captions and guided tours, the fundraising luncheons and gala dinners, the seminars and workshops, the cattle market that is a jury, not to mention the administrative micromanagement and the e-mails. With the latter now constituting the bulk of written output. Politicians and clergy aside, few jobs are as vested in the deployment of discourse, in the most fundamental, technical sense of language that produces a subject position. With the subject in question being both the professional vantage point from which to speak, and the viewer/listener that is the audience.

For the purposes of this chapter, I can offer three sets of working examples, two of which are derived from the field of curatorial discourse. Curators are helpful synecdoches in that they represent concentrated ver-

sions of the moral economy that defines contemporary art at large. This makes superb case studies of us, and one is well-advised to take full advantage thereof.

A) Good Objects: samples from my Moleskine note-books (2013–15), where I noted every case of an artist or curator clearly defining a best-case sce-nario for a given project.

B) Three hegemonic definitions of "the curatorial," as proposed in Paul O'Neill's "The Curatorial Con-stellation and the Paracuratorial Paradox" (*The Exhibitionist*, no. 6, June 2012, 55–60).

C) Samples and examples from the CCS Speaker Series (2008–13).

A) Good Objects

Abeyance, Agonism, Amateurism, Ambiguity, Ambivalence, Aporia, Becoming,
Circulation, Contamination, Conversation, Criticality, Critique, Confusion, Contingency,
Deferral, *Dérive*, Destabilization, Deterritorialization, Deviance, Dialogue, Displacement, Disremembering, Disruption, Dissonance, Doubt, Drag,
Emergence, Ephemerality, Equivocality, Error, Escape, Eventhood, Exappropriation, Exile, Experimentation,
Flânerie, Flux, Forgetfulness, Fragmentation, Gray Zones,
Hacking, Heterodoxy, Heteronymy, Hubs,

In-Betweenness, Indecision, Indefinability,
Interconnection, Interrogation, Interruption,
Interstitiaility, Investigation,
Limbo, Liminal,
Madness, Margins, Mavericks, Mediation,
Migration, Multiplicities,
Negation, Nodes,
Opacity, Open-Endedness,
Paracuratorial, Parasitical, Parataxis,
Periphery, Piracy, Play, Plurality, Polyphony,
Polysemy, Polyvalence, Porousness, Possibility,
Post-curatorial, Process, Provoking,
Queering, Questioning,
Rhizomatics,
Schizophrenia, Shifting, Smuggling,
Spectrality, Subversion, Suspension,
Teaser, Threshold, Transformation,
Translation, Transversality, Turn,
Uncertainty, Undermining, Unknowing,
Unlearning,
Vertigo, Virus,
Wandering,
Xeno-epistemics.

To be clear, I am not interested in populist mockery of art-world hot-air blah-blah. The above terms are not arbitrary or meaningless. On the contrary; together they constitute a razor sharp, surgical exercise in subject formation that is breathtakingly precise.

All these "Good Objects" are beholden to their own agendas, nuances, and histories, many of them re-

flecting painful and prolonged institutional battles. In most contexts, few of these terms have much to do with one another. Within contemporary art, however, they constitute seamlessly compatible shades of meaning. A hundred shades of gray. Most if not all these "Good Objects" connote an object to be undermined, subverted, questioned, however benignly. Even a "turn," after all, suggests a move away from something or other, a diversion from the straight and narrow.

As Malik argues, writing in collaboration with Andrea Phillips, it is this trait that both compounds and clarifies the significance of the exceptionally influential Jacques Rancière. To whom the defining essence of art-as-politics is neither freedom nor equality, but "the encounter with the police order since 'it has no place or objects of its own'."[23] In view of the above glossary, the encounter is ostensibly with "truth," "reality," "coherence," "consistency," "knowledge," "meaning," "memory," or indeed anything that might technically stand in for the police order at large. This quantitative, critical mass of subversion—subversion per se, as means and end alike—amounts to a quality in its own right. A gravitational pull that supplants the need for pinpointing the order to be undermined. Indeed, we intuitively come to understand that the dearth of such an explanation is a good thing in and of itself. After all, according to this rationale, to define the opposition too clearly is to get "locked in a dialectic," and to thereby forfeit any genuine sense of xeno-epistemic abeyance.

23 Phillips and Malik, "Wrong of Contemporary Art," 123.

High-profile examples are many, even among the more circumspect curators. Take a prominent, relatively articulate example, Okwui Enwezor's homage to Karl Marx's *Capital* at the 56th Venice Biennale (2015). When it came to querying what is actually to be ventured or gained with this homage, the press release claimed it was there to help question the "appearance of things." While at documenta 13 (2012), Carolyn Christov-Bakargiev's political pointers were organized into four "conditions": dreaming, withdrawing, being besieged, and role-playing. (I have yet to insert her terms into the above list.)

Curators aside, art writers can equally feel at home within this ample hermeneutic leeway. Gallerists and directors, for their part, can pitch the work as necessary, which also means sponsors, patrons, and other politicians are easily accommodated. Audiences are flattered to play a creative part in the artwork, while the artists, finally, can loom ever larger as the guiding light amidst the dazzling pyrotechnics.

B) Definitions

I will now reference a troika of hegemonic definitions of the "curatorial" as suggested by curator Paul O'Neill. By and large, "curator" is shorthand for a cutting-edge ideal type who manages to withstand the constraints currently limiting the field of curating at large. From the tedium of fundraising (in a context of increasing fiscal pressures), to the nonreflexive and antitheoretical bent of the mainstream, to the pop-cultural appropriation of the term ("curating" your living room, your sex life,

your shopping basket, etc.). O'Neill's definitionary trio is penned by a curator, an art historian, and a theorist, respectively:

> Can we speak of the curatorial as a multidimensional role that includes critique, editing, education, and fund raising? [The] curatorial can contain all these varied dimensions as a loose methodology applied by different people in various capacities. Today I imagine curating as a way of thinking in terms of interconnections: linking objects, images, processes, people, locations, histories, and discourses in physical space like an active catalyst, generating twists, turns and tensions.
> —Maria Lind[24]

> To the extent [that a critical practice] is about the political potential of the curatorial, it is quite fundamentally about processing the curatorial role in addition to other processes of "becoming." It represents a continual process of negotiation in which the positions taken vary in relation to the other subjects or objects involved in exhibitions, take on new directions, and appear in various constellations.
> —Beatrice von Bismarck[25]

24 Maria Lind, "The Curatorial," in *Selected Maria Lind Writing*, ed. Brian Kuan Wood (Berlin: Sternberg Press, 2010), 63.
25 Beatrice von Bismarck, "Curatorial Criticality – On the Role of Freelance Curators in the Field of Contemporary Art," in *Curating Critique*, ed. Barnaby Drabble and Dorothee Richter (Frankfurt: Revolver, 2007), 68.

In the realm of the curatorial we see various prin-
ciples that might not be associated with display-
ing works of art; principles of the production of
knowledge, of activism, of cultural circulations and
translations, that begin to shape and determine
other forms by which arts can engage. In a sense
the curatorial is critical thought that does not rush
to concretise itself, but allows us to stay with the
questions until they point us in some direction we
might have not been able to predict.
—Irit Rogoff[26]

Notice the leitmotifs: critique, interconnections, linking,
twists, turns, tensions, a continual process of negotia-
tion, new directions, processes of becoming, circulations
and translations, critical thought, questions, smuggling.
The speaking position in all three definitions is modest
in tone, in that the speaker is a mere master of cere-
mony, nimbly responding to the interests and desires
of others around her. But at the end of the day, our
speaker remains heroic in that she's a versatile infiltra-
tor, surfing waves, smuggling goods, all in a spirit of
"critical virtue," consistently evading the trap of iden-
tifying with power.

Once again, these terms—a productively bewilder-
ing array of interlinkages, trans-connections, hyper-
mediations—all bring their own strengths to the table.
As do the practitioners who coined the above defini-

26 Irit Rogoff, "'Smuggling' – An Embodied Criticality," *Euro-
pean Institute for Progressive Cultural Policies* (August 2008), http://
eipcp.net/dlfiles/rogoff-smuggling.

tions. Rogoff, for one, is an inspiring writer even on matters curatorial, which is no easy feat, God knows. And Bismarck has penned some of the most significant texts on recent curatorial history (addressing issues of accountability).[27] Lind, meanwhile, remains something of a professional mentor to me. But what this book is focusing on is the mechanism of an overarching professional momentum. One that is aided and abetted by much broader, liberal ideas of freedom of choice and personal expression, which we all mirror, to varying degrees, often unsuspectingly. So this is not about the individual strengths of individual practitioners, so much as the hegemonic ethos of formalized criticality. In other words, voices such as the above trio constitute the very ground I am standing on. The habitus I would like to be judged in comparison to.

C) Curatorial Lectures

A third set of case studies is drawn from the CCS Speaker Series. Public speaking is a challenging thing, and a lecture usually brings with it a measure of unintended transparency. At CCS, back in the day, lectures took place on a weekly basis, Mondays, 3 p.m., in a self-contained seminar room with no windows, under laboratory-like conditions. With everyone still digest-

27 See: Beatrice von Bismarck, "Der Meister der Werke: Daniel Burens Beitrag zur documenta 5 in Kassel 1972," in *Jenseits der Grenzen. Französische und deutsche Kunst vom Ancien Régime bis zur Gegenwart*, ed. Uwe Fleckner, Martin Schieder, and Michael F. Zimmermann (Cologne: DuMont, 2000), 215–29.

ing the chicken alfredo from the campus canteen. With the speakers coming and going under identical circumstances, the similarities and differences could shine through very clearly.

Between January 2008 and May 2013, I attended every lecture—providing I was upstate—so the list does not reflect a selection of my own favorites (even if the below summaries are obviously mine). All twenty-seven presenters were encouraged to speak of "methodologies" or "core concerns." The speakers being Lars Bang Larsen, Regine Basha, Richard Birkett and Stefan Kalmár, Saskia Bos, Roger M. Buergel, Stuart Comer, Tom Eccles,[28] Peter Eeley, Anne Ellegood, Charles Esche, Hendrik Folkerts, Lia Gangitano, Krist Gruijthuijsen, Ed Halter, Maria Hlavajova, Jens Hoffmann, Anthony Huberman, Maria Lind, Fionn Meade, Helen Molesworth, Paul O'Neill, João Ribas, Dieter Roelstraete, Irit Rogoff, Scott Rothkopf, Jay Sanders, Ingrid Schaffner, and myself.

As it turns out, a third were women, and half were based in Europe, with the other half based in the United States. Only four were freelancers, all others had salaried contracts with an exhibition venue, a school, or both. Only three of them had any formal curatorial training. And if I were to take a wild but semieducated guess, I would say over 90 percent of our speakers were solid middle-class stock.

Although the roster is exclusively Euro-American, other-worldist quotas would not change the picture—i.e., the makeup of contemporary art's moral economy as

28 Tom Eccles spoke within a smaller seminar setting.

exemplified by CCS—very much. The very crux of this book is to understand why leaving Euro-America does not change the picture fundamentally. The homogeneity of the series is surprising only in light of the field's pride in being so undefinable, so devoid of particularity, when it is actually so cohesive in so many different ways. At this point, we can subdivide the speakers into four categories: "Too Busy," "Very Personal," "Facing Goliath," and "Criteria."

i) The "Too Busy" group is characterized by a breathless staccato of PowerPoint slides. "I've done sooo much stuff you're not gonna believe this." Though the Power-Point always looks like a factual, no-nonsense list—"did this and then this"—it is hardly beyond ideology. The pornography of installation shots is in itself a complex historical development (see chapter 8). As is glamorizing overproduction, and glamorizing one's exhaustion along with it. Not to forget the fast-paced peppering of loaded keywords here and there. "Neoliberalism" is a favorite: in art usage, it dehistoricizes capital by reducing all free-market developments to post-Thatcherism more or less. It also serves to delegitimize anything that can be remotely branded as such. ("Transparency? But isn't that TOdally neoLIBral"?) As used here, the term congratulates the viewer/listener for recognizing a "Bad Object" to which we are all falling victim together, united in critical virtue. Regardless of the fact that, whether in terms of voting patterns, maternity leave, carbon footprints, or Israeli avocados, the art world is nothing if not laissez-faire. The issue, once again, is not the vague-

ness, but, on the contrary, the precision of the operation at hand. Minimal innuendos with maximal denotational effect.

ii) The following are core concerns as formulated by the "Very Personal" group:

- "I really love Huckleberry Finn."
- "It all comes right from the gut."
- "All I know is that I don't know."
- "I curate my friends and it usually happens over beers."
- "I'm excited and I want my audience to be excited."
- "There was no time for methodology, it was all so hard, and everybody was so mean to me."

A tenor that personalizes work as a matter of feelings, friends, and gut intuition. Which is an old trick, used throughout the cultural industries—and brilliantly analyzed by Meaghan Morris in "Indigestion: A Rhetoric of Reviewing."[29] The persona here is the affable anti-elitist. "Like you, dear listener, I'm untainted by the perils of expertise. It's all about the delicate linings of my stomach, and my exceptionally attuned emotions, which I am humble enough to share with you today." The choice of a topic or artist has nothing to do with sociocultural capital, or access, let alone specialized train-

29 Meaghan Morris, *The Pirate's Fiancée: Feminism, Reading, Postmodernism* (London: Verso, 1988), 105–22.

ing. As it happens, the suggestion that curating is about "hanging out with friends over beers" sparked outrage among the CCS students, unwilling to accept bonding as a solid recruitment ethos. To be fair, the outrage was heightened by the otherwise exceptionally conscientious and brilliant Roelstraete being a tall, bearded curator of a major American museum at the time. Less overbearing figures regularly get away with "friendship" as the more humane, cutesy, progressive way to handle things.

iii) Core concerns as formulated by the "Facing Goliath" group:

- "The artist always comes first."
- "I'm guided by transitive artworks as producers of deviance."
- "Holland is a mess."
- "Cooper Union is a mess."
- "Curators can and should be irresponsible."
- "I curate from within the cracks."
- "Curating as smuggling."
- "Curator as mediator."

It is endearing to see who gets to play David, always and everywhere. The final word, this narrative is ultimately implying, is not up to the curator. It is up to the artist, who really calls the shots, or the institution, which must be challenged from without or infiltrated from within. Such institutions might include the Sheikhs, the Society of the Spectacle, the Dutch political class, or the Dutch press. Caught, as you are, within a shit storm

that, God only knows, is never of your making, all you can do as curator is to try and make those people see reason. To reiterate, I am not denying the existence of these shit storms, nor downplaying their importance, but describing a structure that frames us persistently as noble victims, time and again.

iv) "Criteria." Out of the twenty-seven curators, a minority of six did respond to the invitation by addressing core concerns without reserve or ambivalence. Some of these were political, in the narrower sense of the term, others a matter of accounting for impersonal criteria, unapologetically, and translating them into a clearly defined format. Thereby offering the transparency and vulnerability that comes with an objective, and with accepting to be judged accordingly. Birkett and Kalmár focused on working conditions, pledging to make Artists Space a W.A.G.E.-certified organization.[30] Buergel translated his fixation on "the triangle of cult, coloniality, and modernity" into an attempt to democratize the Busan Biennale. Esche presented his old-school social-democratic agenda as propagated at the Van Abbemuseum. Molesworth argued for gargantuan survey exhibitions as a tool for feminist agendas. While Ribas reflected on histories and potentials of the solo show as genre. These are objectives that are not only clear, but refreshingly precise.

30 A promise fulfilled in late 2014.

The latter makes a difference in that indeterminacy need not sound meek and self-victimizing; it can also come in the guise of galactic bluster. On the rare occasions curatorial agendas are spelled out for the audience, the rhetoric is mostly so sweeping, and the proposals so broad, that no one can possibly hold you to them. As curator Matthew Poole puts it, these are cases of "plausible deniability."[31] Curator Anselm Franke sees his task as "destabilizing" the role of "culture, technologies and non-human factors in the making of the limits of the natural." Nato Thompson strives for "correcting injustices around the globe," "honoring human rights," and "a just world," no less. And as curator of the 11th Sharjah Biennial (2013), Yuko Hasegawa called for a "novel culture" almost in passing.[32]

It bears mentioning, once again, that to focus on individuals is to miss the point. Esche & Co. may deserve a cookie and a pat on the back, but first of all, any decision-making process, any example of statecraft, loses dramatically in intelligence when left to personal flair. The idea that the inspirations of the few should be the benchmark of the many is as helpful, and as precise, as

31 Matthew Poole (introduction to the "Anti-Humanist Curating" seminar, Whitechapel Gallery, London, November 25, 2010).
32 As another example of plausible deniability, consider this conference brief, communicated to me via e-mail in 2007: "As already mentioned, this event is of informal nature. Each of you has 10 minutes for a statement on the current state of art criticism, art magazines, the relationship between the art critic and curator, and how contemporary theory and politics feed into curatorial practice."

saying we do not need light bulbs because we have the supernova. Moreover, no practice is transgressive per se, just as nobody, not even young Zolghadr, embodies mindless orthodoxy through and through. Multiple patterns cohabit and commingle, even within the confines of a single lecture, artwork, show, or publication.[33] In other words, the strategic essentialism of this book brutally sidesteps not only the differences between individual oeuvres, but also within these oeuvres, from one instance to the next.

To think beyond Lone Ranger individualism is an ambitious exercise; the stuff is too multilayered a paradigm to be chalked up to the art world alone. Nor even to the "neoliberal" era necessarily. In 1858, Marx was already complaining about the preponderance of what he called *Robinsonaden* around him. His was a time when Jean-Jacques Rousseau, Adam Smith, Hegel, and the Holy Bible were all portraying, albeit in very different ways, some singular Crusoe figure predating historical development. The basis for these "nature's gentleman" types was never empirical reality. (If anything, the further back you go in history, the more tribal collectivity appears to predominate, and the less the individual amounts to anything much.) Instead, the Robinson-

33 Take the contributions to a compilation as middle-of-the-road as *Pigeons in the Grass, Alas*, ed. Paula Marincola and Peter Nesbett (Philadelphia: Pew Center for Arts and Heritage, 2013). Even here, bracing moments are noticeable throughout—see Schaffner's plea for a "craft of curating" (page 98) or Storr's call for "ethical criteria" (page 83)—but can only be alluded to in passing within a publication endeavor that is too orthodox to be conducive to developing alternatives.

aden were prescriptive protocapitalist fables, designed to furnish the heroic overtones that a burgeoning ideology of free enterprise required.

Similarly, in contemporary art, the value of individualism is only barely linked to factual realities. The exterior visualization of our working conditions may suggest that the individual artist still spawns her ideas in splendid isolation. And that creative, technical, and administrative roles are all neatly subdivided among different working teams. But as many have pointed out before me, our projects increasingly rely on capillary collective efforts. In existing production processes within a post-Fordist climate, nearly everyone partakes in nearly everything. Artists do paperwork. Unnamed assistants do conceptual heavy lifting. Unnamed factory employees do production. Interns draft curatorial frameworks. Office staff are recruited for creative disaster management on the day of the opening. Any substantial innovations in art have equally been the result of group dynamics. Which is to say that reform is not an option without transcending our reliance on charming, individual revolutionaries with good intentions. What is required instead is a professional logic, and a support structure, that can offer some traction of its own, beyond the overwhelming gravitational pull of business as usual. (See also "Five Unsolicited Suggestions" in chapter 3.)

STATECRAFT

Working Example: Human Rights

This section addresses the issue of statecraft, and the role critical theory of the post-structuralist variety has played in honing that particular art. I will begin the section with a cross-comparison to the field of human rights. The heritage of theory and post-structuralism enjoys a comparable measure of salience here, albeit along slightly different lines. In his 2006 essay "Translation, or: Can Things Get Any Worse?," human rights scholar Thomas Keenan describes languages of unilateralism on various sides of conflicts in the Middle

East.[34] From Israel's former foreign minister Tzipi Livni to Hezbollah and beyond, Keenan notes a growing refusal of dialogue, and an embrace of totalizing silence, not to mention total war. Livni is quoted as saying that Israel should respond with "recklessness" to any provocation. Dialogue is replaced by a pedagogy of incremental annihilation.

Keenan argues that all this chest beating makes realpolitik—the bureaucracy of negotiations, the tedium of diplomacy—look rational by comparison. Far more rational, of course, than it really is. Keenan himself makes no distinctions between recklessness and realpolitik in terms of any claims to reason. Instead, he insists on the existing chaos, the unavoidable inconsistencies, the endless mistranslations, the de- and refigurations, of politics tout court. Endless mistranslations that Keenan embraces. Not as a lesser evil but a best-case scenario. In a fiery spirit of post-structuralism— Keenan is an authority on Jacques Derrida and Paul de Man—he upholds the foreclosure of closure as a telos in itself. In other words, when, in his practice at large, Keenan refers to "difficult fables of responsibility," to human rights as a place where "effects and conditions cannot be calculated," he is doing so in exasperation and elation alike.[35] His is a classic, Benjaminian sense of *Aufgabe*, with the German homonym referring to

34 A contribution to the Munich edition of the roaming "Dictionary of War" project.
35 See: Thomas Keenan, *Fables of Responsibility: Aberrations and Predicaments in Ethics and Politics* (Stanford, CA: Stanford University Press, 1997), 2.

both "duty" and "surrender." A duty you can only fail to fulfill, a failure that is a duty in itself.

Perhaps the one thing Keenan and Hans Ulrich Obrist might share—albeit for very, very different reasons—is a reluctance to abandon the high ground of aporia for the lowlands of instrumentalization. After all, the project of human rights is itself always running the risk of becoming self-serving, unilateral, and totalizing. Its most basic terms demand consistent redefinition if they are to avoid the violence they have facilitated throughout much of their history. As argued in Neve Gordon and Nicola Perugini's *The Human Right to Dominate*, human rights are not an abstract set of self-same commandments to be appropriated and misappropriated.[36] The retrogressive or emancipatory content of human rights is inseparable from the moral economies of each setting it is deployed within. There is no such thing as a clear-cut program that can rely on guilty reminders of Empire and Hegel, to be redeemed whenever necessary. To remain credible, the field of human rights needs to repeatedly account for an ethical matrix, on the one hand, and open-textured redefinition of translation *toujours*, on the other.

This is where Suhail Malik comes in, suggesting that the field of human rights is actually at its most engaging when it tackles the most ghastly of possibilities, that of "natural law," and when it arrogantly presumes to "judge the present according to the protocols of the past in the name of the future." The formulation

36 Gordon and Perugini, *The Human Right to Dominate*, 53, 129.

is borrowed from Costas Douzinas, but Malik's take is a precise inversion of the eminent human rights scholar's. Douzinas was famously arguing that human rights must, at all costs, avoid being formalized into an "accountancy of rules" and a glamorized series of "diplomatic lunches." Humanitarianism-as-technocracy is the worst-case scenario here. While Malik is daring us to bring it on, suggesting that the clear political contours of a world-as-image is the only alternative to contemporaneity as we presently know it.[37] A contemporaneity that forfeits agency to the benefit of complexity and subtlety as means and end alike.

This, of course, is a tall order for anyone to whom the "diplomatic accountancy of rules" is a possibility only insofar as it might be considered a fable of Benjamian Aufgabe in its own right. Once again, writing from Ramallah, which boasts the highest concentration of human rights debates and NGOs in this solar system, serves to make the political stakes a little more palpable. Judging from those particular sidelines, I appreciate Keenan's take on what is effectively a state of excruciating suspension: as indispensable as it is both perverse and unsustainable. Speaking as a writer/curator of contemporary art, however, Malik's provocation rings true. Within my transnational professional habitus, it is the culture of open-ended translation that is

37 Suhail Malik, "Ape Says No," *Red Hook Journal* (June 2013), http://www.bard.edu/ccs/redhook/ape-says-no/. See also: Suhail Malik, "The Politics of Neutrality," in *The Human Snapshot*, ed. Thomas Keenan and Tirdad Zolghadr (Berlin: Sternberg Press, 2013).

hegemonic in and of itself. Indeterminacy is not what may potentially retrieve contemporary art from its complex state of suspension. At this point, art has happily arrived in the corridors of power, and indeterminacy serves as its welcome mat, if not the very bricks and mortar of the larger edifice.

Theory

Over the past decade, Jacques Rancière is the theorist to have both mirrored and celebrated the above dilemma most lucidly and effectively. The consequences of his ideas, particularly those revolving around a "redistribution of the sensible," have been critiqued with much gusto, and, by and large, I am not one to take issue.[38] Still, what is impressive in Rancière is his genuine mistrust of mechanisms of elite-formation, and their stultifying consequences, an instinct which harks back to his time as a Marxist student activist in 1960s France. This is where, as he likes to recount, he gradually came to notice the silencing effects of his own vanguard aspirations. A process of coming-of-age that is still palpable in much of his writing, especially his widely quoted *The Emancipated Spectator* (2009), in which

38　See, for example, Andrea Phillips and Suhail Malik, *Reading Rancière* (London: Continuum, 2011).

Rancière argues that a level playing field is only genuinely level if the audience, paradoxically, is allowed the luxury of being as silent as it pleases. It need not and should not be expected to speak. To presuppose a visibly "active" audience, a vocal body, to be a prerequisite to emancipation, is just another misguided instance of top-down teaching.

This dogged insistence on the audience's prerogatives is inspiring. But contemporary art is not a factory picket line in the 1960s. Downplaying your privileges and expertise will grant you a very different kind of leverage here. By insisting on a politics that redistributes the right to speak—in a strictly formalized sense of recirculation per se—without accounting for the way this distribution is instantiated, by artists and curators, Rancière's output fails to account for its de facto role in elite formation qua contemporary art. To be fair, these are issues that have haunted art's relationship to theory since the advent of post-structuralism itself.

In the early 1990s, as a student of comparative literature, I discovered post-structuralism as a newly hegemonic force. A jarring, trans-institutional momentum, a promise of a new dawn, no less. By the time I began curating, a decade later, mapping critical theory onto curatorial practice had accumulated a colorful track record. The two were hand in glove. Yin and yang. The perfect lyrics to a catchy tune. Whatever theory had lost in revolutionary sparkle, it now made up for in sheer efficiency. Even in terms of discursive tone and political mannerism, the Conceptual art heroes of the 1960s—

Seth, Lucy, Harry & Co.—seemed immediately familiar to me, what with all their hybridizing terminologies and polyviral attitudes. And Harald Szeemann was the most fetching of them all.

To understand the cultish attraction of the bushy Renaissance man, it is worth taking a glance at Christian Rattemeyer's fantastic study *Exhibiting the New Art* (Afterall Books, 2011). The book is a comparison between two 1969 group exhibitions that both drew from a near-identical body of artworks: Szeemann's "When Attitudes Become Form" and Wim Beeren's "Op Losse Schroeven." Rattemeyer contrasts the muted reception of Beeren to the raging historiographic success of Szeemann. Beeren's fastidious insistence on clear selection criteria, and on materiality as experienced in space—not to mention that nerdy title, which translates as "On Loose Screws"—none of this fastidious insistence did him any favors. Szeemann's radiance, by contrast, can be traced to a combination of adventurousness in tenor, and comprehensiveness in style. Some would imagine the adventurous to be anathema to the comprehensive. But only if you assume comprehensiveness to be an encyclopedic, taxonomic endeavor, as opposed to an adventurist gesture that lays claim to sweeping open-endedness. Szeemann's Promethean swagger, that whole cult of vertigo, was the pitch-perfect approach at a time when the academic expectations placed upon art were all but stifling. So it would be pointless to deny our debt to Szeemann, as curators and artists alike. The question, however, is what to do when Thermidor ar-

rives, and the expectation is one of vertigo precisely.[39] Expectations formulated and enforced by contemporary art itself. And it is in terms of helping art formulate and enforce those expectations that critical theory remains significant today.

It is true that a recent "philosophical turn" has reoriented the conversation away from "correlationism" (the new curse word for the post-structuralist agenda), and toward Triple Oh, Spec Real, Accelerationism, New Rationalism, Xeno-feminism, and other, even newer dawns. But examples of a decisive, tangible impact on contemporary art are still few and far between. At the risk of sounding antiquated, I would venture that, in terms of deep-seated intuitions—in terms of the nomos, the stuff that produces a discursive bedrock—post-structuralism remains the only game in town. This is because our highly selective take on *différance*, rhizomatics, paratextual jouissance, and obtuse third meanings—all peppered with a dash of Theodor Adorno's dystopia—allows for an incomparable set of political and professional advantages.

To be sure, at the hands of the post-structuralist grandparents themselves, the above leitmotifs were used as ammunition in stark intra-institutional battles.[40] They helped foster a mentality of formidably

39 Art historian Hal Foster agrees that indeterminacy, "disdained not long ago," is now "prized" as a quality, but still considers it a contrarian, critical thing within today's institutional and societal context at large. See: Hal Foster, *Bad New Days: Art, Criticism, Emergency* (London: Verso, 2015), 134.

40 The post-structuralist call to take responsibility for co-defining both the institutional landscape and the great outdoors—

(self-)critical positioning, and eventually achieved an unprecedented politicization of knowledge across the board. Often at a rather high personal price to the theorists themselves. Postcolonial theory, in which I was enthusiastically invested as a student, would pick fights with colonial paradigms as well as the very localist paradigms that were used to resist them. Jacques Derrida, for his part, has written poignantly about the tribulations involved in obtaining his PhD.[41] But as Michel Foucault would have it in *The Archaeology of Knowledge*, a discourse must not be referred to some "distant presence of the origin," but assessed "as and when it occurs."[42] As and when it occurs within contemporary art, poststructuralist discourse is deployed to make clear-cut

by means of critical theory—is a decisive point all too often overlooked in recent anticorrelationist diatribes. A recent corrective to this trend is: *Genealogies of Speculation*, ed. Suhail Malik and Armen Avanessian (New York: Bloomsbury, 2016). See also: Armen Avanessian, "Speculative Poetics – Preliminary Reflections," in *Realism Materialism Art*, ed. Christoph Cox, Jenny Jaskey, and Suhail Malik (Berlin: Sternberg Press, 2015).

41 My thanks to theorist Dieter Lesage for this reference: see Jacques Derrida, "Ponctuations: le temps de la these," in *Du droit à la philosophie* (Paris: Galilée, 1990), 439–59. This was the introduction he made at the presentation of *De la grammatologie* as a special thesis (*doctorat d'état*), June 1980, at the Sorbonne. Jury members were De Gandillac, Aubenque, Desanti, Joly, Lascault, and Levinas. Published in English as: "The Time of a Thesis: Punctuations," trans. Kathleen McLaughlin, in *Philosophy in France Today*, ed. Alan Montefiore (Cambridge: Cambridge University Press, 1983), 34–50.

42 Michel Foucault, *The Archaeology of Knowledge*, trans. Alan Sheridan Smith (New York: Pantheon, 1972), 27.

disagreements, let alone transparent agendas, a near impossibility.[43]

It is helpful to revisit the etymology of the term "theory" here. In an ancient Greek context, theory was not a polar opposite to practice. Rather, the public *theorein* stood in opposition to *aesthesis*, which was a matter of private contemplation.[44] The theorein were designated by the *polis*, "summoned on special occasions to attest the occurrence of some event, to witness its happenstance, and verbally certify its having taken place." The polis needed this "ascertainable form of knowledge if it was not to lose itself in endless claims or counterclaims"; claims or counterclaims of individual citizens offering only aesthesis, instead of the certainty embodied by the *theoria*. So, it invested an assembly of *theoros* with the authority to mediate the passage "from the seen to the told"; "between the event and its entry into public discourse." This "theoretical picture" may help bridge the transition away from theory as a means to indefinite postponement, and toward theory as a deictic act of statecraft. Away from subversive intentions, and toward a depersonalized sense of proactive subject formation, as proposed in this chapter.

43 At times is seems that what this book is effectively doing is charting a strange peace, an awkward paxography.
44 Wlad Godzich, foreword to Paul de Man, *The Resistance to Theory* (Manchester: Manchester University Press, 1986), xiv.

Beyond Show and Tell:
Tear Catchers

In a monograph on painter Zohdy Qadry, sociologist Esmail Nashif sketches a brief history of Palestinian painting.[45] More conventional, Eurocentric approaches use the prism of the painter's easel to tell a very short story of local production. Nashif emphasizes alternative sites of artistic labor, and demonstrates in which ways the surfaces of various walls are more significant. The walls of private homes, markets, cafés, government buildings, and houses of worship offer coordinates from which to map a more complicated history of local painting. Nashif's is a classic postcolonial exercise, 101, reinscribing material histories within and against a master narrative that inevitably presents Euro-America as the best possible yardstick, the "Center of the Real." You could also argue, in only slightly different terms, that Nashif's easel-vs.-wall dyad is instructive in terms of revealing all showing to be a form of doing. Of conjuring a Eurocentric subject that you are free only to

45 Esmail Nashif, *On Palestinian Abstraction: Zohdy Qadry and the Geometrical Melody of Late Modernism* (Haifa: Dar Raya Publications, 2014), 27–29.

politically emulate or personally envy. It is in this sense that Nashif's walls become analogous to the agency of contemporary art at large. The role the Palestinian paintings play within an overarching apparatus of audience formation goes far beyond what they may represent in terms of form or content, painterly technique or historical reference. The painters and their work are satellite terms within a larger moral economy, and the subject positions it locates and produces.

Allow me a second example of an East-West parable, one that is perhaps not as clear-cut in its postcolonial qualifications. Recently, in situations of teaching contemporary art theory, I have been using the ashkdan artifact as a conversation piece. At the Metropolitan Museum of Art in New York, ashkdan are presented as items from the Iranian Qajar period, fashionable in the eighteenth century. Though the Met refers to them as "Swan Neck Bottles," the Farsi name ashkdan translates as "tear holder," or "tear catcher." According to the Met's captions, the name echoes the legend that ashkdan were designed to hold the tears of women mourning their husbands.

If you set aside, for a moment, the likelihood that these were tears of joy, the vases become remarkable examples of an aestheticization of suffering, an ornamental display of empathy. Your average homo sapiens, male or female, would be incapable of filling even a fraction of this forty-centimeter jug with tear water, so the suffering we are talking about is not a material reality so much as an abstract, symbolic item. In other

words, this crystal Kleenex ashkdan is effective not as a functional household tool ("sweetie please remember to empty the ashkdan in the morning"), but by virtue of creating a particular viewing subject.

The viewing public in Manhattan, for example, can sympathize with that faraway, battered Brown Woman, as it rarely tires of doing. The curvy jug even suggests a voluptuous Orientesse, filled with tears. (Misery embodied!) Meanwhile, standing on some eighteenth-century living room shelf in Isfahan, the vase was presumably capable of creating a very different viewing subject by reminding this viewer, however surreptitiously, subliminally or ironically, of what the ideal housewife should indeed be. On the other hand, the ashkdan were based on designs imported from Venice.[46] So the Isfahanis in question may well have been fascinated mainly by the idea of those weeping ladies over in Renaissance Venice. ("Those Italians are crazy!") The tear catcher elegantly conveys that imbrication of description and prescription: the idea of showing as a form of doing. Or of showing being part and parcel of something that is done—beyond showing alone, and beyond a mere "redistribution" of visibilities.

Critical theory itself was consistently framed by post-structuralists as a future-oriented operation that belligerently acts upon the world—a point which is not often acknowledged by latter-day anti-correlationists. Similarly, art produces the audience it purports to cater

46 My thanks to curator Maryam Ekhtiar of the Metropolitan Museum of Art for this point.

to. Such is its agency. Show-and-tell always has a measure of impact generally speaking, but its clout is rarely comparable to the traction of sparking a theoretical persona in the viewer, along the lines of art. As a matter of fact, art is so good at creating its viewership that it does not even need artworks in the room. Just talking about them will suffice—or even talking about talking about them. A homeopathic dose of the art elixir is enough.

The additional forte of art, well beyond what any Palestinian tableau or Persian tear catcher has on offer, is that it brings an audience to believe it is channeling and completing the creative process in the exhibition space. This act of interpellation produces a surprisingly consistent profile: cosmopolitan, sophisticated, unique, creative, and critical. Contemporary art is an epistemic selfie. Viewers are flattered into thinking it is their individual sense of creativity that is needed for the work to come alive. They are even buttered up to feel complicit in art's critical virtue. To feel privy to the transgressions at play, and to gain a conspiratorial sense of being on the right side of history (and standing against its "neoliberal" institutions). All of which needs to follow a stringently formalized protocol. To take a hyper-institutionalized vocation like art, and cast it as some kind of crazy adventure, you have to very precise, not to say surgical, at what you do.

Indeterminacy, however, cannot account for such exercises in subject formation, for it inherently insists on the premise of open-ended level playing fields, as opposed to specialized skill sets. Of individual experiences, as opposed to acquired levels of competence.

Few cultural traditions are invested in such gestures of largesse. Even mainstream sports will demand a modicum of effort and expertise. If I watch a Formula One championship race, all I see is a bunch of cretins driving around in circles. Given that I have never closely watched a race before, this is not surprising. Now if I read an article or two, and had a friend explain the basics to me, and actually watched a Grand Prix—preferably in a bar—I would begin to remember strategies, tactics, names, histories, gossip; and my opinion of Formula One would begin to change. Better said, I would be entitled to an opinion to begin with. Contemporary art, by contrast, suggests the idea of access undeniable. Regardless of your commitment to the material in front of you.

This is why we are no connoisseurs, God knows. We are just peddling tickets to the big discovery tour. We raise interesting questions, no more no less. How can it be otherwise, given that art is a category that—and in that it—defies all others. Routinely questioning all structures in sight; thereby rendering art intrinsically other to these structures. A journalist or scholar says: "This is my field of competence, and I dare you to sack me if I get this wrong." An artist or curator says: "Just like you I am untainted by the perils of know-how. I have learned through personal interest and patient friends who've had the kindness to share with me." In this model, as Meaghan Morris would say, expertise is flaunted and denied, authority is wielded even as it is apparently neutralized, and powerful decisions are admitted only on condition that they be attributed to

someone else. While power itself is rendered seemingly harmless and maintained in the province of the few. And this is how ideology is reproduced most efficiently.

After all, you do not have to be Hannah Arendt to realize that snubbing the seat of power, and playing the anti-expert, is the best way to cling to that seat in the long term. If a throne makes you vulnerable, then you are better off cross-legged on the floor.[47] As Arendt herself puts it in her canonical *On Violence*: "If, in accord with traditional political thought, we identify tyranny as government that is not held to give account of itself, rule by Nobody is clearly the most tyrannical of all, since there is no one left who could even be asked to answer for what is being done. It is this state of affairs, making it impossible to localize responsibility and to identify the enemy."[48]

To double up with a quote by artist Michael Baers, writing from Ramallah at the time: "What was previously considered an obstacle to the 'normal functioning of power' (… the gap between this place and the one who actually exerts power, the ultimate indeterminacy of power) now becomes its positive condition."[49] Once

47 Which is also why populist calls for curators to "step aside," for example, will only serve to make things worse—see chapter 3.
48 Hannah Arendt, *On Violence* (San Diego: Harcourt Brace and Company, 1970), 40.
49 Baers borrows from Slavoj Žižek in a brilliant discussion of Khaled Hourani's *Picasso in Palestine* (2011): "No Good Time for an Exhibition: Reflections on the Picasso in Palestine Project, Part I," *e-flux journal*, no. 33 (March 2012), http://www.e-flux .com/journal/no-good-time-for-an-exhibition-reflections-on -the-picasso-in-palestine-project-part-i/.

again, writing from Palestine proves instructive; the political quasi vacuum that is currently the West Bank is an eerie example of rendering indeterminate the source of power, precisely as the best possible way to consolidate it.

The
Post-critical Era

Given that the seat of power looks so forlorn, so completely empty these days, who can blame us for thinking that we are now policing ourselves. Critique, including even the critique of power, is now free to do its bidding, apparently. Unhindered by any imposing monarchs. As a matter of fact, it looks like the institutions themselves have started engaging in institutional critique. In other words, critique is "co-opted," supposedly. The tone is set by Andrea Fraser's own assertion that, ever since the critique of institutions has become an "institution of critique," she gets invited by one museum department to come criticize the other. New Institutionalism, which upheld self-criticality as a venue's modus operandi, reflected this post-critical zeitgeist so efficiently and famously, that even the curatorial trend's

de facto extinction has not hampered the feeling that it is still somehow ubiquitous.

In my personal opinion, as it presently stands, the melancholia of this "critique institutionalized" story amounts to yet another conservative parable, of art as an incommensurable hall of mirrors, bereft of hierarchies and boundaries. Instead of admitting that art is indeed occupying the seat of power, and channels or thwarts critique as it sees fit, it suggests that critique is swirling through a decentralized circuitry of co-optation, of such kaleidoscopic complexity, all you can hope for is a watered-down caricature of what critique once was. Thus when critique is visibly kicked in the groin, and censorship does take place, it happens in the name of something other than contemporary art itself. But at the hands of ignorant politicians and so forth.

Empirically speaking, none of this corresponds to my experience as a curator, neither in Euro-America, nor in the Middle East, nor Taiwan for that matter. To this day, artworks are quietly nixed on a daily basis. Uncomfortable proposals are routinely met with backstage resistance that can range from the meanderingly polite to the outspokenly vicious. For every brazen example of critique, paraded about to prove that anything goes, you will find a dozen examples, or more, that are quietly shelved. As argued more extensively below, you can always recognize an example of genuine critique by the way it demonstrates prevailing limits as they really exist.

Criticality depends on the way it is administered. It can smother confrontation with fashionable palaver, just as it can sharpen your sense of reflexivity, or even

kick-start effective change, all depending. The same goes for the critique of criticality itself, in equal measure. And I cannot shake the suspicion that the idea of a post-critical era serves to promote a self-image of Euro-America as an exceptionally sophisticated biopolitical arena. Given that I regularly work in the Islamic Republic of Iran, I am of course aware that the old-school "shut-the-fuck-up" approach prevails in some places more than others. But even here, the domestication of a project need not happen in a confrontational fashion. It can take place over tea. Technical, financial, administrative, or meteorological reasons can be evoked with regret and consternation. The Sharjah Biennial, for its part, is eerily representative of the field at large: critical matter is parleyed and negotiated just like everywhere else; sometimes vis-à-vis curators like myself (see chapter 5).

Whether in the bowels of a Guggenheim Abu Dhabi, or an underground project space in Berlin, the scenario of heaving hegemons, encroaching upon us from without, is simply too smug to be taken at face value. Even when the terms are as intelligent as those of writer Mostafa Heddaya—who argues against "playing ball with tyrants" and "art as a diplomatic chip"[50]—they essentially imply that when censorship ends, art speaks.

50 See, for example: Mostafa Heddaya, "When Artspeak Masks Oppression," *Hyperallergic*, March 6, 2013, http://hyperallergic .com/66348/when-artspeak-masks-oppression/; and his follow-up response to Guggenheim director Richard Armstrong, March 12, 2013, http://hyperallergic.com/66749/guggenheims-richard -armstrong-responds-to-when-artspeak-masks-oppression/.

And where art speaks, censorship is, ipso facto, up-ended. At least for the duration of the Tania Bruguera performance. Sooner or later, we do have to account for the fact that these scuffles are taking place deep within the corridors of power, where art has long arrived.

– 3 –

THE EFFECT ON
ARTISTS

The Benefit of Clergy

Artists like to say a curator should make the art look good, then get out of the way. "A bit like a barber," as artist Meg Cranston puts it.[51] The other popular suggestion, these days, is to do away with "anachronistic categories" altogether. As artist Natascha Sadr Haghighian argues: "The border made no sense, as it reaffirmed the very definitions and divisions I found pointless in the first place—curator, artist, writer, blah blah. So I was ac-

51 Meg Cranston, "Do It with Style," *Red Hook Journal* (August 2011), http://www.bard.edu/ccs/redhook/do-it-with-style/.

tually shooting myself in the foot with this checkpoint mentality."[52] Both Cranston's and Sadr Haghighian's positions are derived from a series of commissions for the online *Red Hook Journal* (see chapter 1), under the rubric "Artists on Curators," an invitation to turn the tables, at least for the space of one essay.

At this point, it is helpful to mention some poignant questions raised by art historian Tara McDowell, in her essay "Post-occupational"[53]: "If there is a shift in contemporary art away from identifying with specific occupations, [then] it matters, and we should interrogate this shift. Why is it occurring, what new worker has it created, and what reskilling does it ask of this laborer? […] How are they paid, and who pays them?" If there are artists who support a post-occupational shift, this is because they believe it is to their professional benefit, and Cranston's barber analogy is the perfect emblem here. It is undeniably compelling—I quote it all the time—but it also cutesifies the issue, in that it occludes the question of which artist is the one who gets to be coiffed, and why. And, for all the differences between Cranston and Sadr Haghighian, their unwillingness to theorize what a curator realistically can or should do results in a conventionalism they both share.

52 Natascha Sadr Haghighian, "Dear Curator," *Red Hook Journal* (December 2012), http://www.bard.edu/ccs/redhook /dear-curator/.
53 Tara McDowell, "Post-occupational," *Australian and New Zealand Journal of Art*, vol. 16, issue 1 (2016).

The preceding section of this book already addressed the pitfalls of suggesting the gatekeepers get out of the way; nothing will please a gatekeeper more than hiding decisions behind gestures of largesse. And the reason for the persistence of Sadr Haghighian's aforementioned, occupational "checkpoints" is the fact that few artists are genuinely committed to creating structural conditions for their art.[54] At the end of the day, if a curator offers to do the legwork, an artist will not complain. No matter how postoccupational she may be in spirit. In which case you are back to square one, with decision makers effectively operating with a supposedly postoccupational carte blanche.

A more angry, and rather more widely circulated version of the barber allegory was penned some years ago by Anton Vidokle, an artist so influential he dwarfs the powers of many a curator combined. His essay "Art without Artists" was distributed by means of the worldwide mailing list of e-flux, which Vidokle cofounded with Julieta Aranda and other artists. It is from this trans-planetary stage that Vidokle mourned the powerlessness of his creed, and the growing clout of the curatorial one. "The necessity of going 'beyond the making of exhibitions' should not become a justification for the work of curators to supersede the work of artists. Movement in such a direction runs a serious

54 Natascha Sadr Haghighian herself, to be sure, is no stranger to ambitious examples of institution-building. I myself had the pleasure of cofounding *kaf* together with her and artist Shahab Fotouhi, an informal project space in downtown Tehran that operated between 2010 and 2015.

risk of diminishing the space of art by undermining the agency of its producers: artists."[55]

What is most remarkable, in this essay, is its plea for "opening up" the space of artists, as if they were caged tropical parakeets. In point of fact, the spaces of artists are "opened up" more and more regularly, to the despair of those around them. Students, interns, pop cultures, and political minorities are routinely tokenized, plagiarized, and condescended to, one venue after another. The more prominent the arena, the more brazen the attitude. It is true that artists frame their own work with more aesthetic ambition and political sophistication than your average curator. But in terms of sheer outreach and overreach, time and again, artists in power have proven to be the worst-case scenario. Which is why the idea of the curatorially benign artist—as implied, for example, by the book project *The Next Documenta Should Be Curated by an Artist* (2004), published and promoted by Vidokle himself—is misleading. The instrumentalization of context is pursued to greater effect than curators could ever hope for. This includes the many cases of artist peers and allies being instrumentalized with cannibalistic appetite.

Examples of artists imbibing the work of their colleagues rather liberally, not to say voraciously—and yet unproblematically more or less—are legion. From the hipster cool (Urs Fischer's "Who's Afraid of Jasper Johns" at Tony Shafrazi Gallery, New York, 2008) to the badass (Bjarne Melgaard's "Melgaard + Munch" at

55 Anton Vidokle, "Art without Artists," *e-flux journal*, no. 16 (May 2010), http://www.e-flux.com/journal/art-without-artists/.

the Munchmuseet, Oslo, 2015) to the absolutely mes-
merizing (Arturo Herrera's "My Lonely Days Are Gone"
at Arratia Beer, Berlin, 2010).[56] Most iconic of all is the
case of the negotiations in 1972 between Daniel Buren
and Harald Szeemann: Buren was officially boycotting
Szeemann's upcoming documenta, but the curator
shrewdly lured him in, by granting the artist permis-
sion to run his work across the whole show, like some
madcap Atari game. To the chagrin of artists, like Jasper
Johns, who had 3.4-inch stripes running right under-
neath their work.

Group shows aside, the settings in which artists
secure themselves maximum leeway are the larger, mul-
tifarious structures and infrastructures that can double
as artworks, such as unitednationsplaza, Berlin, and
also the Riwaq Biennale in Palestine (see chapter 9). As
onetime co-organizer of both unitednationsplaza and
the 5th Riwaq Biennale, I am not attempting to absolve
myself from responsibility, to instead point fingers at
the artists—especially Vidokle, whom, despite the dis-
cursive patterns quoted here, I have consistently admired
as an artist—but to highlight overarching, impersonal
patterns, which will continue to grow more and more
dominant as long as the myth of personalized, artistic
innocence hogs the limelight.

If the statecraft of a curator hinges on the plausible
deniability of an empty throne, that of an artist can be

56 Herrera's show had the works envelop the gallery wall to
wall, ceiling to ceiling. No curator would have had the aptitude,
or the moral license, to pull this off with quite such brilliant
panache.

compared to the medieval tradition known as the "Benefit of Clergy." Medieval clergymen were rarely tried under the jurisdiction of civil courts. They could escape imprisonment, or execution, by simply reading the "Neck Verse": "*Miserere mei, Deus, secundum misericordiam tuam ...*" (O God, have mercy upon me, according to thine heartfelt mercifulness ...). A practice that was banished once enough laypeople had memorized the lines. Considering the privileges, the trans-institutional collusion of interests, and the mystical exceptionalism before the law, it is hardly an unfair comparison here. No one self-marginalizes and *misere-meis* more passionately than artists. The more clout they enjoy, the louder the chanting.

Artist Talk

When it comes to indeterminacy, the consensus among artists is just as solid as among curators, regardless of the take on activism, formalism, or the role of discourse. For every artist who takes pride in her authority and expertise, I can show you ten who insist on associative bricolage and the innocence of trial and error. The discourse does vary according to setting; published artist statements, say, do not have the same effect as studio visits, lunch meetings, or MFA theses, for instance. The

latter are particularly grim. On a number of occasions, I have had the privilege of being the thesis advisor, or juror, to MFA candidates. Even if a minority are more structured in style, most will actively attempt to undermine any hint of a clear direction in the writing, cheered on by faculty who roll their eyes at any hint of positioning. ("Why all the Marxism??") Many students claim that "confusion" is the best-case scenario, and that artists who try to spell out what they are doing are doing themselves, and their art, a disservice.

It seems the degrees of physical proximity to the art in question can also play a role in the degrees of indeterminacy at play—which is maybe why studio visits can lead to more convincing conversations than MFA papers, for example. Since every setting is subject to the observer effect, it is naive to assume that the one is more authentic, more true to the artist's heart of hearts, regardless of time, place, and interlocutor. (Such is the monogamist fantasy of everlasting harmony between the artist and her voice: the dream of a relationship free of promiscuities, till death do them part, is a surprisingly persistent expectation to this day; see chapter 8.)

What you will often witness in MFA theses, interviews, and in artists' talks—though very rarely during studio visits—is artists engaging in free association. Artists are people who are entitled to take us from a recent artwork, to a theory informing the artwork, to a history informing the theory, to something more personal (a breakup, a family anecdote, a memory of Gezi Park), to a recent good read (*Neuromancer*), to a random observation on ricotta cheese, or pornography, before finally

moving on to another artwork in the room. Luckily, even if it is considered inspiring on behalf of artists, the tactic is still considered pretentious and vacuous on behalf of curators.

To be sure, free association forms an important part of the production processes of many outstanding artists, and to other professions too, so there is little hope of doing away with it. But we need to revisit the assumption that it is just another harmless case of xeno-epistemic freethinking. Artistic free association is a more charismatic rendition of the polyvalence-as-syntax described above. With an emphasis on the artist persona's gut intuition as the seat of meaning; a "compulsory individualism" (Beverley Skeggs) that organizes and rationalizes other orthodoxies around it. After all, the act of successfully tying one elusive, seemingly incompatible point to another insinuates a single mercurial consciousness that is polyvalent enough to do so. In the end, the fewer the clear didactic pointers between audience and artwork, the larger the artist persona looms as the only hermeneutic foil that lends contours to the whole thing. A process described long ago in Michel Foucault's "What Is an Author?," which argues, among other things, that proclaiming the death of the author is what ensures her survival as zombie.[57]

57 Michel Foucault, "What Is an Author?," trans. Donald F. Bouchard and Sherry Simon, in *Language, Counter-Memory, Practice*, ed. Donald F. Bouchard (Ithaca, NY: Cornell University Press, 1977), 113–38.

Five Unsolicited
Suggestions

The Sonics of Curating

Artists need to stop sounding like curators. Consider the following editorial from *e-flux journal* (October 2013): artworks, it states, are "historical counter-narratives" and "exceptions." "One piece wants to join with other pieces to heal the scars of breaking off. Another little Promethean piece wants to explode again and again to make infinitely more of itself. Yet another wants to retire with a good pension on a plinth. These little worlds come in editions you can buy, but their volatility makes them impossible to possess. And that keeps them somewhat market friendly, but a really horrible challenge to historians who at this point can only watch as historical narratives multiply faster than they can ever hope to keep track." A better summary of our moral economy would be hard to find. I am not quoting e-flux because it is wrong, nor because it is exceptional—nearly every curator and art writer I respect (and there are many) engages in such figures of a-topia, but because the transcontinental clout makes it a more

helpful metonym than others. The fact that e-flux offers its creators an unprecedented degree of artist empowerment is both commendable and pretty brilliant. It is symptomatic, however, that when opportunities arise to discuss this influence, and add a new twist to the conversation, e-flux will cast itself as one of the teeny tiny volatilities in its editorials, powerless in the wake of the working conditions, language codes, and social hegemonies. Why blame the breeze? It need not always be this way, and, thankfully, it is not. In a seminar setting, for example, or a studio visit, artists are much happier to take responsibility for what the work can and should amount to, in terms of its objectives, successes, and failures alike.

Great Expectations

According to the traditional charges against curators, they trespass on artists' territory, instrumentalize art, and disregard local context. Said charges spark the famous "pre-apologetics and post-justifications" (Liam Gillick) that frame the curator as a good listener, a humble mediator, a thoughtful compadre. Curators are none of these things. Nor should they be. Aside from sounding like curators, artists need to stop expecting them to be sensitive souls. It is as unrealistic as it is self-denigrating. Why expect curators, or anyone else for that matter, to curtail their own professional interests? Whenever you see anyone doing so voluntarily, be very surprised.[58] By and large, it is a terrible idea to guilt

58 Artists who dislike explaining their work, and prefer that it "speak for itself," do not always realize they are curtailing their

people into charity, or to suggest that artists, audiences, and locations need to be handled with care, like ginseng shoots, or bedridden children. Rather than guilting them into charity, artists should submit curators to collective pressure. The alternative to spending one's career in hope of a selfless curator is to threaten with credibility, as artists once used to do on a regular basis. We need to be coerced into reacting—creatively, if possible—to a situation defined by artists' common interests. And the reason I am in favor of this approach is not because I like artists (I do not), but because this is the kind of negotiation that would benefit the quality of curatorial practice in equal measure.

Coalitions

There was a time when even the most prestigious shows were prone to boycotts, for reasons no more dramatic than a clumsy curatorial premise. Consider the petitions and open letters preceding documenta 5 in 1972, all protesting that Szeemann's take was too restrictive. This although his slippery web of leitmotifs would fit in well with today's themes. Today, a rebuttal of documenta is typically framed as a protest-letter-as-artwork, and exhibited center stage. The more common response to the most horrifying invitations, however, is to grin and bear it. This in the hope of career advancement ("one day I'll be in a position to say no") or infiltration ("critique from within"). Admittedly, this is

—— professional interests. Curators greet this attitude with polite applause; the outsourcing of a work's definition is always in our interest.

easier said than done. For refusals to have an effect, beyond sabotaging careers, and brandishing artists as "difficult individuals," they have to unfold *en groupe*. Which, in turn, requires that artists define their interests as a class or professional body.

Consider how infrequently artists dominate the room. Even at a biennial, with a hundred artists or more, there is rarely a moment when artists set the tone, let alone steer the conversation. Some towns do have a proud tradition of artist initiatives, but on most of the occasions practicing artists do come together, it is as teaching faculty, drinking buddies, or competitors in a group show. All of which casts a painful, harsh light on the rhetorical question raised by McDowell: To whose benefit is the deregulation of occupations exactly?

As argued in chapter 8, piling up heaps and heaps of art always forces artists to compete with one another for audiences, press, money, space, curatorial attention, and even the Makita drill, not to mention the high-lumen projector. Moreover, artists in group shows are mostly kept in the dark as to who else is participating, which strips them of the possibility of negotiating as a group. It also puts the curator in a comfortable bargaining position: As long as a curator deals with the artists individually, she can play them against each other. ("You do realize you're the only one complaining?") And if an artist withdraws, no one will know. At one national pavilion in the Venice Giardini in 2011, all the artists withdrew in exasperation, but unbeknownst to one another, so the curator quietly invited a whole new roster from

scratch. It turned out to be another group show, with an even larger number of invitees.

Their statements and editorials aside, when it comes to creating an effective coalition around common interests, e-flux is an inspiring scenario. As a system that shrewdly uses institutions as eager cash cows, the platform has provided the foundations for innumerable projects and infrastructures. Vidokle, the main figure-head here, enjoys a leeway few artists have had since the days of Andy Warhol's Factory.

Similar, if less prominent examples include Marion von Osten, for instance, who takes exhibition display into her own hands whenever possible, to realize it with a team, preferably as a member of the Labor k3000 collective which she cofounded in the 1980s. Normally, the exhibition design is outsourced to third-party service providers. Pooling the resources lends more artistic lee-way to Osten and her collaborators, but also leads to situations that are economically less exploitative. So the advantage of claiming ownership of the design process lies in a modest reshuffling of the usual division of la-bor that tempers the post-Fordist pressures we are all familiar with (see chapter 4).

Unfortunately, the Robinsonaden described in chapter 1 prevent most artists from developing a more acute sense of commonality—beyond the shared notion of critical virtue that comes with contemporary art at large. Attempts to create coalitions are routinely put down with knee-jerk warnings of groupthink, bureau-cracy, and "fascism." Not only are these warnings rarely

based on any personal experience, they also misjudge the nature of collective action. I myself was long turned off by direct action because of semiconscious, unrealistic expectations of the kind, when the threat of fascism is part and parcel of any coalition work worthy of the name.[59] To wish for collective change without the slightest whiff of political risk is a deeply sentimental idea; and one which can only lead to self-fulfilling disappointments.

As musician and activist Bernice Johnson Reagon puts it, coalition work is "some of the most dangerous work you can do." But many will rate the success of a coalition on "whether they feel good when they get there. They're not looking for a coalition, they're looking for a home. They're looking for a bottle with some milk in it and a nipple, which does not happen in a coalition. You can't stay there all the time. You go to the coalition for a few hours, and then you go back and take your bottle wherever it is, and then you go back and coalesce some more."[60]

Vernissage

The lack of a shared sense of purpose, as well as the lack of transparency, are both compounded by the scarcity of spaces catering to artists specifically. Two

59 I owe this point (and the following Reagon reference) to artist Martine Syms.

60 Bernice Johnson Reagon, "Coalition Politics: Turning the Century," in *Home Girls: A Black Feminist Anthology*, ed. Barbara Smith (New Brunswick, NJ: Rutgers University Press, 2000), 359.

centuries ago, such spaces were less of a novelty. The word "vernissage," as it is used in an art context, points to the act of varnishing paintings before a show. The smell alone was enough to dispel a broad audience, so varnishing days were when artists critiqued, bonded, and bitched, between artists and as artists. William Turner warned that without varnishing days no artist would ever have gotten to know the other. As more and more people jostled for access, the difference between a varnishing day and a private view became less and less important, until they finally became what they represent today.

It is worth indulging in the etymology here. The term "vernissage" stems from "Berenice," as in Queen Berenice II of Bengasi. The queen was known for her love of hair oils, but also for being a bit of a philanderer. Until one fine day, when she decided to make amends. For want of an ashkdan tear catcher to serve as a token of newfound fidelity, Berenice II cut off all her oily locks to make her point, and placed them in a temple. Embarrassingly enough, however, the hair disappeared overnight. So, in an attempt at damage control, her poet friend Cronos of Samos wrote a poem for the king, in which he explained that Berenice's hair had actually ascended to the heavens, and was still very visible to all. All the more so, in fact: as a star constellation up above. In sum, varnishing went from personal cosmetics, to a token of commitment, to a clue for promiscuity, to a cosmic tear catcher, to a painter's tool, to a short-lived socio-professional enclave. Clearly a term with potential: political, poetic, erotic, and otherwise.

Polemics

To be clear, I am not advocating for fewer preroga-
tives for artists. As the above suggestions may have
clarified, the opposite is the case. After all, when it is
neither the curator nor the artist taking responsibility,
the alternatives are dismal. We do not want sponsors
and philosophers running the show. We have been
there before. But unfortunately, no amount of socio-
professional enclaves, remodeled discourse, artist-run
infrastructure, or class awareness will amount to any-
thing much, lest it comes with a tiny bit of pluck. And
when it comes down to it, few artists are big on *Kon-
frontationslust*. We all have our stories and examples. I
myself would like to go ahead and share a story about
Chicago-based JG. As editor of the *Red Hook Journal*
from 2011 to 2013, I commissioned him to contribute
to the aforementioned "Artists on Curators" column.
What he handed in was a soliloquy to the genius of
Hans Ulrich Obrist. Though I do very much like the
guy, as editor and commissioner, I needed at least a
nod to the many criticisms that are out there.[61] When
I carefully asked JG to acknowledge them, he accused
me of "slander," "blackmail," and "censorship," and
goaded me into a regrettable e-mail exchange, during
which I compared him to all kinds of zoological spe-
cies, and lost all sense of professional etiquette. Almost

61 Some of which I do share, as did my students—rather more
vociferously at that. Projects such as "Do It," *A Brief History of
Curating*, and "Il Tempo del Postino" are all groundbreaking. On
the other hand, Obrist is to indeterminacy what Michael Jackson
was to the moonwalk. He did not exactly invent it, but, I mean,
hey, who are we kidding?

losing my job in the bargain. As it turns out, JG bcc'd Obrist throughout. His priority never was writing the text, but currying favor. Such is a corrupt mentality that favors careerism over content, and is liable to turn artist against artist at any moment, whenever it is propitious to do so. No wonder curators have it easy.

– 4 –

TRANSPAR-
ENCY

In the context of curating, transparency ideally denotes a description of the objectives at hand, and of the way you intend to get there, no more no less. Whether by disclosing the names of artist collaborators, selection criteria, conflicts of interest, fee structures, or conceptual "core concerns." The tone can be technical, as in the "code of ethics" of the American Association of Museum Curators 2009,[62] or point to abstract, long-term principles instead. This book, for its part, is one big stab at transparency. After all, art always creates its locations and its public, and the one main difference between the

62 See: American Association of Museums Curators Committee, *A Code of Ethics for Curators*, 2009, accessed April 8, 2016, http://www.aam-us.org/docs/continuum/curcomethics.pdf?sfvrsn=0.

status quo and what this publication aims for lies in the degrees of transparency at play. The willingness to openly claim that proactive process as you move along. In other words, the main reason for demanding transparency is to clarify how our audiences are not catered to, but defined. It is to revisit the sentimental premise that all viewers are welcome unconditionally, and that their individual take on the work is inherently relevant. When it comes to transparency as a working principle, there are two main objections out there. The first laments the naïveté of being transparent in an era of the NSA, glass citizens, and biopolitical overreach. The second deplores the inefficiency: we need actions, not words, so even if people walked their talk, precious little would change.

On Being Irrelevant
and/or Naive

Let us begin with the first concern: the fact that, as we speak, superstructures are aggressively pushing for glass citizens. This does make openness look somewhat self-defeating. From Scandinavia to the Middle East, artists and curators increasingly deplore the technocratic nosiness, the calculated, demanding voyeurism of their

funders and politicians. And they also insist on the right, even the need, to be as opaque as possible. Though this is an understandable response, it also leaves us little ground to stand on, beyond the folkloric claim to critical virtue in contemporary art once again. For the response essentially frames art as intrinsically other to the powers that be. Simply by virtue of being representatives of art, our marginality explains and justifies the need to protect ourselves from encroachment.

As a private complaint over beers, that is all fine. As a professional self-identity, it does not hold water. The art field aside, the macropolitical stakes are considerable here. If the "other side" (i.e., the wealthy and powerful) snooping around is enough to discount transparency as a value, then how to demand transparency from our funders, let alone our governments?

In a shrewd take on the above argument, curator Peter Eleey agrees that we need to be consistently "irresponsible," as opposed to accountable (a line of reasoning he defended in the CCS lecture series described in chapter 1). His essay "What about Responsibility?" foregoes any claim to critical virtue, and equates curating with "control."[63] But it argues that, even as controlling instances, curators need to pursue irresponsible behavior because that is what is warranted by politics at large. Such, Eleey says, is the contemporaneity demonstrated by the deep-capitalist compliance of artists such as Jeff Koons. The man is only a messenger. If

63 Peter Eleey, "Chapter X — What about Responsibility?," in "Ten Fundamental Questions on Curating," ed. Jens Hoffmann, special booklet in *Mousse*, June 2012.

society has a skewed relationship to power, artists and curators have little choice but to embody that too.

Eleey's approach is refreshing in that it does not draw a line between the virtuous and the institutional, which we are then morally entitled to outwit. But his take is misleading, in that it suggests a level playing field between the professional curator and her audience. The pathos of "It ain't me! It's society!" eclipses the place you enjoy within that society. You become a helpless commoner even as you partake in policing the very definitions of professional conduct.

The more influence you have, the more opacity works in your favor, regardless of curatorial inclination. Eleey aside, whether we take Maria Lind, who is unflinchingly self-critical, and very much invested in a politicized theorization of her practice, or Douglas Fogle, a man of old-school swagger ("a curator should do the job and get out"), both will proudly insist on an ethos of "artist first." Not because they are afraid of admitting to the subjugation of artists to their (very dissimilar) aesthetic arguments, but because transparency offers few advantages, strategically speaking. Authority is a shy thing these days.

Eleey's essay also serves as a point of departure from which to test the second objection, that of irrelevance. What if Eleey's anti-ethical comportment were put into practice? Would it make the slightest difference if we flaunted our roles in elite formation, shrugged off any artist prerogatives, rammed and crammed their work any which way we wanted, ignored all conflicts of inter-

est, accepted blood money, kissed ass to anyone with a yacht, and openly curated whoever is good for our careers—and fun to sleep with? Sounds familiar. But would making it explicit change anything fundamentally? As a matter of fact, it would. To prove my point, I will compare two different arenas, within which transparency comes at two different price tags, one high, one low. We can then discuss which of the two applies to the art world.

The first shade of transparency is exemplified by the airline industry. A little while ago, I booked a flight on United Airlines, by means of the telephone.[64] The line was crackly, and every time I asked a question, the clerk had to put me on hold, to consult his "supervisor in Houston." The reservation took ninety minutes, and my debit card stopped working. The friendly agent actually overdrew my account by booking fourteen tickets instead of two. When I called United Airlines' customer service, I wound up at the very same sweatshop, where someone sweetly assured me, "If I was in your situation sir, I would be very tense."

It is tempting to think that, by virtue of being sealed off from its constituents, United Airlines exemplifies a degree zero of accountability. But does it really? Consider a corporate slogan such as the following:

64 These days, people only pick up a phone to make a travel reservation if they have special needs, such as an infant bassinet, for example.

Would transparency leave a mark? I dare say so. Let us compare a second type of transparency by means of Alain Juppé, onetime Prime Minister of France. While still in office, Juppé once declared "les promesses n'engagent que ceux qui y tiennent" (promises bind only those who cling to them). A decade after which he was convicted of embezzling public funds. Only two years after his conviction, Juppé was mayor of Bordeaux, and, by 2007, he was a government minister all over again. According to the January 6, 2016, edition of *The Economist* magazine, he is currently the most popular politician in France. A modus operandi that is stomach-turning, but indeed fully transparent. If United Airlines announces it is "committed to being a responsible global citizen," even as it discreetly outsources jobs to faraway low-cost outfits, understaffed and undertrained, the French government will happily clarify its indifference to its own pledges, parade its perversions in courts of law, and just keep a-rockin and a-rollin.

Compare the two registers. If you vote for the good old boys of the Élysée Palace, where talk is cheap, you do so with the clarity of "I know that you know that I know."[65] By contrast, if United Airlines started banking on the same spirit of laissez-faire, you would have the CEOs tarred and feathered by sundown. The same applies to contemporary art. This is not some Parisian fool's bargain, perfectly operative regardless. For all its

65 The very bluster of the cynicism seems to be a selling point that has benefited, not hampered, a good number of bad-boy political careers, from Bernard Tapie to George W. Bush to Silvio Berlusconi to Stephen Harper, etc.

indeterminate allure, the discourse at play is a razor-sharp, tightly policed endeavor. Not unlike corporations, and their claims of global citizenship, the art world can always allow for a small measure of candor, but only so much, before things would begin to slip and slide. Which is why genuine critique is hard to come by. Consider the countless settings in which discourse unfolds within contemporary art—pitching, negotiating, fundraising, researching, commissioning, mediating, teaching, etc.—for which, in the long run, the bluntness of a Juppé would spell professional suicide.

Art world actions not only require words in order to be perceptible as such, the two are part and parcel of the same moral economy. Contemporary art does not revolve around artworks any longer, but, to use Suhail Malik's terminology, operates via "broader semantic, cultural, and market configurations in which the artworks are satellite terms of a greater moral claim."[66] Indeterminacy, in such a context, is not merely a cloak, under which wicked folk do their bidding. The discourse constitutes a key component of the economy at hand, irretrievably enmeshed with the statecraft, the market, the exhibition venues, the educational complex, the artworks, and other factors (see my discussion of critique in chapter 2).

66 Suhail Malik, "Vindicating Didacticism" (lecture, Ashkal Alwan, Beirut, as part of the 5th Riwaq Biennale's contribution to the Home Works School program, November 2014).

On Being Partisan
and/or Didactic
(Feel the Fear. Do It Anyway.)

Again, there is much fun to be had in being opaque, unaccountable, irresponsible, incommensurable, or deep within the interstitial shelter of a studio or seminar room. To paint with a hammer, and go to the gym drunk. It is another thing to account for your work ethic, your historical position, and your cultural capital with these murky moments in the half-light. To turn the above macropolitical argument against transparency on its head: especially in a society governed by impenetrable market flows and post-Fordist insecurities, there is nothing subversive about hermeneutic flux. Whether in Silicon Valley or Dubai, opacity and unpredictability have long been the order of the day. It is about as common, and as crazy, as yoga.[67] Only in contemporary art do we still consider open-ended flux to be a weird and wonderful thing.

67 Nato Thompson argues quite forcefully that stability represents a subversive wager in today's context in: Thompson, *Seeing Power*, 163.

In other words, outsourcing clarity and didacticism to museum education departments is a thoroughly system-affirming gesture. Speaking of which, we should acknowledge a third objection to transparency, one that is formulated not along sociopolitical but along politico-hermeneutic lines, namely that explaining an artwork will destroy its artistic potential. That to spell out what an artwork does is to strip it of its magic.

This is an unproven generalization at best: the most overexplained masterpieces, hogging the limelight for centuries at a time, grow ever more mysterious the more they are analyzed and reanalyzed. Of course there are explanations which are infantilizing, imbecilic, or both, within education departments and beyond. But this is all the more reason to raise the bar. The terrors of clarification rank among the most deep-seated phantasmagoria of contemporary art.

As artist Phil Collins would say, "Feel the fear. Do it anyway." By and large, what raises the level of conversation is not opacity but a partisan clarity of criteria (for a discussion of the implications within a pedagogical context, see chapter 9). This even in cases of boycott initiatives, the most gnarly of all propagandistic, anti-dialogical silencing machines. Take the Gulf Labor Artist Coalition, an artist initiative that aims for an improvement of working conditions on the Guggenheim Abu Dhabi construction sites. Extensive negotiations both preceded and continue to accompany the ongoing petition.[68] It is rare for artists to be as rigorously vocal as this

68 Paraphrased from a Skype interview with Walid Raad, January 2014.

nowadays.[69] Boycott, Divestment and Sanctions Israel, for its part, will insist that the movement has amended, not thwarted, the conversation. It is now more selective, to be sure, but also more candid and precise.

In recent years, the one most articulate defense of didacticism in curatorial and artistic practice is curator Nato Thompson's *Seeing Power*.[70] Though his commitment to didacticism is (not to put too fine a point on it) somewhat indeterminate, Thompson shrewdly describes the bait and switch among socially engaged artists who use playful ambiguity as a lure—so as to attract your attention—to then focus on straightforward didactics. Sometimes to great political effect. In many cases of "equality over quality," to use critic Claire Bishop's angry dyad, that political effect eclipses the artistic value of the individual projects. For better or for worse. But that very political effect, in whose name the art is used as mere bait, is in turn eclipsed by the impact of contemporary art as an international apparatus. Which is why this publication is arguing for the politics of and qua contemporary art to be the primary object of contemplation, beyond the side effects of art-as-decoy, as welcome and salutary as these side effects may be.

Personally, I would go a step further to suggest that, beyond didacticism, in terms of long-lasting, deep-seated visceral impact, a pedagogy of nasty surprises can work wonders. Consider a weirdly violent example;

69 It bears mentioning that as of mid-April 2016, at the time of editing this publication, the Guggenheim had walked out of negotiations with the Gulf Labor Artist Coalition.

70 Thompson, *Seeing Power*, 36–39.

the film-curatorial experiments of the allied forces in occupied Germany, in the late 1940s, in which Theodor Adorno was personally involved. Audiences would settle down to see *Gone with the Wind,* only to be treated to Charlie Chaplin's *The Great Dictator* instead. If you left in a huff, someone would be standing at the theater doors, asking you to fill out a "Fascism Test," coauthored by Adorno himself. In terms of reeducation and nation building, the setup was probably explosive. Imagine booking a ticket for the new *007,* and being offered Guy Debord's *Society of the Spectacle* instead. To then be interviewed on your way out. Perhaps you would be outraged. Perhaps not, all depending. Such are the hazards of partisanship of the overbearing, violent variety, which need to be gentle in touch, and gracefully staged.

Doing Laundry
in Public

The issue of transparency is at its most salient when it comes to conditions of production, to the working lives of not only artists and curators but also their interns, assistants, students, and administrators. Again, the challenge is not personal greed so much as structural propensity. There are far-reaching advantages, for ex-

ample, to artists being systemically underpaid. As a curator, you can do more shows, to which you can invite more artists, which boosts the reach and glamour of each show, and covers up their conceptual weaknesses, but also pits artists against one another in competition. Moreover, in a vicious circle, a class of exhausted, economically desperate artists are more likely to accept the very stuff the precariousness hails from: the idea of art as an untamed bohemian preserve.

This is not, of course, the way budgeting is usually justified. From what I have noticed from working as a board member of W.A.G.E. (Working Artists and the Greater Economy, a political organization fighting for artist fees in the United States), there are three typical rationalizations for the lack of any form of payment, however nominal. One is that artists should appreciate the currency of exposure. Another is that artists should not be in it for the money: art should be a pursuit that is beyond remuneration. Funnily enough, none of this advice is ever followed by the curators who share it. But a third line of reasoning is that the overall funding is too scant for artist fees. Which can be valid if and when no one is getting paid, across the board, and the number of artists participating is too small to be reduced any further. (More often than not, halving the number of artists would not only free up cash, but would also increase the quality of the project.)

Happily, contracts are slowly replacing the usual handshake agreements, based on a wing and a prayer. Contracts are still exotica within our post-Fordist environment, where we are meant to greet every unexpected

interruption of our daily lives as an opportunity to be creative. And to see every missed opportunity as a personal failure. The post-Fordist merger of work and play, careers and emotions, makes everything look like an individual challenge, as opposed to a structural routine. The more personal your investment in your work, the more any critique of your work, for example, will seem like a personal attack. Which makes the issue of de-personalization, as discussed in chapter 1, even more pressing. Consider how many art-world collaborations are framed as an emotional thing. ("You're invited because you're a friend.") It is true that intimate ties count enormously in a field where any conversation might be a job interview, and alliances are revised at the speed of *Like*. But if you prefer not to merge all measure of personal affection and professional achievement, you do need working premises beyond "friendship" alone.

Lest we create another catchall muddle such as "neoliberal," it might be useful to spell out what is meant by "post-Fordism." Particularly within the service industries and IT sector, the term is shorthand for a historical move beyond standardized models of mechanization. In a Fordist environment, movements are primed for efficiency. Spaces are designed to eradicate every unnecessary millimeter between point A and point B, and punch cards monitor your time. All of which is made bearable by lifelong job security. A post-Fordist environment, by contrast, creates a situation in which autonomy, unpredictability, criticality, and personal enthusiasm can be both cultivated and harnessed. As a coping strategy within an unbridled, feast-or-famine

economy, post-Fordism cultivates a pervasive sense of "servile virtuosity" (Paolo Virno); the art of catering to the whimsy of individuals, as opposed to the clarity of rules. The accumulation of such efforts, within the arts and business sectors in equal measure, has served to develop an industrial personality to whom a layoff is not the opposite of employment, but part and parcel of any job.

Contemporary art flaunts a rich oral history of decision makers taking advantage of the overall servile virtuosity with self-confidence and nonchalance. Some of the stories are comical, some less so. Artists are disinvited from shows, for example, on a regular basis, and they never, to my knowledge, challenge these decisions in public. Reasons for being disinvited can range from aesthetic disagreement, to political antagonism, to sexual blackmail, to a pregnancy at the "wrong" time. ("Maybe next time!") The question is how to retrieve these critiques from the status of gossip, and wash some of this laundry in public. Once again, it is only when complaints become a depersonalized, transparent matter that you can afford to risk pushing back without losing out.

Working Example:
"The Human Snapshot"

"The Human Snapshot" was a CCS Bard College con-
ference organized in Arles in 2011, in collaboration with
Thomas Keenan's Human Rights Project. At the core
of this event was the research of scholar Ariella Azoulay,
particularly her work on the "Family of Man" exhibition
curated by Edward Steichen at MoMA, New York.[71]
When Azoulay began work on "The Family of Man,"
the 1955 exhibition was considered hokey at best, im-
perialist at worst. Azoulay's project was to rescue the
landmark show from its ungenerous, narrowly anti-
humanist reception, which materialized very early on, by
a budding post-structuralist establishment-in-waiting,
Roland Barthes among them. The case of MoMA aside,
Azoulay has long argued that the most important ques-
tion to ask about photography is that of its "use."[72] Her

71 See: Ariella Azoulay, "The Family of Man: A Visual Uni-
versal Declaration of Human Rights," in Keenan and Zolghadr,
Human Snapshot.
72 Ariella Azoulay, *The Civil Contract of Photography,* trans.
Ruvik Danieli and Rela Mazali (New York: Zone Books, 2008).

extensive engagement with what she terms "photography as civil contract" is an attempt to reposition the debate, away from a grammar of the object, and toward an ethics of the spectator; an addressee who accepts the dialogical responsibility that comes with any "civil contract" worthy of the name.

In other words, Azoulay is invested in conflicting histories of interpretation, in shifting horizons of expectation then and now, and, in terms of an overall scholarly enterprise, it makes perfect political and theoretical sense. Curatorially speaking, however, an analysis of photographic "use," especially when it comes to a curator as versatile as Steichen, would have to go beyond hermeneutics and reception studies to discuss photography as a chrono-spatial, socio-aesthetic phenomenon; "usage" in material, situational, and physical terms.

"The Family of Man" marked the end of an era. The last gasp of humanity-as-family, but also the moment immediately preceding the invention of Rolleiflex cameras; 1956 was the year photography finally exploded into the streets. So Steichen's universalism was not only skewed by geography, but by technology to boot. The institutional politics of Steichen's show were just as juicy, reflecting a stark reaction to the *Kunstfotografie* espoused by MoMA at the time. His show was essentially an angry plea for transcending the focus on form and content, traditionally speaking, to the benefit of captioning, cropping, editing, reprinting, re-narrating, and redistributing. The exhibition design emulated the sensation of an oversized "walk-in magazine." Much of the audience found the design to be as important as the photographs.

Lots of meat to sink my curatorial teeth into. Most of it, however, simply slipped to the background as we scrambled to lay the ground for the CCS conference. In this case, given that the angle was as ambitious as "universalism and humanism," I was both too anxious about the scope, and too eager to tap the titanic brains of Azoulay and Keenan. In all its crazy ambition, ours was a conference that would have required time and leisure to ferment into something worth its curatorial salt. But (speaking of chrono-spatial, socio-aesthetic phenomena, and "usage" in material, situational, and physical terms) a conference is an embodied, economic creature, much as "The Family of Man" itself, and subject to very similar pressures. In a classic case of cart before the horse, "The Human Snapshot" was not conceptualized, timed, and organized according to some curatorial logic, some inner necessity: with funding patterns being what they were at CCS, the symposium's time window was not entirely ours to define.

Bankrolling an entire institution through private donors allows for a kind of dexterity and experimentation that the checks and balances of government spending are not always amenable to. CCS in particular was a cutting-edge experiment at the time of its founding in 1990, when curatorial training was still an anomaly, and it arguably owes its very existence to that pioneer swagger of private initiative. If ensuring financial sustainability, in such cases, may not imply the same hoops as those a state university jumps through, it does require an incessant, nimble hopping from one stepping-stone to the next. With all the eagerness and angst you

would expect from an individual freelancer. "The Human Snapshot" was without any doubt a fascinating and original exercise in and of itself, but it did epitomize the quirks of latter-day patronage in myriad and sometimes comical ways.

Within less than a year, the conference was already unfolding, on a weighty patron's private estate in Arles. On the second day of the symposium, the housekeeper noticed me with a Camembert sandwich in my hands. Unknowingly pilfered from a stash reserved for Hans Ulrich Obrist, Philippe Parreno, and Liam Gillick. My patron came to find me, and I was publicly berated, in the way you would a poodle pissing on the carpet. I was expecting my snout to be rubbed in the Châtelain de Normandie at any moment. When I shared the anecdote with colleagues, few were impressed. Most of them offered buffets of similar stories. All manner of poodles, publicly humiliated at the drop of a hat.

With more time on my hands, perhaps I would have paid more critical attention to Azoulay's "civil contract," Steichen's "walk-in magazine," and the royal court of Arles. Then again, perhaps not. After all, it is not about good intentions alone. It is about an overarching pattern of interdisciplinary hubris and servile virtuosity—well lubricated by that breezy confidence of indeterminacy—that has us gravitating toward the same old models time and again. After all, I myself had willingly agreed to the impractical intellectual objectives, the generous salary, and the trip to southern France. Which is why I co-organized the conference, and a second one the very next year. Who wouldn't have?

WORKING EXAMPLES:
THREE
BIENNIALS

A student once pointed out that the London World's Fairs of 1851 and 1862 were important meeting grounds for organizers of the proletariat, and even served to launch the international workers associations. They were international platforms used against the grain, with resounding success. Why, my erudite friend was asking, could the biennial and triennial platforms of contemporary art not become comparable sites of internationalist willpower? I am still not entirely sure what to tell him. As it presently stands, biennials take the concerns of this book to caricatural extremes. Their potential, in terms of sheer volume and traction alone, are enormous. As are the possibilities of building a strong sense of institutional memory, and a unique sense of location to boot. Yet at the end of the day, we all seem

to agree that your typical biennial is just some pompous exploitation machine. Funnily enough, the moment we take the helm ourselves, we proceed to do exactly the same old thing. This has little to do with hypocrisy or laziness, and more to do with a ferocious institutional dynamic that has its own agenda, its own baggage, and its own velocities. In order to push against this gravitational pull of business as usual, you need structural measures beyond revolutionary intentions. Structural measures that would take time to conceptualize, let alone build. None of the below working examples are shining cases thereof. But they do offer clues and propositions, and lay the ground for the idea of "location" as introduced in chapter 6.

The 7th
Sharjah Biennial

It is March 2005, and young Zolghadr is a hungry, overconfident man-child, who has recently been appointed associate curator of the 7th Sharjah Biennial (SB7). Ken Lum is the second associate curator, Jack Persekian curator in chief. Perhaps the most challenging item to get ready on time is Santiago Sierra's *120 Hours of Continuous Reading of a Telephone Book* (2004). The piece

consists chiefly of pages from the segregationist phone books reserved for Palestinian citizens of Israel. When Sierra's piece was first installed the previous year, every name was read aloud, and the resulting recording served as the soundtrack to our installation in Sharjah.

Page after page of flimsy phone-book paper was carefully removed, framed, and hung across the high walls, a grid of glassy rectangular units slowly covering the room. We finished it only hours before the opening. This is when Sierra showed up, with his Ray-Ban sunglasses, cowboy boots, and a BBC camera team in tow. He curtly approved of the installation, and immediately suggested we move on to something entirely different. Something that turned out to be a brand-new piece for the biennial. A work about "immigrants in the UAE," a topic dominating the international headlines, then and now. It so happens that the exploitation of guest workers had already attracted the attention of another participating artist, Peter Stoffel. Unfortunately, Stoffel's work fell prey to shrewd delay tactics from within our biennial team, and the best I could offer, in the end, was a poster featuring a timeline of those very delay tactics, to be displayed within the show. Sierra's proposal, by contrast, came only hours before the opening. No research involved. Which is why, anxious about the "poornography" you so often witness at international biennials, I declined. And thus, my international career began with a twin act of censorship: one of them mired in complicated backstage maneuvering, the other sim-

ple and smug, before the rolling cameras of the BBC.[73] Looking back, with more experience confronting disingenuous colleagues and last-minute artists alike, I should have encouraged Sierra to join forces with Stoffel. We would have had a perfect storm on our hands. Then again, within the context of this book, there is something to be said for unapologetically marking a curatorial prerogative.

Although Sierra's installation was "about" Israeli apartheid, its content only partially defined the politics of the piece. Sierra's critique of Zionist modes of visibility was legitimate enough, but it was facilitated by selective modes of visibility on behalf of the work itself. In order to get the job done, SB7 resorted to a mix of staff and volunteers who slaved away day and night, under questionable conditions that still are, unfortunately, routine biennial fare. The fact that Sierra's work is largely about the labor masked by glossy art commodities introduced an irony that was not lost on us. But bewailing the interns is no match for the critical virtue of art, which allows us to bask in easy ideological credentials, by means of a "Bad Object" (Zionism) somewhere beyond the confines of the show.

On the other hand, it does bear mentioning that Sierra's was the contribution which, as far as I remember, was most eagerly discussed by museum staff members, local and foreign alike. Its lucky placement

73 I may be misremembering bits and pieces. But there's a BBC documentary on Santiago Sierra, made roughly ten years ago, where much of this is documented. I have never dared watch the footage myself.

within the overall chronology of the exhibition—an extravagantly spacious, conspicuous corner, within an otherwise monotonous corridor trajectory—allowed it to architecturally hold its own. Formally speaking, meanwhile, it was the minimal brunt of the black and white phonebook pages, stacked like ultramodernist wallpaper, that set it apart from the colorful attention economy of the wider setting.

Shortly after SB7, the Sharjah Art Foundation promoted Persekian to the role of director, only to fire him again in 2011, ostensibly over a blasphemous artwork in that year's biennial (an edition curated by Suzanne Cotter and Rasha Salti). An outraged petition gathered 1,600 signatures. I sympathized with Persekian, even if I did not sign the petition.[74] The following edition, however, pursued the brilliant move of hiring Yuko Hasegawa, a curator with a professed interest in Arabian courtyards. These became a master trope of the show, and, in her curatorial statement, Hasegawa railed against the imposition of a "Western perspective," insisting on a culturalist approach instead: "In selecting artists for the Biennial, we sought out individuals who have a deep interest in the culture in which they were raised. [...] This process produces hybrid knowledge and intercultural products that could potentially constitute the genetic material for a novel culture."[75]

74 I found Persekian's martyrdom on the altar of free speech just a little too dramatic.
75 See: Yuko Hasegawa, "Curatorial Statement," Sharjah Biennial 11, September 2012, http://www.sharjahart.org/biennial /sharjah-biennial-11/information.

The postcolonial appeasements, not to mention more strong-arm PR tactics, all did their bit. Two years on, the list of names on the petition pretty much covered the list of hotel guests at the Sharjah Rotana. Two years after that, the Sharjah Art Foundation's annual March Meeting conference was commended for its "spirit of genuine critical inquiry" on the *Artforum* website.[76] Today, Sharjah remains a platform for ambitious art production and transregional collaboration, which is in many ways important, but it could be even more than that.

Back at SB7, my most ambitious fantasy, as a fledgling curator, was to incorporate the royal collection of Orientalist paintings within our show. Sharjah's head of state, Sheikh Al Qassimi, the single main backer of the biennial, had long assembled a sizable collection, ranging from a good number of classics to more cheesy recent examples. Some of these paintings were already on display here and there throughout the biennial's museum venue. Remarkably, the paintings were left uncommented, with the sandscapes, the brave British troops, and the racy titles—*The Savages Attacking Us*—all left untouched, *tel quel*.

Some assumed this to be a case of sheer ignorance of the historical stakes at hand. Judging by my one encounter with the ebullient, self-ironic, articulate pol-

76 Kaelen Wilson-Goldie, "Global Affair," *Artforum Scene & Herd,* March 27, 2014, http://artforum.com/diary/id=45990. I appreciate artist Yazan Khalili's candor in this regard. For further reference, see our conversation: "Does That Make You Feel Bitter? Relieved? Blasé?," *WdW Review* (May 2014), http://wdwreview .org/desks/does-that-make-you-feel-bitter-relieved-blas/.

itician, a man with five languages under his belt, and a PhD on the history of piracy in the Arab Gulf, I find that hard to imagine. If I were to take a wild guess, I would say the understated gesture, although indeed intended to reinscribe a national past, was simply too imbued with slapdash optimism. ("Here's the history; today's context will do all the framing and reframing by itself.") My own proposal, at the time, was to integrate the collection within the conceptual architecture of the biennial, and cast a wry, postcolonial light on the biennial industries at large. A well-intended reflexivity that, looking back, is hardly as radical as I assumed. If anything, it was a textbook example of the critical virtue described in these pages. What is more significant about the gesture is that it would not have amounted to an artist project, or a curated selection, but a structural intervention on behalf of a political leader upon whose executive support the biennial still relies. Unfortunately for me, and my wild sense of imagination, the sheikh decided to house his collection within a small museum of its own. This is where it can still be seen, to this day, a stone's throw from the biennial venues.

The 2010
Taipei Biennial

We will start with the good things. To begin with, Hongjohn Lin, my cocurator, and I, along with assistant curator Freya Chou, stuck to a limit of thirty invited participants, which meant higher fees, and more breathing room for the work, than was usually on offer. After all, the artist list of astronomical proportions is the most distinctive item of biennial folklore, and the one that hampers its experimental promise the most. This for many different reasons (see chapters 3 and 8), but not least because it wildly overestimates the attention span of your average Homo sapiens. All the participating artists were invited to produce new commissions, or reinvent older ones. Can Altay, Chris Evans, Shahab Fotouhi, Jao Chia-En, Pak Sheung Chuen, Christian Jankowski, Michael Portnoy, Olivia Plender, Shi Jin-Hua, and Hito Steyerl all took the opportunity to produce new works of a caliber that was, for lack of a better word, fantastic.

As a working premise, the 2010 Taipei Biennial (TB10) sought to trace and highlight the institutional

memory of the biennial: this by means of a kind of conceptual piggybacking, or *aemulatio*, to use Dieter Lesage's rather more elegant term. In ancient Rome, aemulatio was a key moment in the education of a poet, and amounted to the technique of acknowledging and imitating, yet also excelling in the methods of one's teacher. In this spirit of aemulatio, many artists explicitly and often polemically grappled with artistic precedents, setting out to "appropriate," "normalize," or "curate" them respectively.[77] TB10 also echoed that hallowed Roman tradition by avoiding the usual tabula rasa impulses, and actually revisiting the preceding edition instead. A small number of artists from the 2008 Taipei Biennial (TB08) were invited to critically revisit their previous contributions. Thereby creating a very particular relationship to those segments of the local audience who remembered the preceding biennial. Chiefly among these re-invited artists were Burak Delier, IRWIN, and Superflex.

The aemulatio was noticeable also in our thematic response to the premise of the 2008 edition, curated by Vasif Kortun and Manray Hsu. If TB08 tackled globalization and its discontents, as a prism for the show, our own was to "observe art as a political locus, instead of a lens to see politics beyond itself." Early on in our work-

77 To mention the half dozen most clear-cut examples: Can Altay took on Chiu Chien-Jen, Silvia Kolbowski grappled with Gerhard Richter, Shi Jin-Hua focused on Joseph Beuys, Keith McIsaac took on Michael Asher, and Mario García Torres took on Asher and Robert Barry alike, while Michael Portnoy set out to "improve" Olivia Plender's commission, which integrated other artworks in turn.

ing relationship, Hongjohn shared an anecdote that helped clarify and epitomize our approach to our curatorial TB10 precedents. In late 2008, as Kortun and Manray's biennial was nearing its end, a violent political demonstration against the visit of a Chinese official unfolded just outside the museum. Given the TB08's activist overtones, the contrast to the quiet museum left the artists frustrated.

As long as art is compared to burning cop cars, it will always look drab. This even though there are few things more symbolic, and more aesthetic, than a burning cop car. In fact, the struggles within a museum can be just as consequential in nature, even if they are not always as immediate as a street demonstration. The politics of art, as Hongjohn and I attempted to argue via TB10, are a matter of being watched as you are watching, in the knowledge that you are internalizing the model of the cultured citizen as you are doing so. And also a matter of whose labor gets visualized, valorized, and remunerated. Such was the stuff we were focusing on—and with good reason—even if we ultimately failed to take our observations to their own logical conclusion.

As it happens, the 2012 Taipei Biennial, curated by Anselm Franke, cranked up the number of artists to galactic heights, and packaged them with a more typical gargantuanism ("THE MONSTER OF HISTORY"). Generally speaking, the more names, materials, and political melodrama you stuff into a show, the less the audience takes in—and the more visible the show becomes. Without dwelling on TB12 any further, let us focus on

the monstrosities of TB10 itself. For the purposes of this chapter, we will zoom in on two in particular.

True to international biennial tradition, Hongjohn and I were appointed eight months before the opening, with the local curator assigned with playing Sherpa, safely guiding the visitor away from intercultural blunders. As it happens, Hongjohn is as socially awkward as I am, or almost. He and I made for a Beavis and Butt-Head kind of duo. What is more, the Taipei Fine Arts Museum was embroiled in a messy search for a new director, and the transition made the atmosphere, and the logistics, twice as arduous as usual. If logistical and emotional catastrophes are part and parcel of any biennial, our own staff would pepper our disasters with a curt, "We told you so!" and "We predicted it!" The artists, meanwhile, were routinely hollered at, or sulked at, by the technical staff. So when it came to our meet-the-press moment, artist Michael Portnoy took to hollering a string of conceptual obscenities as we took the stage. "Fucking self-reflexivity fuck you biennial fuck."

I will now set these catastrophes aside—any more whining and a violin will start playing in the background—as the more interesting shortcoming was actually our curatorial inability to take the show's premise to its own logical conclusion. "Biennials," we said in our curatorial statement, "are widely used for urban marketing ploys, activist platforms, postcolonial statements, art-world careers and more, when they're not particularly good at any of these things." This, unfortunately, flies in the face of empirical evidence. Bienni-

als promote and consolidate tourist destinations, business environments, political causes, art ideologies, and art-world careers—sometimes to incredible effect. They are infrastructures that mark entire generations of local artists and curators, but also technicians and administrators, over the years.

It is great for curators to take an exhibition more seriously as a political arena in its own right, rather than point to so many global monsters around it. But, to ignore that arena's effects on the global setting around it is to linger, rather primly, within the orthodoxies of contemporary art curating as we know it. Offering little more than a refinement of self-critique, an uncertain middle ground between purity/autonomy on the one hand, and corruption/co-optation on the other.

A synecdochical case study can help us trace the good, the bad, as well as the ugly sides of TB10, and I suggest Olivia Plender's *Google Office* (2010). The sprawling installation doubled as discursive infrastructure and symbolic centerpiece, effectively setting the tone for the exhibition as a whole. The title referenced the famous Google facilities, and duly featured free Wi-Fi, tea, coffee, work stations, and "Discussion Islands," alongside a "Steve Jobs Discussion Pit," and a tropical beach hut and loungey VW bus, but also table soccer, Astroturf, and a Masonic Lodge, replete with bewildering mirrors and a fancy chandelier, not to mention a backhanded intellectual property proviso posted on the walls. ("Reading this text indicates your consent to the terms stated above.") Plender also embedded within this apparatus

other artist contributions, from performances to workshops to sculptures. So the office resonated not only with the burble of Facebooking teenagers, and the clonk of table soccer, but also talks and screenings, and the deafening "Salsa Lessons" by artist Larry Shao. Along with drawing classes by the Taipei VT Artsalon collective, and "Free Chinese Medical Advice for Art Laborers" by artist Doris Wong, and so on.

As many readers will know, the Google Inc. offices are where post-Fordist conditions of production are taken to ever-newer extremes. Google is a place where work and play famously amalgamate, and old-fashioned notions of personal and corporate, home and away are meant to bleed into each other seamlessly and profusely. This at the price of never being sure just how much leisure you are having (to use Liam Gillick's formulation).

The piece faithfully mirrored the discursive, legal, iconographic, and quasi-auto-ironic parameters of any given Google office. But despite the huge variety of daytime activities, despite the plethora of props, and the cheerful yellow of the towering walls, Plender's office invariably came across as artifice. The ambiance was formal, the audience self-conscious, the aesthetics composed. In other words, it looked like art, and felt like it too, and no amount of salsa could change that. There was never a moment of mistaking the setting for some kind of corporate HQ.

You could argue, as most of us would, that a post-Fordist period room will never reproduce the competi-

tive claustrophobia that marks an office biotope. The financial stakes, personal risk management, and threat of failure are harder to reproduce than a discussion pit with free Wi-Fi. There will always be more adrenaline in a single corporate power lunch than art could ever summon. Art, supposedly, is never more than an actor screaming "fire" onstage.

My own argument, however, is that Plender succeeded not by realistically portraying a culprit, safely contained by the hygienic powers of artistic critique, but by virtue of materially creating an art-exhibitionary arena for post-Fordism in her own right. All activities in Plender's office, whether overtly creative or not, were beset with the usual glare of biennial visibility, and the karmic management and competitive claustrophobia that comes with it. They were even saddled with the additional pressure—the vanity, anxiety, and mindfuck—of being part of an actual artwork. Maybe this can explain why the hammocks were never used, not even once. And why the lectures and panels were even more awkward than usual.

The case of Larry Shao's *Salsa Lesson* was telling. Previously, Shao had always separated his art from his dance classes, which were meant to pay the rent, no more no less. It was in the context of Plender's *Google Office* that the idea of splicing the two emerged. His dance-lessons-as-performances became an instant, raging success, boosting his teaching career to unprecedented levels, even as they blurred the boundaries between his art and his life. Contaminations of the

kind, and there were many, are what made Plender's piece—as insistently artificial as it was—a penetrating experience, and a hauntingly pedagogical one at that.

Though perhaps camouflaged as institutional critique, Plender's piece could only truly succeed as an embodiment—not a critical echo—of the alchemy of post-Fordism. And thinking about TB10 through the prism of Plender's work is a lesson in consequentiality. Any biennial, even TB10, which prided itself in being a thinking person's biennial, *klein und fein,* produces its own brands of competitiveness, claustrophobia, and karmic management. Our noble gesture of inviting fewer artists, for example, was offset by the frantic megalomania of dozens of new commissions.

Much of the reception of Plender's oeuvre insists on the subversive character of the work, and on the willful amateurism of the artist. But is there really any amateurism at play, when Plender drafted her ideas within a minuscule time frame, drawing from long-term research, and eloquently argued her case, to then personally oversee the execution of the piece; all with the savoir faire of a prolonged trajectory through the institution that is art? Suggesting that Plender's *Office* actively and materially embodies the "liberation management" (Peter Fleming) of Google may sound cynical to some. But it is promising and inspiring in that it underlines the agency Plender enjoys as an artist. An agency that places her well beyond the coy melancholia, and self-cutesification, that contemporary art has become accustomed to, and that even TB10 itself indulged in a little too cleverly.

The 5th
Riwaq Biennale,
Palestine

Ramallah is in some ways the perfect antithesis of Tehran. The Iranian capital is a metropolis of fifteen million that is all but isolated from the international scene. Ramallah, meanwhile, is a tiny town ("small as a scorpion's cunt," as the locals fondly put it) that is unrivaled in terms of international foot traffic. People like me, with good intentions and bad Arabic, cover this place like a fungus. So, writing the first draft of this book from Ramallah was not exactly some lonely account of self-exile. If anything, the prevailing circumstances have made very coveted individuals of the artists and curators working here. Sometimes it was hard to keep the local art academy, where I was teaching part-time, from turning into some kind of professional petting zoo for international curators. In sum, Ramallah as the setting for the early draft of this publication only amplified contemporary art's pitfalls and fantasies alike.

The Riwaq Biennale itself is no less complicated a mindfuck than the context it springs from. But one relatively simple, didactic way to introduce faraway

readers to this complicated creature is Israeli architect Sharon Rotbard's *White City Black City*, a book that describes Tel Aviv's love affair with whiteness, and its successful efforts to include its supposed plethora of Bauhaus masterpieces in the UNESCO World Heritage List.[78] This whiteness is not only about spanking white architecture ("Dessau on the Mediterranean"), but also about race, in terms of defining Israel as a European outpost. And about innocence as well: Tel Aviv as a city built on beach dunes, not on Palestinian ruins. Rotbard does an eloquent job demonstrating that, whether in terms of skin color, the ethnic cleansing of 1948, or architecture, Tel Aviv is not so white after all. (The city is racially very mixed, its midcentury history is steeped in military violence, and Bauhaus examples are neither very numerous, nor very Bauhaus.)

He also pinpoints the beginnings of the powerful misnomer in question: a 1984 exhibition at the Tel Aviv Museum of Art, curated by Michael Levine. So Rotbard is not only helpful in that he demonstrates the imbrication of colonialism and its representation, but also in that he tells a story of harrowing curatorial prowess, of an exhibition with far-reaching prospective agency. Both of which become two more parables of showing and/as doing.

The issue of doing-as-showing-as-doing is particularly salient in a Palestinian context. When talking to photojournalists, filmmakers, media scholars, or ac-

78 Sharon Rotbard, *White City Black City: Architecture and War in Tel Aviv and Jaffa*, trans. Orit Gat (Cambridge, MA: MIT Press, 2015).

tivists here, you are often confronted with the notion
that representation, as in testimonial content, has not
served anyone very well over the decades. Especially in
light of the relatively generous exposure of the Palestin-
ian situation, in comparison to other sites of butchery
and dispossession. The result of which is an appetite
for something beyond testimony alone. Though the lat-
ter will always be crucial, the shift toward something
enacted and embodied, as opposed to something that
illustrates and points, is increasingly obvious. This in
turn presents a challenging new twist to an old conver-
sation within the visual arts, where you once had com-
parable appetites in feminist practice, for example with
artists such as Mary Kelly calling for a moratorium on
pictures of women's bodies.[79] (But you also have a broad,
rich tradition of scopophobia reaching back all the way
to Plato—see chapter 8.)[80]

Circling back to *White City Black City*, its historical
backdrop of Zionist urbicide and willful amnesia, of
444 towns and villages obliterated to make way for
Israel, is being continued and complemented in today's
West Bank—but at the hands of Palestinian investors.
Heritage is a big deal anywhere in the world, but rarely
is its importance as staggering as it is here. Which is
where the Riwaq Center for Architectural Conservation
comes in, with its impressive track record of historiciz-

79 My thanks to Maria Lind for this point.
80 Amanda Beech, "Last Rights: The Non-tragic Image and
The Law," in *The Flood of Rights*, ed. Thomas Keenan, Suhail Malik,
and Tirdad Zolghadr (Berlin: Sternberg Press, forthcoming).

ing, preserving, and rethinking the countryside of historic Palestine.

The biennial, for its part, is named after that institution, and not after a place. It is a biennial with an agenda, and a rather determinate one at that. With this concrete political outlook, together with its durational, discursive approach, Riwaq Biennale has always challenged what a biennial can be, ever since its founding in 2005.

For the 5th Riwaq Biennale (RB5), the commissioned artists were few in number: Phil Collins, Yazan Khalili, Jumana Manna, Katya Sander, Apolonija Šušteršič, Oraib Toukan, Sandi Hilal and Alessandro Petti, and Reem Shilleh and Mohanad Yacoubi. Along with a small handful of scholars and curators, they were invited to partake in three overlapping pursuits: promoting Riwaq's agenda, developing an educational program for practitioners in the West Bank and Gaza (a program entitled "Nadi"), and/or building a program of events and commissions around existing debates within Ramallah.

During the commissioning process, the artists were made aware of the fact that their work would be evaluated primarily via the Riwaq mission statement. Which usually presented more of a challenge to the curator than it did to the artists. When I was encouraged by Riwaq director Khaldun Bshara to think along the lines of "encouraging tourism," for example, I balked. With exactly the kind of snobbery you would expect from someone with a tote bag and a Moleskine notebook. But when, for example, sculptor and filmmaker Jumana Manna went on a site visit to the village of Jab'a, she enthusi-

astically agreed to build a sculpture garden to exactly that purpose. Tourism, after all, is one of the few realistic economic prospects in the West Bank, whether of the cultural, religious, activist, expatriate, or happy-hiker variety. And even if we Otherize it as a lowbrow, commercial "Bad Object," in a variety of ways, the knowledge production specific to cultural tourism plays an intrinsic, central part in biennials almost anywhere.

Another example of engagement with the Riwaq mother ship's agenda was Sandi Hilal and Alessandro Petti's proposal to draw Riwaq into the unfamiliar territory of a refugee camp. The idea of conserving a public square within the Dheisheh Camp, near Bethlehem, is a political provocation. After all, preserving a camp is perceived as a direct challenge to the Palestinian Right of Return to the historical homeland. But "camp conservation" equally challenges general, common-fare ideas pertaining to conservation. Over the last few decades, conservation has moved from preserving antique monuments, to that of mainstream modernism, to even the revitalization of industrial wastelands from the 1950s and 1960s. At present, it is overtaking the present to envisage "conserving the future." Which is where the Dheisheh Camp sets in.

A third example of an RB5 commission, finally, was *Cinema Sayara*. The token big-bang, high-profile piece was essentially a rooftop drive-in cinema by the artist Phil Collins (loosely based on his *Auto-Kino!* project, which had been rolled out in Berlin five years prior). The film program was selected by artists, filmmakers, and the immediate neighborhood, and it ran for four

weeks. If you lived nearby, you could watch the program from your balcony by tuning into a standard FM/AM frequency, and catching the soundtrack on your radio.

The host venue for this rooftop spectacle was the historical Beit Saa, a 1910 edifice being renovated by Riwaq at the time, located in downtown Ramallah. The municipality of Ramallah had decided that Beit Saa was to join the swelling ranks of museums in Palestine. Many of which were already in various stages of neglect. Since Riwaq is always confronted with accusations of "museifying villages," this did not sound promising. The last thing they needed was to be involved in the literal museification of downtown Ramallah.

With *Cinema Sayara*, RB5 was attempting to get a foot in the municipal door, and reorient city efforts toward something more versatile, and more dynamic, maybe even artist-run. "Instead of a homage to the past, in the name of some faraway future," we wistfully argued in the press release, "*Cinema Sayara* proposes a celebration of the here and now. It suggests that contemporary art, architectural conservation and cultural policy need not be in conflict with dynamic local engagements. Also, it hopes to spark a sense of curiosity, enthusiasm, and collective ownership, within the neighborhood and beyond." At the time of writing, museum designs are moving ahead unabated. Both the collective programming and the sheer sculptural pizzazz of the cinema had their undeniable qualities, but as for the desired political traction, it simply did not materialize.

RB5 was programmed to span two years—fall 2014 to spring 2016—of which I curated the first, before re-

locating to Oxford in the fall of 2015. Compared to the usual ten-month incubation period, followed by two months of limelight, the advantage of a protracted, or "chronic" timeline, as we liked to call it, is that it invites more interlocutors to be part of the conversation from the outset. The input bleeds in and out of the process more profusely.

Consider that at the very moment of the RB5 kickoff, Gaza was being relentlessly bombarded by the Israel Defense Forces, with thousands killed in plain view. Many in Ramallah were paralyzed by a sense of guilt and self-disgust, and held tortured discussions about what artists can and should do. The day the bombing finally stopped, funding deadlines had to be respected, money needed to be spent, and life had to go on. Our hope, as the RB5 team, was that the structural imposition of a two-year working process might allow for something more sustainable in terms of a response. Looking back, it may have been a case of biting off more than we could chew. I cannot help but think that there are certain challenges curating should not even attempt to rise to, and few challenges are as pathetically, violently absurd as the situation in Gaza.

Commissions aside, as part of this two-year program, RB5 held a series of artist roundtables. The first of which was moderated by Haifa scholar Esmail Nashif, alongside Jerusalem curator Rawan Sharaf, and addressed the issue of art-world internationalism (it took place in October 2014). Ten Palestinian artists were invited to discuss the price they were willing to pay for international exposure. The event coincided with the

biannual Qalandiya International, the largest art event in the country. During which everything happens at once, and no one has time, and the general mood is one of breathless excitement. Among the organizers, the focus is very much on statistics, and the sheer numbers of artists, journalists, and visitors flying in are undeniably impressive. One would even be forgiven for assuming a widespread eagerness to expose the "Palestinian situation" to a broader audience (and yet, as argued above, it is striking to which point show-and-tell has long been losing currency here).

Palestine aside, internationalism is a strange thing in art. We scoff and belittle, but in the end we do play ball, even if the working conditions are abysmal, the politics stereotypical, and so on. We content ourselves with nagging behind the scenes, promising ourselves it is the very last time we ever do this, ever ever. It seems there is little hope of amending a conversation which has been merrily chasing its tail since "Magiciens de la terre."

With this in mind,[81] RB5 conceived of the event as a response to Qalandiya International, one which did not announce its opposition so much as embody an alternative stance. The setting was the tiny village of Deir Ghassaneh, from which no one could easily escape. A no exit situation, for a discussion held not in English but Arabic, spanning five hours. With such ghastly parameters, the audience was predictably small, but devoted. Setting aside the language, the number of

81 My thanks to the behind-the-scenes support and conceptual prompting of artist Hassan Khan.

speakers, the marathon timing, the heady intimacy, the entrapment of the setting, but also the terrific food prepared by village locals, the most exotic aspect at play was the fact that ten individuals were speaking as artists. Admittedly, it was only after a good hour of denying their identity as artists ("I'm an architect"/"I don't know what art means"/"I don't believe in categories"/ "Why the Arabic") that a rigorous discussion—of artistic priorities specifically—began to materialize.

The upshot of all this is somewhat difficult to circulate, even in a setting as propagandistic as this book. In some ways, the roundtable was just a pleasant conversation, no more no less. In others, it was an ambitious take on the said imbrication of showing and doing. A setup of this kind is where local priorities are articulated not by means of a broad panel of dialogical opportunities, but by means of something more testing, something demanding enough to drastically restrict the audience numbers. Whether the issue is art production at large, or something more violently urgent, the creation of a specifically committed audience can be just as pressing as a globally sympathetic crowd. Perhaps the creation of the specifically committed audience actually precludes the production of all other ones.

- 6 -

LOCATION, LOCATION, LOCATION

I will begin this chapter with a famous Chris Marker quote: "Gods and heroes have now sought asylum in art collections, like political refugees in foreign embassies."[82] We are all familiar with these glamorous retiree types. Thanks to their amazing stories, they remain simpatico even as they are dethroned and beleaguered: still crazy after all these years. As for the art collections within which they take refuge, one imagines a plush kind of place, replete with tax-free cognac and *cadeaux diplomatiques.*

Perhaps this is where we have come to. What kind of a place is art? And, what kind of place would we like it to be? A place behind thick, heavy curtains, where

82 I have heard this phrase in very different contexts, but never sourced or referenced.

the rule of law is suspended in a smoky haze of good cigars? Or are we talking more about a studio, or an experimental university, or a roaring biennial perhaps? Artist Phil Collins likes to say that art is where you can offer free beer on a Friday night, and no one will show up. Is that still true nowadays, and, if so, would we really prefer they show up for the lager? Yet another spatial metaphor, discussed in this chapter, suggests that art, flighty and frail, is breezy enough to be everywhere and nowhere. What this section argues is that there are surprising commonalities between the breezy and the ambassadorial, and even between the open university and the roaring biennial at that. It also argues the importance of firmly locating our field somewhere beyond the idealized porousness described in previous sections of this book.

Working Example:
Ethnic Marketing

In the spring of 2004, I curated the thematic group show "Ethnic Marketing," together with artist Martine Anderfuhren, at the Kunsthalle Geneva. In 2006, it traveled to Tehran, where it materialized in various venues, including the artist-run 13 Vanak Street, and

the commercial gallery Taraneh Azad. In terms of a first near-professionalized exercise as a curator, it was ambitious, to say the least. Among the exciting challenges, "Ethnic Marketing" offered a very first chance to send an e-mail invitation to an artist. Who just happened to be the eminent Kutluğ Ataman. His response was swift, and to the point.

> Dear Tirdad Zolghadr,
> Thank you for sharing your proposal with me. I am only interested in theory as long as I am in the receiving end. Then again, of course I respect your job—I only wish you did it after I am dead.
> Best regards
> Kutlug Ataman.

I am particularly fond of the punctuation mark following "Ataman." (The name alone speaks volumes.) It is telling that I have never again received quite as harsh a response to an invitation. Either because I am less of a complete nobody than I was in 2003, or because I have learned to pepper invitations with the prerequisite, liberal doses of indeterminacy.

"Ethnic Marketing" also prompted my second exhibition review, following the already mentioned trashing in Tehran's *Hamshahri*, four years prior. This one was even more scathing. Upon seeing the show, Edith Krebs of Zurich's *Wochenzeitung* took offense not only at the show's "cynicism," but also at the curator's "cos-

mopolitan smile."[83] It is funny how I can clearly remember the supportive, friendly impression Krebs made upon me, as I paraded her around the exhibition, beaming throughout.

Young Zolghadr reacted to all these slaps in the face with narcissistic ire, but to a certain extent, I have come to mistrust my own motives at the time. Better said, what I now consider the show's strength was indeed treated with indifference, maybe even cynicism, back in the day. In a nutshell, the show's working hypothesis was that first-world vs. third-world divisions still prevail, in a way that turns any artworks moving northward or westward, from the south or east, into a supply chain for an overpowering market demand for particular forms of cultural production. A demand that defines the art in its essence, even including art that is reflexive or auto-ironic of this happenstance.

For us curators, the existing ethnic marketing industry offered a welcome foil through which to approach this topic; a burgeoning niche within the marketing industry at large, which penetrates minority markets by essentializing that clientele, then catering to the taste, humor, and buying power of the very essence it just invented. In other words, it creates the audience it purports to cater to; thereby, we argued, allegorizing art itself. The show attempted to turn the tables by strategically essentializing the Euro-American art crowd instead, and exploring what it takes to whet the aesthetic appetites of the prototypical White Art Aficionado. It

83 Edith Krebs, "Ethno-Pop oder was?," *Wochenzeitung*, November 4, 2004.

also attempted to critique, self-reflexively, the opportunities that were opening up to me when I moved from Iran to Europe in 2002.

By assembling dozens and dozens of artworks, new and old, all of which demonstrated, deconstructed, or overidentified with the premise, in myriad ways, the project was a conventional thematic group show: heliocentrically organized, even as it was devoid of a clear proposal (see chapter 8). Arguably, it even enacted a fuzzy version of what it sought to critique. By virtue of unveiling the mechanism of ethnic marketing, the show assumed it was automatically above it. The project did not illuminate or illustrate the topic, through a glass darkly. Instead, it became what it beheld. In a sense, however, the exhibition's saving grace was precisely the way in which it embodied its premise, with unintended, clunky transparency. From the art, which was crassly transfigured into an object of knowledge, to the exhibition design, which amounted to one big labyrinth of art fair booths, and which sarcastically underlined the economic crux of the conversation.

It was this set of harsh gestures that allowed for a good look at persistent hierarchies between first world and third, and at the light that these archaic categories, for all their moral violence, continue to shed on contemporary art. In other words, the project was hardly remarkable in terms of critiquing the marketing industry, let alone the art world. Its achievement lay in establishing a rather weird location: materially, as a quasi-didactic labyrinth within the Kunsthalle, and polemically, from somewhere deep within the postcolonial shadow of

Okwui Enwezor's documenta 11, which towered over the conversation at the time.

Refugee Camps
of the Mind

David Levine and Alix Rule's essay "International Art English" (IAE) was a more concerted, ambitious attempt to map contemporary art as a location.[84] It sparked much controversy, and was accused not of "cosmopolitan smiles," but of Anglo-chauvinism, colonialism, and worse. Levine and Rule analyzed e-flux newsletters, in order to argue that, first of all, such a thing as a grammar of contemporary art does exist, but also that, secondly, its rules remain in effect even if unacknowledged, and that, thirdly, this grammar has long been informed by poor translations of key post-structuralist texts from the original French versions.

It is telling that among the many angry reactions, the principal argument was that IAE is an elitist idea, a linguistic gatekeeper, barring access to nonnative speakers. In point of fact, these critics railed, the failures in

84 David Levine and Alix Rule, "International Art English," *Triple Canopy* 16 (2012), https://www.canopycanopycanopy.com/contents/international_art_english.

and of contemporary art discourse are what make art a worthwhile pursuit to begin with. Thus, the critics valorized "slipping through cracks" and "smuggling across boundaries," even if that means using the sloppy grammar of IAE. In other words, the deeper reason for all the fury was not that Levine and Rule rallied for better writing, but that they failed to rally to indeterminacy. Even an elite idiom needs to be framed as a passport to marginality. As it happens, some of my Ramallah students are speaking of an emerging International Art Arabic that resembles its ever-indeterminate Anglophone cousin.

So the reactions had less to do with a critical appraisal of IAE's existence, and more to do with a self-image of the peripheral. The latter is the spatial translation of indeterminacy, an existence beyond the centers, too flighty and frail to define. Any tighter circumscription of art is delegated to the bigots of the *Daily Mail*. The problem, of course, is that as we encourage each other to think outside the box, we partake in a grand tradition of ignoring it. To the point of instinctively assuming that the box no longer exists. The upshot of which is that, beyond a handful of neighborhoods in New York City and London, the claim to peripheral status is ubiquitous. In Ramallah as well as Montreal, Los Angeles as well as Stockholm, it is always some faraway metropolis that is the art-world epicenter to be envied, or dissed. "Oh this ain't Soho or Mitte my friend! Welcome to little old Munich/Taipei/Dubai."

The re- and de-territorializations that conflate what is irreconcilable, and exoticize what is actually alike, are

part of the overall draw, in that they replace the center-periphery dyad with something more interchangeable, more intricate, more acceptable. *Die Liebe krepiert an der Geografie* (Love gags on geography), as Erich Kästner would say. A porous sense of placelessness is best. Or, as Dave Hickey argues in "Earthscapes, Landworks and Oz," a "Shem-Shaun dynamic" is constitutive of many key moments in art history. Consider Pop art and Earth art: "both arts of location and dislocation, deriving energy from sophisticated forms of trespassing. The Pop artist imposes his vulgar image on the sanctioned 'art' environment, while the Earth artist imposes his artificial image upon a secular 'non-art' location."[85]

To take a slightly more dramatic example, Thierry de Duve's 2008 essay in *October* magazine, "Art in the Face of Radical Evil," discusses the case of photographs from the Khmer Rouge genocide, and of curators anxiously oscillating between priorities that are "strictly formalist" and priorities that are indebted to the invocation of human rights violations, such as "the duty of memory."[86] Far from a contradiction in terms, to uphold an ambivalence between the two will lend a show, no matter how problematic, some necessary breathing room. Embedding your material within unambiguous boundaries—using NGOs or embassies, for example, for images of genocide as a nonaesthetic category—renders a curator more vulnerable. It forgoes the topo-

85 Dave Hickey, "Earthscapes, Landworks and Oz," *Art in America*, September–October 1971, 48.
86 Thierry de Duve, "Art in the Face of Radical Evil," *October* 125 (Summer 2008): 4.

graphic fortes contemporary art has on offer. (If only by dissimulating the aesthetic moment that is always part of an ethical argument regardless.)

Such is also the tired irony of the postcolonial insistence on being "off-center," or of embodying a polyphonous alternative to the "monocultural centers" of the West. The logic of this premise remains as unfalsifiable as it is tautological. Art is peripheral because it is other to the international powers it decries, and it is other to the international powers it decries because it is peripheral. Thus the idea of art-as-institution can forever be quarantined to occasional homages to Andrea Fraser.

Within the larger scheme of things, the rationale of framing contemporary art as one big refugee camp of the mind is to suggest a level playing field that is always negotiable, never universalizing. Anyone who has worked outside Euro-America will have noticed that key working premises inherent to this very publication—critique, creativity, commodification, canonization, post-Fordism, and more—are all shot through with universalizing assumptions. But, when we travel to Palestine, only to find artists who sound like Californians, or even Iranians, we can assume this is due to the malleability of art, not the expansionism of a precise set of middle-class cosmopolitan codes.

For all this planetary expansionism, contemporary art is a major site of the critique of universalism as we currently know it. Some would say it is the very critique of universalism that makes the planetary expansion

possible to begin with. Consider the pious insistence on "local sites," the vernaculars of creolization and *mondialité*, and the healthy sense of critical virtue that serves as an Other to universalism. All of which makes contemporary art one of the most important operators of "existing universality" today. This bewildering bait and switch is facilitated by the fact that the languages of universalism and humanism are already beset with creative misunderstandings and *faux amis* from the very outset. (In much of the American mainstream, for example, "humanist" quite simply means "secular.")[87]

I am not suggesting there are alternatives to the above re- and de-territorializations that would render epistemic violence avoidable on an international stage. There probably are none. As Thomas Keenan has pointed-ed out, at the end of the day, any theoretical premise aspires to a universal condition, regardless. So turning international curating into some tender horticulture of guilt is hardly an alternative. What might be more helpful, by contrast, is an unapologetic sense of territorialization: of more transparently creating the very places we purport to cater to.

87 For example, Jason Torpy, president of the Military Association of Atheists and Freethinkers, argued for introducing "humanist chaplains" in the army, to do everything religious chaplains do, including "aiding" soldiers in "following their personal beliefs." Torpy explains, "Humanism fills the same role for atheists that Christianity does for Christians and Judaism does for Jews. It answers questions of ultimate concern; it directs our values." James Dao, "Atheists Seek Chaplain Role in the Military," *New York Times*, April 27, 2011.

As Matthew Poole suggests in "Specificities of Sited-ness," the working premise of site specificity will always struggle to offer a clear "hypothesis" in and of itself, and will always run the risk of becoming a "prosthetic" instead, a "functional appendage of already existing ideological vectors."[88] Indeed, in my own working experience, the still hegemonic notion of "site," and its implicit demand to do justice to its purported specificity, is rarely conducive to an artist or curator taking clear responsibility for actions undertaken. The breathless, post-Fordist working conditions of contemporary art make it almost impossible to genuinely do justice to the specificities of any given site, which, in turn, leads to indeterminate disclaimers of dialogical goodwill. Only to be disparaged as "political tourism" nonetheless, by frustrated locals and bored internationals alike. "Location," as described in this chapter, is an attempt to transcend the innocence implied by "site." But also to take on more gnarly prospects, such as "cultural tourism," more proactively, and more candidly than is usually the case in contemporary art.

88 Matthew Poole, "Specificities of Sitedness," in *When Site Lost the Plot*, ed. Robin Mackay (Falmouth: Urbanomics, 2015), 89.

Spite
Specificity

Many years ago, Hauser & Wirth hosted a designer "concept store." No art, or even any semi-Warholian apologia in the press release, just the gallery assistants helping you into corduroy outfits. I remember them frowning at my shoes, and commenting on my unnaturally long forearms. Though I duly scowled at the shamelessness of it all, I did mark the occasion with a flannel suit.

At the risk of being accused of "hating art" (it would not be the first time), I would say that very often, the best show is no show at all. At some point or another, most, if not all of us, have caught ourselves relieved to find exhibition doors locked and bolted. Stuck on the sidewalk, rattling the door, cursing the curator, but secretly enjoying a weird sense of deliverance. The following sections address the possibilities of withdrawal, refusal, and negation in contemporary art. They aim for a belletristics of lines in the sand. Among the many shades of "No" that are currently at play in contemporary art; some are playful, some less so. I will

begin by taxonomizing the principle shades that are currently on offer.

To begin with, there is what they call "withdrawal." You complain about the exhaustion, compare yourself to Bartleby, and turn down a commission or two.[89] Eventually, you turn up at an art fair for a panel discussion on "Refusal," and quote Franco "Bifo" Berardi. Given that not everyone can afford a temporary retreat, this kind of *tristesse royale* tends to privilege the already privileged.

Another shade of "No," paradoxically, amounts to the precise art of saying "Yes." Like Abdel Rahman Badawi, who did not show up to accept the 1999 Mubarak Prize for literature, preferring to send his bank details instead.[90] Though you do not "self-deport" exactly, your compliance is jarring enough to jolt expectations.

A blunter shade of "No" is the thud of the slamming door. Good old Ataman comes to mind, or our hero Edward Fry, the curator who was fired for defending that fateful Hans Haacke exhibition at the Guggenheim in 1971. While Haacke's career soared, Fry's took an irreversible nosedive. Luckily, he is still referred to and referenced now and then, most notably by Haacke

89 Again, the said narrative has little to do with Melville. Nor is the "indeterminacy" described in these pages a faithful rendition of Barthesian third meaning or Derridean différance. I am not addressing any original theoretical intentions here but their effective deployment within the existing contemporary art world.
90 Oraib Toukan, "We the Intellectuals: Re-routing Institutional Critique" (lecture presented during the conference "Cultural Production: in dialogue with Palestine, Jordan, and Egypt," Akademie der Bildenden Künste, Nuremberg, June 13, 2013).

himself (the artist begins many a talk by acknowledging a debt to Fry).

Withdrawal-as-artwork can abide by any one of the above. It was arguably Lee Lozano who took her *Dropout Piece* to the most uncompromising conclusion: a brutal one-way burnout, meticulously executed, making itself knowable without allowing for the possibility of capitalizing on that attention. It is that impressive shade of "No" that rises to the challenge of betraying your own class.[91]

For all the stark differences between these shades—from professionalized coquetry to professional suicide—there is common ground to be found. Most of these modes of refusal are expressive, and individually so. They are authored, even anthropomorphic, in that they allow for the fantasy of pure agency to be granted a human face.

This brings me to yet another variation of "No"; the most determined shade of all, if you will, is the "No" of a boycott. It is louder, and more effective, because the figurehead here is depersonalized, to be substituted by collective abstractions. Admittedly, anthropomorphism may be inevitable, to some degree, as people love to look for mouthpieces regardless. But even the most popular boycott delegates are beholden to group decisions. Take Rosa Parks. I always assumed she was just a gutsy Alabaman with sore feet. When in point of fact, her actions were collectively prepared, rehearsed, and orchestrated (a significant element of the protest that

91 See Sarah Lehrer-Graiwer's brilliant *Lee Lozano: Dropout Piece* (London: Afterall Books, 2014).

has very much disappeared from mainstream historical narratives). The very idea of a spontaneous cri de coeur was engineered by means of a deft exercise in group organizing.[92]

Any other kind of mouthpiece can be a liability. The boycott of the Cologne Art Fair in 1971 paid a high price for the bungling Joseph Beuys, who both supported the protesters at the door, and allowed his art to be sold within. Critics had a ball. "Beuys harvested the acclaim of emblematic social action while his dealers used the acclaim to increase the sale of his work at the very fair he was boycotting. Artists without similar influence or a similar dealer network paid a far greater price to support Beuys' initiative than Beuys himself paid."[93]

The individuals who are actually boycotted are equally submitted to criteria that are technical, financial, and geopolitical, which brings me to another distinctive feature of the shade of "No" that is a boycott: it cannot do without a recognizable dose of symbolic violence. "All conversation," Hans-Georg Gadamer suggests, "presupposes that the Other may be right." A boycott replaces this flexibility with something chewier. It opts for strategic essentialism: a victory of form over context, in which an incongruous situation is magically summarized into a seamless narrative, allowing a strange new voice to speak through a miraculously formed body.

92 Alternate ROOTS (presentation, Creative Time Summit "Living as Form," Skirball Center for the Performing Arts, New York University, New York, September 23, 2011).
93 "Prinzip Gerechtigkeit," *Der Spiegel*, September 1971, 155.

Interestingly, rather than a negotiation by other means, boycott tactics are typically dismissed as overzealous cases of sabotage.[94] For every artist who subscribes to some boycott, I can quote dozens, including close friends and allies, who tell me, "silence isn't the answer," "the way out is the way in," "I say yes to everything," and then refer to tempting metaphors of contraband and Deleuzian becoming. Chalking it up to laziness or indifference does not cut it. My colleagues are obsessively hardworking, and their ethical concerns are debated more loudly than in many other fields (sometimes cynically, sometimes not).

My assumption, rather, is that the skepticism toward boycotting is linked to the deep-seated epistemic assumptions discussed in this publication. Boycotts do happen in contemporary art, but they are rarely historicized or theorized as such. Which is why a boycott is typically faced with more emotionalized drama than its usually modest demands would call for. Even Ahmet Ögüt, one of the articulate spokespersons for the 19th Biennale of Sydney protests (2014), shuns the word altogether: "The term 'boycott' implies something different. A boycott is a destructive act that cuts off the opportunity for dialogue."[95]

94 In an e-mail exchange, Ahmet Ögüt later clarified that we should not use the term boycott lest we get stuck in polemics that might then overshadow the political aims themselves.
95 Ahmet Ögüt in conversation with Marisa Mazria, "Editor's Letter – April 2014," *Creative Time Reports*, April 1, 2014, http://creativetimereports.org/2014/04/01/editors-letter-april-2014-ahmet-ogut-biennale-of-sydney.

Boycotts

Boycotts are shockingly common in the arts. I spent 2010–13 in New York, where I watched the pressure build on Sotheby's, and, shortly thereafter, on Frieze. Both organizations had opted for nonunionized labor, and both relented. Another example is the aforementioned Biennale of Sydney boycott, where the withdrawal of biennial participants led to the severing of ties with a major sponsor, Transfield (a contractor for Australia's immigrant detention centers).

Needless to say, not all boycotts culminate in Mandela scenarios. Few remember the 2010 picketing of Tate for its ties to BP, a firm that makes Transfield look like a Paolo Virno reading group. But, whether of the meek or glamorous variety, boycotts have a short shelf life in art-world memory, which, in turn, strengthens their reputation of being nuclear options: very rare and a little barmy. It is the shock value itself that is interesting: the fact that boycotts may well be out there, but are rarely acknowledged. When exactly did lines in the sand gain such an exotic reputation?[96]

96 Lee Lozano's *Boycott* piece, for which the artist stopped speaking to women, was not a boycott at all, but a counterintuitive

The Boycott, Divestment, and Sanctions movement against Israel (BDS) is an equally important reference in that the organizers looked to an artist initiative for their own initial wording, namely the 2001 appeal by Emily Jacir, Anton Sinkewich, and Oz Shelach.[97] The movement is supported by a surprising number of artists internationally, even if only a minority have voiced support in public (especially within the Euro-American circuit). And in contrast to other fields—dance, theater, academia, music, film—Israeli funding still poses little threat to a critical reputation in contemporary art. Take, for example, Creative Time, an organization explicitly dedicated to art and activism, which allowed Independent Curators International to take the exhibition "Living as Form" to several Israeli venues; including Technion – Israel Institute of Technology, which plays a decisive role in developing the military technology of the occupation. The show includes artists who openly subscribe to BDS, and who were reportedly unaware of its itinerary.

In efforts to delegitimize boycotts, they are sometimes framed as restrictions not only on art's indeterminacy, but on free speech tout court. Countering calls

response to the disempowerment of women in the art world at the time. (The piece was never titled *Boycott* by the artist herself.) And yet it is a helpful example. In an underhanded violation of her own guidelines, Lozano reportedly continued to talk to a certain number of women, through which discussions with both genders must have gained not only in awkwardness but also in reflexivity and intellectual charge. See: Lehrer-Graiwer, *Lee Lozano.*

97 See: "Boycott All Israeli Art Iinstitutions [sic], End the Occupation," April 7, 2002, http://oznik.com/petitions/020407.html.

to cancel Manifesta 10 in St. Petersburg (2015), curator Kasper König suggested: "We have to make sure not to censor ourselves. [...] The environment and the possibilities for this exhibition are very rich and it would be a mistake to reduce our possibilities down to the level of just making a particular political statement."[98] Art's indeterminacy dovetails, in this instance, with the classic liberal argument of freedom of speech.

Consider another narrative—subtler than König's—in writer Negar Azimi's response to the turbulent ambiance of 2011.[99] Azimi takes a very wide range of collective efforts, from boycotts of prerevolutionary Iran, to venues like Townhouse Gallery, Cairo, to collectives like Decolonizing Architecture, and contrasts them with examples of more facile, superficial activism. Azimi offers an early-Susan-Sontag-ian warning: "Easy Listening Art in the name of the political leads to the sedation of our aesthetic and critical appetites." Then, taking her cues from Tania Bruguera, Azimi vouches for an "art of uncomfortable knowledge," for "knowing that we actually don't have all the answers," and "an art that refuses to serve as a moral compass." In fact, the boycotts, in-

98 Kasper König, quoted in "Manifesta 10 Will Stay in St Petersburg," Manifesta, March 12, 2014, http://manifesta.org /2014/03/manifesta-10-will-stay-in-st-petersburg/. König has since grown more skeptical, even if his fundamental position remains unchanged, see: Nadia Beard, "Manifesta's Kasper König Says Biennale Has Hit an 'Impasse,'" *Calvert Journal* (June 4, 2014), http://calvertjournal.com/news/show/2633/manifesta-kasper -koenig-biennale-has-hit-impasse.

99 Negar Azimi, "Good Intentions," *frieze*, March 2011, http: //www.frieze.com/issue/article/good-intentions.

stitutions and political collectives commended by Az-imi undeniably embody "answers" and "moral compasses." It is just that our paradigms make that hard to acknowledge.

In sum, when art is unfettered from Russia, moral answers, or boycotteering fanatics, it can speak in more "rich" (König), "critical" (Azimi), or "uncomfortable" (Bruguera) fashion. In a context such as this, the forte of a boycott does not lie in wagging fingers at the Sheikhs, in one more blaze of critical virtue. Rather, it lies in recognizing how art can shape the discourse as a hegemon in its own right. When artists use expectations invested in them against the apparatuses that require their services—whether in Sydney, Jerusalem, or New York—the clout of contemporary art does not impede their agency. On the contrary; it allows for the leverage to unfold in the first place. Take the Guggenheim Abu Dhabi, where you have a museum in need of a collection tout de suite. This allowed a marvelous bargaining chip to be put at the disposal of the Gulf Labor Artist Coalition.

Today, with positions being circulated at the speed of "Like," this is becoming all the more obvious. Even in 2001, Susan Sontag could still accept a prize from Ariel Sharon without too much headache. Few even knew about it.[100] Today the limelight is ubiquitous, and part of what lends you said leverage. With a renewed emphasis on the body and voice of the artist, as opposed to material displayed in publications or shows.

100 Toukan, "We the Intellectuals."

To be sure, the content is never eclipsed. It will always hold an agency of its own, and any mouthpiece will need a convincing body of work to fall back on, somewhere along the line. But, the discursive positionings, or the refusals to board the airplane, or to FedEx the work, have gained traction in a manner that goes a long way to explain the heady tenor of this book.[101] This brings me to the common tactical denominator all above examples share: namely, the fact that for all the sound and the fury, they are hardly all that radical.

Let us take the example of BDS raising its grisly head at the 31st Bienal de São Paulo (2014). When the existence of Israeli funding became apparent—the money stemmed from a PR attempt to whitewash the most recent massacres in Gaza—the resulting protests were surprisingly beefy. The vast majority of artists signed up for a withdrawal from the show, unless the money was returned. (It actually amounted to a meager sum of some 10,000 USD.) Some took considerable risks to their careers, even exposing themselves to threats of litigation, on account of expensive commissions being canceled. At the eleventh hour, the biennial foundation struck a compromise with the curators and artists, in that the cash flow was not returned but redefined. Instead of just another case of cultural sponsorship at large, the funding was repackaged as a purely national

101 A development that echoes, in a roundabout manner, the aforementioned Palestinian effort to transcend testimony in favor of more structural, embodied strategies—see also Really-ism in the concluding chapter.

subsidy, going strictly into the pockets of those Israeli artists who accepted it.

This did not go down well in some circles. "A Christian solution!" one artist quipped, back in Palestine. All the muck was channeled into the bodies of a select few, washing the rest clean of their mortal sins. Meanwhile, Israel continues to flaunt its civilizing mission as promoter of the arts. Similar accusations, of "Christianic" pragmatism, were raised in the wake of the 19th Biennale of Sydney protests. In the heat of the moment, immigration activists saw an opportunity for a clear stand beyond Transfield and its role in the biennial. Their suggestion was to picket the hell out of the exhibition, shut it down if necessary, and push for a national debate. Most of the artists, by contrast, were focused on removing any connection between the firm and the show, no more no less. So, when the Transfield chairperson stepped down from the board, the biennial went on as planned, even if the policies which the company facilitated all continued unabated, and still do to this day.

For better or for worse, the strength of all the examples in this section lies in a realpolitik that hopes to eventually spark a domino effect further down the line. BDS itself relies heavily on a language of United Nations resolutions, and stops shy of the economic redistribution a more controversial approach would imply. From a militant perspective, this may sound pathetic. From the perspective of contemporary art, where conservatism is dissimulated by the fireworks of formalized radicality, the oomph of all these protests lies in mod-

est demands, along clear criteria. It is the exactitude of most boycotts, their reformist modesty, that sits uneasily with the constitutive indeterminacy of our field.

The very subject position interpellated here is very different to the one created more generally in a latter-day art setting. Art is keen to flatter its audience, as a creative partner and critical citizen, along the lines of the epistemic selfie described in the introductory chapter. A boycott, meanwhile, not only forces the viewer into a position; very often, it dares to suggest that the audience is part of the problem. In order to be part of a solution, said audience will need to invest a modicum of effort, of some kind or other.

At times, the initiatives in question are more ambitious, in that they subscribe to a good measure of intersectionality. The Gulf Labor Artist Coalition is an alliance between artists and other pressure groups, including a parallel initiative tackling NYU Abu Dhabi. The resulting cross-references to broader political economy debates have lent them sway. But even here, the point of departure remains the crux of the matter, and that point of departure is simple, concise, and consensual above all else. "Please stop treating construction workers like serfs." (Or, "Please stop building racist detention camps.")

Given the field's preference for subtlety as a principle, the "complexity" argument is regularly invoked to dismantle the rationale of any given boycott. Nerds like me, who squirm at the idea of collective action, are recognizable by long lists of subtle complications we passionately insist on. "Why boycott Abu Dhabi and not

Manhattan? Why Israel and not Russia? And what about the kids who built your MacBook?" Such is the sound of the "radical perhaps," which often succeeds in ensuring that any political momentum, if it ever gets off the ground to begin with, is short-lived. Even the canonical Art Workers' Coalition (AWC) subsisted for only two years, from 1969 to 1971, before succumbing to the entropy of wildly conflicting agendas.

The W.A.G.E. collective is a more heartening example. "Capitalist Pigs" is the preferred self-epithet here, and the scope is shamelessly myopic. ("Artist fees, please.") As items on the budget sheet, artist wages could slowly lead to decisive decelerations, to smaller shows and/or fewer of them, which may have far-reaching implications in turn. But for now, the only way beyond the comfort zone of utopianist subtlety is that of unidimensional criteria, which may or may not lead to a long-term domino effect.

It is easy to underestimate the potential of the domino and the snowball. What if the São Paulo "dramarama" sets new anti-Zionist standards? What if the Gulf Labor thing were not to spread outward, to ever more far-flung museums, but boomerang right back to labor conditions in New York City? And what if the Sydney initiative has consequences beyond sponsorship: the fallout has been brutal—at the time of writing, Australian government officials plan to retaliate by withholding public funding—but a biennial would already have an impact simply by virtue of scaling down and revisiting the galacticism of its format. A modestly worded point of departure has more explosive

prospects than the plausible deniability described ear-
lier in this chapter. It can result in a slippery slope that
may genuinely lead in any direction whatsoever. If un-
predictability is what you are after, it does not get much
better than this.

ELITE FORMATION:
TWO
TAKES

Contemporary art is a surprisingly tangible location not only in terms of a moral economy, a global infrastructure, and a network of physical environments. It also constitutes a class. Or, better said, it forms a seamless unity with the interests and inclinations of the cosmopolitan middle classes. On the one hand, our moral economy replicates the ideological prerequisites this relatively privileged social stratum necessitates. On the other hand, the socioeconomic stratification that still blocks or enables many an arts career deeply relies on vast streams of ultracheap labor. Most entryways into the contemporary art field initially lead through a rocky terrain that lies well below the poverty line. This is why art is heavily dependent on an entry-level labor force with middle-class family support. On financially stable

parents subsidizing students and interns, gallerinas and emergent artists, as well as independent art writers and assistant faculty, too.

Our dependency on a privately subsidized *Lumpenprekariat* is not some passing crisis. Take Richard Florida's seminal *The Rise of the Creative Class*, a manifesto that boils down to Florida's insistence that creative workers, having reached a third of the overall workforce, should at last come to call themselves a class. The bourgeoisie overthrew the aristocracy, proletarians unionized to raise living standards, and the creative class now needs to define its priorities in turn. The forte, or historical mission, of this creative constituency, is to bestow quality of life upon its own neighborhoods and cities. For this quality to emerge, a quantitative tipping point of high creative density is necessary. Florida repeatedly admits that cities with the required measure of creative density can produce high income inequalities; creative labor, after all, is no less dependent on poorly paid service work than other sectors. The necessary remedy, he somewhat hazily argues, is to either render monotonous service work an anomaly through automation, or to render it more creative in turn.[102] In

102 Richard Florida, *The Rise of the Creative Class* (New York: Basic Books, 2002), 323–25. Florida now also concedes that the wealth that does accumulate in such creative clusters does not trickle down to wider parts of the population, see: Richard Florida, "More Losers Than Winners in America's New Economic Geography," *CityLab*, January 30, 2013, http://www.citylab.com/work/2013/01/more-losers-winners-americas-new-economic-geography/4465/.

other words, as things presently stand, the inequality comes with the landscape.

Job markets aside, in the United Kingdom and the United States, much of the recent discussion around inequality in the arts tends to focus on the crippling effects of student debt. The debt burden is indeed a prime ingredient in securing art's role in elite formation, and in making the field even more of a classist biotope than before. And yet, at the same time, this section of the book raises the question of whether contemporary art would be any more egalitarian if constraints such as debt and low wages were tackled, while the prevailing moral economy remained fundamentally in place. What are the ideological presuppositions that facilitate and consolidate monetary factors, and that structure the hierarchies at play?

A Middle-Class Sense of Entitlement (Beverley Skeggs)

Class is hard to broach in the art world. When it comes to elephants in the room, this one takes the ticket. A big leathery creature, primly concealed by a paravent of

gender, queer, ethnic, and nationality issues. On the rare occasions class is mentioned in the arts—the YBAs as metonym of the rough and tumble, or Roger M. Buergel's dismissive use of "petty bourgeois"—you rarely get far. As a conversation piece, it is a true icemaker. Class does not offer escape hatches of any kind: if you are middle class, as I am, you are dull; if you are upper class, you are a nepotist; and, if you are working class, you embarrass anyone who is not. But no discussion of art's "location" would be complete without addressing class hierarchies. The indeterminacy narrative frames them as regrettable matters extrinsic to art itself, along with the Sheikhs, the glossy magazines, the art fairs, and the admissions committees, all of whom are to blame for the VIP thing. The challenge, here as elsewhere, is to offer an idea of art that does not defy the hierarchies as it travels, but that travels as part of them.

The harder it is to talk class, the more we talk exclusion/inclusion, which allows us to bond in a flutter of win-win conflict resolutions. Exclusion as the "Bad Object," reminiscent of the elitism of modern art, and its disciplinary expertise, inclusion as the contemporary, progressive variation, a case of finding one's way through life by observing, listening, and critically self-reflecting, discovering a Self only inasmuch as you are looking to the Other. Needless to say, even the latter temperament is riddled with class-based assumptions. Indeed, as nearly any sociologist would point out, a more textbook take on how class is formed through disposition and knowledge might be hard to find. In other words, the inclusionary stumbling is a particular

form of elite formation in itself. A point that is made compellingly well in sociologist Beverley Skeggs's *Class, Self, Culture.* This is where Skeggs analyzes "middle-class entitlements" as observed in Liverpool club culture during the late 1990s and early 2000s, and the parallels to the arts are well worth mentioning.

Skeggs begins with what is by now a stereotypical notion of bourgeois omnivorousness; the ability to move from one register to the next—from opera to hip-hop to samba to John Cage and back—thereby demonstrating an ambidextrous sense of taste and entitlement. She then contrasts this model with what she terms the "prosthetic" variation: a slightly more reflexive approach to aesthetic and intellectual appropriation, insisting on the very performativity of de- and reassemblage—one that actually highlights the pain of intercultural encounters.[103] Whether in terms of awkward language barriers, cultural faux pas, or even the guilt of a colonial past: as the name indicates, the prosthetic approach emphasizes the seams in the opera/samba/hip-hop narrative, the artificiality of the appendix (even if this artificiality can breed a new type of quasi-naturalness over time).

The prosthetic temperament, I would argue, is without a doubt the prevailing cosmopolitan style within contemporary art. The more difficult the encounter, the more convincing, genuine, and heroic the outcome. If "omnivorousness" predictably dissimulates difference, the prosthetic model is more maverick, more mischievous, in that it can even create new differences as it

103 Beverley Skeggs, *Class, Self, Culture* (London: Routledge, 2003), 138–40.

goes along. In some cases, it might go so far as to make the accumulated knowledge surplus difficult to share. Hence the recent fascination with irony, the most exclusive of tropes, or with all things subcultural, even when they are, in essence, tediously middle class. Take documenta II (2002), where a Thomas Hirschhorn project (*Bataille Monument*) in a perfectly boring Turkish-German suburb was widely pitched as a daring adventure in an ethnic ghetto. It is telling that in its European reception, the project tenaciously served as an emblem of documenta 11 as a whole.

When moving internationally within contemporary art, you are indeed well advised to insist on the prosthetic difficulties of the cosmopolitan encounter. The clash between "local" audiences and "international" ones, the pitfalls of the English language as lingua franca, the colonial conceit of art-as-European-invention. Class, for its part, is best discussed as one of these many prosthetic challenges that "need to be acknowledged," somewhere along the line, but not as a structural factor that facilitated your research trip to begin with.

Less Access Is More Access
(Hans Abbing)

In *Why Are Artists Poor?*, another sociologist, Hans Abbing, raises the issue of structural poverty in the comparatively cushy and subsidized artscape of the Netherlands, between the late 1990s and the early 2000s.[104] If they were poor here, you wonder, where on earth would they not be? Over the course of the publication, Abbing spells out the rationale of the pyramidal shape that comprises our field: without a good percentage of losers, there would be no geniuses to celebrate. It is a rationale that perfectly mirrors Florida's structural argument mentioned above.

In an almost concomitant publication, artist Gregory Sholette confirms Abbing's point; the labor market glut, far from a temporary problem, has become a constitutive element of art as we know it. In 2004, the European Union listed more artists than the working populations of Ireland and Greece combined (5.8 million), while for the 2005 United States census, two

104 Hans Abbing, *Why Are Artists Poor?* (Amsterdam: Amsterdam University Press, 2002).

million Americans listed "artist" as their main profession, more than there are members of the military.[105] There is a fascinating difference, however, in terms of how Abbing and Sholette evaluate the data.

Sholette lays the blame for the pyramid on "the predetermined eye," that only sees what stands out in relief amidst a "vast flat field," and regrets that the "amateur" and the "failed artist" remain invisible to this institutional gaze.[106] The stratification, in other words, is due to a myopic, conservative, restrictive definition of what quality can be. This is arguably true in that contemporary art is far less indeterminate than it purports to be. But, Sholette's contention with the "predetermined" experts ultimately suggests that selection can somehow be avoided. Thereby encouraging artists—all of whom are "predetermined experts" in their own right, after all—to underestimate their proper contribution to the problem. Abbing's proposal, by contrast, is to theorize, formalize, and improve our selection processes, without apology.

Abbing contrasts today's glut to a period preceding Romanticism, when a regulated pool of specialists ran the show. Up until the nineteenth century, Dutch painters made a higher profit per painting than today's artists on average, and even enjoyed higher primary prices than those on the secondary market. Gradually, however, the cult of bohemia made regulations difficult

105 Gregory Sholette, *Dark Matter: Art & Politics in the Age of Enterprise Culture* (London: Pluto Press, 2011), 126.
106 Ibid., 3.

to impose; even as it made the arts more attractive and more sacral.

Today, the arts are one of the few professions that do not regulate their memberships—at least not transparently or formally. The tenacity of the resulting glut, and the poverty it generates, can be explained by way of a confluence of three present-day factors. First, the traditional notion that the value of art transcends monetization as a "public good" is still prevalent (even if it is not entirely ubiquitous). Second, the creative imperatives of post-Fordism, the latest update of the bohemian premise, are gaining ever more ground, and allow art to emerge as a sophisticated, glamorized survival strategy. And finally, the star factor—the proportionately high visibility of the very few success stories out there—serves to propagate factors one and two in various ways, further calcifying norms and expectations alike. In the Netherlands, these three selling points were further enhanced by the preconception that "the government takes care of artists."

However, even in the Dutch land of milk and honey, only 8 percent of all artists focused solely on their art, and actually covered all living expenses through it. The vast majority tapped into just enough financial support, or worked just enough hours, to allow the pursuit of an artist vocation, while still remaining below the poverty line. As long as it could be contained and controlled, financial hardship remained an acceptable price to pay. As Abbing puts it, "You have to be able to afford to be

poor."[107] By means of access to resources (private or public) that subsidize your artist income, and/or, at the very least, by way of the cultural capital, the *certitudo sui*, and social network that come with a well-heeled background.[108] All of which makes the argument of "art as a public good" doubly problematic. If taxpayers subsidize what is produced by the (upper) middle classes, then income is distributed in an even less fair direction than it already is. The already educated become even more so, and inequality increases.[109]

Most of Abbing's proposals boil down to the regulation of access. To begin with, the hype around art schools cannot continue without further enhancing the glut. In order to manage its scope, a restriction of access, of student numbers and programs, is a prerequisite. To be clear, any such access restrictions would ultimately result in a complex and painful process of shrinkage. Less unpaid labor and less servile virtuosity, to be sure, but also fewer projects, and less work to go around. Which is why Abbing equally insists on artists considering themselves integral parts of a larger specialized labor

107 Hans Abbing, "Why Are Artists Poor?" (lecture, Tohoku University of Art and Design, Yamagata, Tokyo University of the Arts, and the National Museum of Art, Osaka, 2009), quote taken from the transcript, available at: http://www.hansabbing.nl /DOCeconomist/Why%20are%20Artists%20Poor%20Japan%20lecture%20091021.pdf.

108 The number of students with parents with university degrees was 40 percent higher in the arts than among the national student body as a whole.

109 Abbing, *Why Are Artists Poor?*, 212, 225.

force, with their remuneration calibrated accordingly.[110] Government welfare measures should be pitched wholesale, to working constituencies in the cultural industries across the board, and not to artists as a distinct subcategory.

Ideally, the standardization would go beyond the creative sector, along the lines of the "Universal Basic Income" model (also known as "Guaranteed Revenue" or "Citizen's Salary"), an international initiative cutting across party-political factions, which aims for a guaranteed, equal stipend for every citizen, regardless of means testing or any other qualifications. The model is premised on the assumption that removing criteria for welfare eligibility—and the administrative efforts of monitoring them—would free up enough resources to allow all citizens to rely on steady government support, with no strings attached.

It always struck me as odd that among the most passionate advocates of the Basic Income premise, you would find, of all people, accelerationists.[111] After all, standardized minimal revenue—like other proposals made by Abbing—would have a severely decelerating effect on our working lives. It would render completely unnecessary, perhaps even unthinkable, the velocity that art is currently subject to. In fact, the prevailing art-world speeds are both symptom and cause of the way

110 The W.A.G.E. collective, which cites Abbing as a key reference, pushes for calibrating artist fees as part of a broader calculation including administrators, technicians, art handlers, and others.
111 See: Nick Srnicek and Alex Williams, *Inventing the Future: Postcapitalism and a World without Work* (London: Verso, 2015).

we define ourselves professionally. Whether in terms of the countless projects we Kickstart, the topics we zap, the agendas we cater to, or the airline bonus miles we accumulate.[112] The allure of "access undeniable," on all levels, amounts to a lifestyle that has everyone short of breath. And it is impossible to engage in cognitive mapping, let alone structural overhaul, when you are constantly on the move, project to project, audience to audience—and neighborhood to neighborhood, as rents rise and government support is hollowed out to the benefit of speculative private investment.[113] All ways in which our actions become mere preludes to ever more preludes in turn.

112 People like to object that not everyone is privileged enough to be privy to this kind of pressure. But, even the under-occupied tend to envision the very same best-case scenarios, and will strive to busy themselves accordingly.

113 As David Harvey and others have argued, the precarious-ness as described here is superstructural and systemic in character. Urban regeneration has its roots in patterns of capital investment that hollows out civic statehood, forcing even the members of precarious classes to invest in property to ensure a measure of financial stability, thereby aiding and abetting the mechanism that led to a government shortfall to begin with. See, for example: "Section 1: The Right to the City," in David Harvey, *Rebel Cities: From the Right to the City to the Urban Revolution* (London: Verso, 2012).

BODIES IN SPACE: PLOTTING THE **EXHIBITION** EXPERIENCE

"Why is this an exhibition? It should have been a book." What the accusation usually means is that the whole thing is too top-heavy, with wall texts as wordy as Tolstoy, and so on. The latter is quite prevalent. It is funny how many curators firmly believe that standing upright, in the foyer of a white cube, is a great place to read an essay. Having touched upon art as a political, ideological, economic, and institutional location, this part of the book addresses the physical exhibition space as a location in its own right.

How to develop a stronger sense of moving bodies through exhibition space? The pace, the gait, the wear of leg muscles moving, the strain on the shoulders as the neck is craned. The suspense as you turn a corner. The mnemonics that result. How can this amount to more than the succession of room after room, to preambles to ever more preambles in turn. To what Hegel would have called "bad infinity": one plus one plus one plus one, with no antithetical denouement in sight.

Once again, our biennials, triennials, and quintennials are where possibilities are most dramatically overlooked. Of course, there are XL shows with more architectural sensibility than others. But, the typically tight deadlines, and the resulting lack of familiarity with the physical premises, will have curators reliably subdividing the number of works by the number of square meters, with a good bit of tweaking here and there, according to formal necessity, maybe also according to the artist's ego. Even something as evocative and unforgettable as the onetime Jewish Girls School in Mitte, Berlin, for example, was reduced to a choo-choo-train sequence of room after room.

In some ways, such near-successes are the most telling. Documenta 13 (2012), for example, impressed with its use of the city park. Who would have guessed that the famously ugly Kassel would possess such a shining jewel, hidden right there in plain view, only minutes from the usual exhibition venues. Carolyn Christov-Bakargiev's outdoor trajectory, from artwork to artwork, was a cartography of custom-built chalets, shrubby patches, and rough clearings within which art

was de- and/or recontextualized. This produced moments that were riveting, to be sure; the contributions from Omer Fast, Pierre Huyghe, and Akram Zaatari among them. But, by and large, for all its jarring qualities, the foray could not shake the impression of an interminable Easter egg hunt.

Given the formidable choice of artists, this is odd, and makes sense only in light of the sheer scale of the overall operation, the marathonian overload of your standard mega-exhibition mapped onto the public Staatspark. The XL proportions resulted in an effort to calibrate artworks according to XL space—to cover a given plot of public parkland—instead of following some inner necessity. With the artistic director following a peripatetic sightseeing imperative, instead of owning, shaping, claiming, and emplotting the place as her own. Add to this the unrelenting indeterminacy of the documenta 13 premise, and every artistic contribution became another stepping stone to the next stepping stone, rather than a location in its own right.

The chapters preceding this one might seem at odds with such matters, yet it all needs to be seen as one and the same clusterfuck. The www notwithstanding, moving bodies through space remains a good part of what we do. If I am invested in pinpointing the chief responsibilities of contemporary art practitioners, then I need to theorize these movements through space in light of—not alongside—all other queries, and vice versa. It would be absurd to suggest that the codex of indeterminacy were somehow divorced from the material setting of a soft power exercise such as an art show.

To begin with, there are few concepts that summarize the soft power play of an exhibitionary context as helpfully as "plot." In theorist Benedict Singleton's essay "The Long Con," the term's history is traced over the course of the Renaissance, from a piece of land to the speculative planning of the future of a piece of land. And then on to its dramaturgical usage in theater, long considered an example of the "mechanical arts" first and foremost: a "practical geometry" relying on a bewildering array of ropes, pulleys, hoists, and other mechanical contraptions.[114] The theatrical plot, in other words, was a matter of moving and arranging people and props across a space, over a given time frame. A play was something to be "emplotted." And a play is also, of course, where people pretend to be something they are not: where they are, in other words, plotting. A piece of land, an exercise in conspiracy and manipulation, a practical geometry, and a storyline are all key ingredients of the future-oriented operation that is a show.

Singleton's proposals are especially intriguing in that, by and large, our possibilities of moving bodies through space are as perplexing as they are undertheorized. The bibliographic choices at hand are a rich history of phenomenological studies, on the one hand, and an equally rich history of exhibition sociologies, on the other. To build, or emplot, a bridge between the two, let alone translating either into concrete measures, is no easy feat. After all, to contemplate the intricacies of physical movement is to move beyond the comfort zone

114 Benedict Singleton, "The Long Con," in Mackay, *When Site Lost the Plot*, 107–9.

of language. Walking and moving—especially amidst the kaleidoscopic, shifting targets of an exhibition—include things that reading and writing can never account for. Language just gets in the way. Noisily imposing its own priorities long before the first site visit.

One is reminded of Maurice Merleau-Ponty's celebrated points on dance, in *The Phenomenology of Perception*. It is pointless, he argues, to memorize the formula of a dance move; it is the body which first needs to "catch" and "comprehend" the movement. In order to "get" this movement, you need to carry it out, and vice versa: you carry it out according to a significance that needs to be comprehended independently of formulae.[115] I am not a great dancer, and, surely enough, there are few instances in my practice where space is accounted for as a process, along the ambitious lines spelled out in this section. To make things worse, my *déformations professionnelles* as a novelist and essayist have made me all too partial to words and sentences. In short, this chapter is where the logocentrism of my book will be at its most obvious.

This is why the chapter consists strictly of five to-do notes to myself—five ways to rise to my grand "locational" ambitions more assertively—and two working examples. The latter are the only halfway convincing curatorial emplotments I have to show for myself; "It's Not You, It's Me" (2009) and "Monogamy" (2013).

115 Maurice Merleau-Ponty, *The Phenomenology of Perception* (London: Routledge, 2002), 165.

Note 1: Solo Solo
(A Moratorium on Thematic
Group Shows)

You would be forgiven for thinking that thematic exhibitions speak louder than words. After all, they suggest a heliocentric logic of artworks rotating around some curatorial leitmotif or other, this being the reason they were selected in the first place. In fact, the themes are often barely voiced. A group show typically abides by a para-conceptual line of reasoning; what feels, tastes, and smells like an intellectual wager is bereft of the falsifiability, the possibility of disagreement that comes with a hypothesis. Instead, the curator asks a question the artworks are not expected to answer, while the artworks ask questions that are eclipsed by the curator's. So, any rigorous scrutiny of the art on its own terms is just as rare as rigorous scrutiny of the theme itself. Thus thematic group shows have long been the format of choice among curators and their students. The art may be stacked to the ceiling, the artists may be pitted against one another, and the audience may be sledge-hammered with content, but the curator is all smiles.

When curators account for the morass of discourses and
disclaimers, artists and artworks, vitrines and videos,
you will hear them claim it is a good thing "no one sees
everything." The excess, supposedly, allows visitors to
make "active choices." It offers them "the last word."
And if you can choose your own adventure, that means
there is something for everyone. Unfortunately, there
is little evidence to support the idea that guesswork
and intuition lead anywhere beyond the most conser-
vative of readings. Time and again, the temptation to
confirm what you know already, as you grope your way
around a darkened Kunsthalle, proves too strong for
the audience to resist.

Then again, this is precisely where the surrepti-
tious power of the format lies, in all its oscillating con-
tours. Given our widespread sense of habitual distrust,
it is the blurry image we prefer to believe in. The more
an image points to its own impossibilities, the more we
trust it. This instinctive dismissal of mimesis reaches
all the way back to Plato. As argued compellingly by
artist Amanda Beech, this grand tradition still informs
a prevailing contemporary preference for images that
point to their own shackles, or even morosely celebrate
them.[116] So if the image we trust is the one that parades
its own contradictions, surely the kaleidoscopic criti-
cality of a thematic show harbors the most powerful
reality effect of all. (The resulting, unbounded sense of
knowledge-as-atmosphere is becoming increasingly
dicey as art partakes in world politics at large.) When

116 Beech, "Last Rights."

categories do appear, with coherence and clarity, disclaimers take the stage. The term "Middle East" does not represent the Middle East. The "documentaries" do not document. The "abstract photography" does not really cover abstract photography per se. And always remember that artists are not historians, nor scientists, nor journalists, nor activists. In fact they question the boundaries between all those things.

In order to stop complaining, and refer to a comparatively successful example, I would like to mention Marion von Osten's "Be Creative!" (2002–3) commissioned by the Museum für Gestaltung Zürich. The show was a concerted group effort to come to grips with the "creative imperative" of a post-Fordist economy (as described in chapter 4). There are several factors that set "Be Creative!" apart from your customary group show.

First of all, there was the ambitious layout and exhibition design. It is true that many group shows use thematic subsets to coordinate the spatial ensemble. After all, no matter how underdetermined, a theme always offers the potential of a narrative logic, a choreographic plotline. Rarely, however, is this opportunity used for anything beyond maximizing the para-conceptual leeway (anything to avoid the feel of that oft-quoted "straitjacket"[117]). The latter is pursued by spatially oscillating between two antithetical poles, either in terms of the last room overtly undermining the first, or in terms of artworks reduced to stepping stones to one another—each one "in dialogue" with its neighbor. By contrast, "Be

117 Like "overexplaining," "straitjacketing" is another curatorial bogeyman I have yet to encounter in the flesh.

Creative!" was invested in a scenographic punch that did not undermine the overall plot but worked to ram it home as loudly as possible. The show was not installed in an exhibition space, but deep in the bowels of the design department of the Zurich University of the Arts—a rather charged locus within the *Grafik* bastion that is Zurich. The resulting setup was as instructively polemical as it was evocatively, exquisitely weird. Its complexity was also the result of daily negotiations with the exhibition designers, who were preordained by the school.

The didactics, in other words, did not impede so much as enhance the somatic potentials of the project. And they amounted to an argument that was falsifiable, polemical, and historically situated. Reaching back, on the one hand, to the advent of cultural studies, the work of fashion scholar Angela McRobbie in particular, and effectively laying the ground, on the other hand, for ideas proposed by *Le nouvel esprit du capitalisme*, the game-changing publication by Luc Boltanski and Ève Chiapello, which was shortly to make its uproarious entrance into the art world.[118] The upshot was a pedagogical introduction to the role of art within the creative economy. Basic introductions of the kind are no exception here. In the best of cases, the contribution of a group show to any given debate is precisely that of a layperson's initiation, however partial, fuzzy, or kaleidoscopic. Whether the issue is Marx, forensics, or the idea of Europe, what your standard thematic exhibition

118 Luc Boltanski and Ève Chiapello, *Le nouvel esprit du capitalisme* (Paris: Gallimard, 1999).

offers is a refined form of vulgarization (even when it is a little antiquated and behind the curve). (Speak to anyone who has spent decades dealing with *Capital, Volume III*, Euro-phobia, or Mengele's skull and notice their tired amusement as the art world picks up an issue and runs with it.) I am forever grateful for basic intros to the Anthropocene, or abstract photography, say, just as I am to be thanked for introducing others to Ethnic Marketing 101.

For most of her curatorial itinerary, Osten has abided by the "project exhibition" model, which is typically a collective query unfolding over many years, and in multiple transversal arenas. The benefits—in terms of rigor and positioning, but also in terms of decelerating the overall production process—are obvious. That said, the model can prove frustrating in that it creates a radical discrepancy between the project and the audience, or the backstage and the stage itself. For the participants, pursuing these multifarious, long-term investigations is an incomparably rich and inspiring experience. Unfortunately, it is an experience that is impossible to convey very well to a public, at least by means of the fuzzy format of the thematic group show. At worst, the audience of a project exhibition remains subject to pretty much the very same indeterminate onslaught as your average biennial crowd.[119]

119 To name an example of my own, "Lapdogs of the Bourgeoisie" (2005–9), a five-year collaboration with curator Nav Haq investigating class structures of the art world, was an unforgettable experience for us as a team, in more ways than one, but for all its strengths, from the viewers' perspective, it was very much an-

As "Be Creative!" demonstrated, there are always exceptions. But to really avoid the pitfalls described here, you are better off going monogamous. When all is said and done, a solo show requires curators and their institutions to stick their necks out in ways a group show never will. Multiple participants always offer a good deal of leeway, while a single artist highlights the fact that a selection process is inevitably an arbitrary, ideological one. The smaller the number of artists, the more vulnerable the curator.

Note 2: Period Rooms
on Mute

Let us go back to the aforementioned curatorial straitjacket, for a moment. If institutions will forever be accused of "instrumentalizing" art, regardless, why not make a virtue out of necessity? A decent straightjacket might suit the work better than all the loose hippy tie-dye (not to mention the Fendi fox fur). Compare earlier moments from the exhibition history canon, such as Frederick Kiesler's conceptions of "endless movement" and "elastic space," hallmarks of a bullish approach that

—— other case of *tout qui tremble et rien qui bouge* (all trembles and nothing moves).

defines humans as "condensations of forces"; forces that could and should be manipulated "biotechnically" by the spaces around us. Weird, indeed, but ambitious. In Bauhaus shows, meanwhile, the didacticism was even more famously sweeping, and even more bullish. At some point, however, in that murderous era of art-as-propaganda, the tone began to sound creepy. So the didactics were soon mitigated by something more gentle.

Among these jarring, inspiring examples, I would also include the schoolteacherly violence of the period room. A show always spatializes time, but a period-as-room actually overstates and overdetermines it, to the hilt. Whether in a museum or in situ, the *Guckkasten* dioramas are stages for pedantic, unrepentant expertise. If a tour features a period room, notice how designated tour guides love to point out details too subtle to be spotted by the untrained eye. "See that footstool? Now that's a problem. Why is it a problem? Ah, because it was manufactured a century *after* the other objects in the room. Note the bobbin lace embroidery patterns ..."

The first period rooms started popping up two centuries ago, and in terms of their curatorial currency, the apex was arguably the early twentieth century, only moments preceding that brawny generation of Bauhaus and Kiesler.[120] This was when museum pedagogy was linked to a matter of individual contemplation, which in turn made the quiet intimacy of a period room ap-

120 1869 is when the South Kensington Museum acquired the components of a suite from the Parisian Hotel Serilly, originally built in 1778. In terms of sheer quantity, meanwhile, the heyday may well have been the 1920s.

pealing. In 1904, the Kaiser Friedrich (now Bode) Museum reconstructed the living rooms of banker collectors, to use them as exhibition settings.

Today, despite occasional successes, such as artist Fred Wilson's *Mining the Museum*, a 1992 intervention at the Maryland Historical Society, the period-as-room is considered a bit of an embarrassment. "Realism" is now widely considered a question of style, first and foremost, and the stylized realism of a period room is just too full of bluster. "Look at me! I am the glory days of Paris!" Trying too hard to convince too many audiences, with too many different period eyes. After all, even the question of detail—whether something looks cluttered, didactic, or just right—is itself a question of period dispositions. The period room, in other words, is an artistic red flag. The very opposite of the reality effect that comes with a thematic exhibition, in all that soothing fuzziness.

This is also due to the complete and utter reliance on props. Props are too simply didactic to be art. Beset, as they are, with what Andrea Phillips has termed a "weak objecthood." If contemporary art is supposed to stand up itself, beyond explanatory crutches, props are there for a clear-cut purpose that needs speaking for.[121] And the resulting script is anything but indeterminate. If anything, it is pedantic, factual, naively positivist. In

121 Andrea Phillips, "Prop-Objects" (lecture at the conference "Props, Events, Encounters: The Performance of New Sculpture," presented by The Showroom at the Rochelle School, Arnold Circus, London, May 26, 2007).

this manner, a period room is not only a setup that enables a speaker, it proactively predefines one.

As a matter of fact, the prop's narrative is so scripted, it does not really matter who is voicing it. So perhaps this ventriloquism can even unfold without anyone "speaking" in the literal sense of the term. To put it in broader terms, the question is whether speaking for and through an object must occur qua language necessarily.

As far as the mainstream imaginary goes, the nonplus-ultra period room must be the finale to Stanley Kubrick's *2001: A Space Odyssey* (1964). An astronaut is abducted by higher life forms, hurtled through time and space, and ends up in a Louis XVI boudoir. Where else.[122] A boudoir that has been defined by film critics as the astronaut's fantasy of a regal deathbed, a prototypical hotel suite, an extraterrestrial observation room, or an echo chamber of primal memories. Maybe we should aspire for a grim medley of all these interpretations: a space of opulence, fantasy, objectification, primal recall, reeducation, and de- and reterritorialization alike. The ultimate period room as the ultimate plot, primed for the final reskilling of human life as we know it. *2001*, after all, is a story of indoctrination. People are dominated, controlled, made to look small by institu-

122 As for "the period" of period rooms: the eighteenth century is certainly the stereotypical motif. A hyper-emblematic era when opulent design, political brutality, and intellectual achievement went hand in hand. Perhaps the subliminal attraction of that time lies not in the crazy footstools, but in a zeitgeist we recognize as our own.

tional environments. "The house, the room, the office will win," as critic Stephen Mamber puts it.[123]

2001 succeeds in telling its long and complicated tale of indoctrination with almost no help from language. Using precious little spoken word, *2001* resorts to mainly period scenography, sound and image, metaphor and suggestion. Out of 139 minutes of film, only 39 feature dialogue. If a period room can pull it off, surely anything can? It is striking that even Kiesler and Bauhaus relied only sporadically on written language to get their propagandistic points across. You could describe this book as an attempt to understand whether a given object can be determined and overdetermined in excessive clarity, without forfeiting its qualities as contemporary art. While this chapter in particular is an attempt to understand whether given objects can be determined and overdetermined solely by means of emplotment, space, light, pacing, architecture, muscle memory, or the institution as medium.

123 Stephen Mamber, "Kubrick in Space," in *2001: A Space Odyssey – New Essays*, ed. Robert Kolker (New York: Oxford University Press, 2006), 55–68.

Note 3:
Territorialization

Allow me to move from period rooms to theater. Not necessarily a big step, if we consider the tendency to "speak" through props, and resort to speech only as one of many possible methods of emplotment. The Volksbühne, Berlin, specifically, has long been at the center of pioneering dramaturgy. Though drawing on a broad, Brechtian heritage of "audience activation," it also exemplifies a tradition of German *Regietheater* (directorial theater). Which is where the respect for the playwright is sacrificed wholesale, along with the idea of gripping storytelling, or convincing actors, to the benefit of post-dramatic strategies that are kinetic, somatic, chromatic, sonic, architectural, and discursive in character. Plot-as-storyline is submerged among the speculative, political, and spatial definitions of emplotment-at-large.

To a large extent, the success of this ambitious endeavor rests on a tradition of teams working together over many years, sometimes decades, developing collectively and patiently within a given venue something that is not on offer anywhere else within the field. This

admirable sense of purpose is rendered increasingly difficult by festivalized working conditions that are emerging throughout the domain of theater, conditions that are short-term, fast-paced, and very contemporary art.

It is hardly surprising that, of all people, it is a curator who has been appointed to legitimize and consolidate the precariousness. In June 2015, it was announced that our colleague Chris Dercon would be taking over the Volksbühne, complete with a rhetoric of "openness" and "interdisciplinarity," of introducing the actors to flexible "new rhythms" and "new locations." As the Dercon is landing, I rush to describe what has been a rare example of a terrific, slow-burn symbiosis between avant-garde *Regietheater* and other sister arts.

Kaprow City, which premiered in September 2006, was directed by the late artist and director Christoph Schlingensief. The evening already began at the till, which mysteriously offered "standard tickets," at standard prices, and "better tickets" at higher ones. Once the lights were dimmed, those holding better tickets were invited onstage, which featured only a projection screen hanging from floor to ceiling (and hiding most of the stage). They were joined by Schlingensief, who offered some quasi-Brechtian pointers in a conversational tone, before introducing a rather large group of actors, and leading everyone behind the partition screen.

From this point on, the seated audience followed the action by means of live transmission, projected on the screen that was separating the audience from the stage. The action itself, meanwhile, unfolded in a circular structure spinning on its axis; Schlingensief's

"accessible installation" (*begehbare Installation*), a cross between a dollhouse and a spaceship, of perhaps a dozen rooms or more, with each room offering a quasi-Kaprowesque "happening" filmed with handheld cameras. Most of Schlingensief's happenings flaunted a pubescent, Vienna-Actionist enthusiasm for political controversy, but also for the finer things in life: puke and poo, pussy and penises.[124]

From time to time, the partition screen was raised, and the seated audience was treated to an unmediated view of Schlingensief's whirling *Wundertrommel* (wonder drum), with audience members stumbling around within, from one penis to the next. At these moments, the seated viewers were addressed by the director popping up at the edge of the stage, demanding they join him in Kaprow City ("The guys in there paid for better tickets for nothing!"). A queue materialized, and some were indeed ushered into the installation, others were sent shuffling back to their seats. A directorial power play that was repeated three four times over the evening.

That same month of September 2006, I noticed some shocking similarities to a very different project, which materialized in the same neighborhood of Mitte, Berlin; Anselm Franke's "No Matter How Bright the Light, the Crossing Occurs at Night." In some ways, of course, Franke's group show at the Kunst-Werke constituted

124 And for the death of Lady Diana. Her story was occasionally interjected by means of a midget queen in a Hitler salute, sparking a tabloid uproar in London, which, reportedly, is why Frieze pulled out of hosting *Kaprow City* in Regent's Park.

a polar opposite to Schlingensief's *Kaprow City*, while in others, it makes sense that Franke earned his chops at the Volksbühne before going curatorial.[125]

As part of the show's preparation, Franke and the four participating artists agreed on Jacques Derrida's *Spectres de Marx* (1993) as a conceptual touchstone, and gave themselves a year to read the book as a group.[126] Which is why it did not serve as a para-conceptual theme ("Ghosts and Capital!"), but was allowed to bleed into the show in a manner that locked the stuff and the discourse, the theory and the rest, into an unusually compact unit. A gridlock that was further compounded by means of a razor-sharp exhibition choreography: the artworks were not continuously visible, but activated and deactivated at particular moments, forming a unilateral itinerary. It was not up to the spectator, but the display itself to decide which artwork was to be seen at which moment, and for how long exactly. (The experiment was to become a key reference for the 2013 "Monogamy" project, see the working example later in this chapter).

Again, the differences between Franke and Schlingensief are legion. *Kaprow City* was as shrill as Franke's nocturnal passage is grim (doing full justice to the dusky title, borrowed from an essay by Thomas Keenan). And if Schlingensief takes "no-one-sees-everything" to

125 Another odd parallel is a project I commissioned for united-nationsplaza, itself only spitting distance from the Volksbühne, the very next year; Chris Evans's *I Don't Know if I've Explained Myself*—see chapter 9.

126 The participating artists were: Ines Schaber, Natascha Sadr Haghighian, Judith Hopf, and Deborah Schamoni.

ferocious conclusions, Franke creates a hermetic pressure cooker where everyone sees absolutely everything, whether they like it or not. That said, even Schlingensief's take on nobody-seeing-everything is a far cry from the choose your own adventure of contemporary art, where you are free to come and go, as one in a million, buoyed by the promise of your individual creativity lending you contours. Schlingensief seeks to depersonalize. As does Franke in turn.

Both were offering top-down choreographies that claim not only the space but also the public as their own. Both, moreover, are examples of a dramaturgical push and pull that renders unmistakable the primacy of one's location as audience member—over and above one's attitude as individual spectator. And both undertakings are homage to the skill of conceptual and physical territorialization. Moving bodies through space with premeditated, hard-line resolve. As a result of which, finally, both experiments succeed in rendering weirdly somatic the experience of any content at hand. Whether through humiliating flashes of access denied (Schlingensief), or through a visceral understanding of political mourning (Franke).

Note 4: Game Plans and Muscle Memory

Soccer legend Wayne Rooney has revealed how, ever since his days as a young player, he visualizes game patterns and goal-scoring situations to enhance his performance.[127] The striker told ESPN: "Part of my preparation is I go and ask the kit man what color we're wearing—if it's red top, white shorts, white socks or black socks. Then I lie in bed the night before the game and visualize myself scoring goals or doing well. You're trying to put yourself in that moment and trying to prepare yourself, to have a 'memory' before the game. I don't know if you'd call it visualizing or dreaming, but I've always done it, my whole life."[128]

Rooney's fellow athlete Mike Tyson might object to the footballer's nighttime premonitions by pointing out, as he is wont to do, that "Everybody has a plan

127 My thanks to curator Francis McKee for this point.
128 Quoted in: Jamie Jackson, "Wayne Rooney Reveals Visualisation Forms Important Part of Preparation," *Guardian*, May 17, 2012, http://www.theguardian.com/football/2012/may/17/wayne-rooney-visualisation-preparation.

until they're punched in the face." It is much more epic, and more macho, to identify with Tyson, of course. But the key question here is whether contemporary art really is as dramatic and volatile as all that? In my opinion, being jet-lagged, underdetermined, and/or out of breath is not the same as being violently unpredictable. When it comes to the challenges of moving people through an exhibition space, recent formulae for conjuring the punchy and unpredictable have proven more conducive to conservatism and repetition, not less so.

Within the whirligig of art, the real difficulty of creating Rooney's creative sense of muscle memory and "recollection" before the fact—what curator Eyal Danon might call "pre-enactment"—lies in the scarcity of time to breed the spatial familiarity such a take presupposes. Exhibitions, conferences, and other events are fleeting things to begin with. Add to this our post-Fordist economy of overproduction, and nothing comes more naturally than cheerful disremembering. Future scheduling is a matter of wresting control, and of "rendering palpable the economies of commitment and delivery" (Gerard Byrne). To do so on a far-reaching, macro-political level, would require a far more ambitious support system than what we enjoy today. But in the meantime, we can start with embracing the mechanical art of plotting exhibitions, somewhere beyond the fatalism of a Tyson.

It is not as if exhibition-goers are too weird, or too erratic, to preempt and utilize their movements through space. Consider how, for example, when faced with a choice of left or right, the vast majority of museumgoers persistently and mysteriously take a right. After which,

providing they are part of the art crowd, they will walk at a moderately perky pace, and, upon entering a room, they will seek a tactical vantage point, by heading straight for the center, from where they can assess what exactly, if anything, needs to be seen from up close.[129] Nonprofessionals, meanwhile, either scan the room with consistently minimal acknowledgement, at a leisurely rhythm, or they overly respect the layout by moving work to work, counterclockwise, pausing regularly to read the captions. Their pacing looks as relaxed as inching your way across an icy pond, blindfolded, with your hands tied behind your back.

Our vernissages are just as scripted. An opening is marked by the testy adrenaline of a socio-professional caste, whose conversations begin with a careful question ("Do you know Matthew have you met Maria I'm sure you know Suhail"). Questions that we raise with our eyes bouncing off to all sides, scanning the room for more rewarding partners in conversation. Having spotted a more prized object of conversation, we exclaim that "it-was-lovely-to-see-you," with an emphasis on "see"—"lovely to SEE you"—it is all about having SEEN one another. During the weeks and months following these openings, it all depends. A project exhibition is usually as lively as a church at midnight. Biennials and quintennials, by contrast, feature screaming toddlers, Instagramming tourists, old-age pensioners reading the catalogue to each other, or teens sitting

129 My thanks to artist Jason Dodge for this point.

cross-legged in black boxes smearing Philadelphia cream cheese on salted crackers.

Studies have suggested that, whatever the viewers' specific modus operandi—marching, carousing, or edging across the ice—they will, as a rule, move through anything marked as an "exhibition" at the same rhythm. Regardless of content. Whether it is a boat show, a small group exhibition, or a megaplex Picasso blockbuster, one pace fits all. None of which is cause for concern, apart from the failure to instrumentalize the patterns that patently do exist, willy-nilly. Surely there is potential in pre-visualizing—and redetermining anew—these inevitable blueprints and gravitational waves.

Note 5: Linkrot
(Documentation Decelerated)

Moving from pre-enactments to memories after the fact, language and photography are the two aides-mémoires available to exhibition making. As it happens, both language and photography prefer to follow their own rules and agendas, far beyond art itself. Art shows do offer good looks and hard cash, but neither language nor photography is interested in art beyond that. Language, especially, is uncompromisingly beholden to its

own baggage. As the history of criticism has shown, since the early days of the Renaissance and *ut pictura poesis*, it will never be a faithful window to the artwork, no matter what.

More recently, we have been clinging to the fidelity of installation shots, and, right now, the liaison is working well. Too well, perhaps. With the advent of the Internet, installation shots have become to contemporary art what framed studio portraits are to the nuclear family. Moments of idealized harmony, to be handed down through generations. Of course the visual battlegrounds that are installation shots were already raging well before the www.[130] Throughout the history of modern art, documentation has often defined the canonical status of given works, events, and exhibitions, along with their content per se. For instance, the iconic photographs of Marcel Duchamp's *Mile of String*, at the 1942 "First Papers of Surrealism" exhibition, now appear less impenetrable and claustrophobic than what the scholarship suggested for so long. Thanks to more recent analyses, generous gaps in the texture of Duchamp's string have become apparent, making it seem more like a dangly pathway through the exhibition, as opposed to a forbidding spiderweb blocking the way. Impish bad-boy antics suddenly become a gentle testing of exhibition as medium.

To take a less canonical example, in 2010 I heard Barbara Steveni of the Artist Placement Group discuss

130 See: Sohrab Mohebbi, "Caught Watching," *Red Hook Journal* (February 2013), http://www.bard.edu/ccs/redhook/caught-watching/.

their 1971 *Industrial Board Room* (produced for the "Art and Economics" exhibition at the Hayward Gallery, London). That boardroom, Steveni claimed, was the first mix of installation and infrastructure to be termed a "discussion platform." When the audience objected that this honor usually went to Joseph Beuys and his *Honeypump*, at documenta 6 in 1977, Steveni chuckled. "Ah, Joseph and his cameras!" While Steveni & Co. were more or less indifferent to documentation, Beuys always had his mind on the photographs that needed to be secured, and from which angle exactly. Sure enough, the photographs of Beuys's *Honeypump* are few in number.[131] And those few are exquisite. The concrete is perfectly grainy, the honey pipes shimmer, and the hat is cocked just so.

On many occasions, documentation has even decided on the status of a given object as art, and thereby, in some cases, actually secured its very existence over time. You often hear someone regretting the missed opportunity to frame a 1960s commune, a children's playground, or a private research obsession as an artistic enterprise, thereby making it worthy of archival preservation. In sum, documentation has always constituted a prime location in its own right.

And still, our online context ups the ante. Just compare the effort of photographically documenting and captioning *Honeypump*, to an instantly ubiquitous, never-ending Forrest Nash sequence of wordless, sexed-

131 Beuys's *Honeypump* was a distribution network of honey traversing the Museum Fridericianum, and the symbolic core of his Free International University.

up money shots. It is one thing to update the technology, to replace the tedium of essayistic description, or even to rethink the role of language with the help of an iPhone app. It is another to posit that no explanations are necessary. At the risk of sounding exactly like the bitter, jealous writer that I am, the new ocular imperative has taken over the role of policing the boundaries of good and bad, with a verve and efficiency the written word could only dream of. The image itself is presently colonizing—perhaps at times cannibalizing—visual art more pervasively than anything criticism or theory ever dared. (Even when it comes to conferences, it is now tempting to enjoy the "look of thought" via atmospheric snapshots, as opposed to watching the footage, let alone reading the transcript.)

Writer and curator Brian Droitcour is worth quoting at length:

> The post-internet art object looks good in the online installation view, photographed under bright lights in the purifying white space of the gallery (which doubles the white field of the browser window supporting the documentation), filtered for high contrast and colors that pop. The post-internet art object looks good online in the way that laundry detergent looks good in a commercial. Detergent doesn't look as stunning at a laundromat, and neither does post-internet art at a gallery. It's boring to be around. It's not really sculpture. It

doesn't activate space. It's frontal, designed to preen for the camera's lens.[132]

I do acknowledge the need for theorizing and historicizing the online. I see its potentials for artists based in far-flung places, and also for time-based art in general—given the shitty acoustics and lack of seating in so many exhibitions, many works have found more adequate settings online. That said, I readily admit to an offline bias here.[133] At this point, a viewfinder is what allows you to think and claim to have visited an exhibition, and depicts space in a manner that depreciates the experience of moving through it—and this movement, after all is said and done, is the sensory crux of any art exhibition. (As Gerard Byrne puts it, "installation shots treat exhibitions as if they're Pompeii.") What is more, the installation shot has made its way into very minutiae of production, to become the telos of our efforts as producers. We increasingly judge our work by how well it will travel as a JPEG. And the latter-day, ferocious competitiveness of our milieu is not exactly helping.

I only came to realize the full extent of my own visual indoctrination while teaching an "Introduction to Fine Arts" seminar at Al Quds Bard College, in Abu Dis, Palestine. To a roomful of students who—for the most part—had never seen a white cube exhibition space

132 Brian Droitcour, "Why I Hate Post-Internet Art," *Culture-Two* (blog), March 21, 2014, https://culturetwo.wordpress.com/2014/03/31/why-i-hate-post-internet-art/.
133 Key references for me personally, when it comes to this conversation, are the three very different artists Harm van den Dorpel, Andrew Hieronymi, and James Bridle.

before. It turned out that latter-day JPEGs presuppose a surprising degree of literacy; the inexperienced eye can barely read the artwork in the picture, nor acknowledge its relation to the space, let alone enjoy the visual kicks that are intended here. Pedagogically speaking, it is hard to acknowledge the eerie art-historical powers of documentation, and still knock it off the teleological throne it inhabits. Try selling that double bind to an undergrad.

I often fantasize about an all-out moratorium, allowing all those shots to be accessible only after a full decade has passed. For her part, writer Jennifer Allen has suggested, almost as quixotically as myself, that all reproductions be restricted to shades of black and white, so as to highlight the artificial, partial nature of these photographs.[134]

I will end by combining the anxieties and proposals of the above subsection with the "post-critical" issue raised in chapter 2. Consider, for a moment, the effects of the online ocular imperative on the legacy we call institutional critique. One of the main features, and mixed blessings, particular to this genre, I would argue, is its propensity to be summarized in easy terms. By means of JPEGs, and by means of one-liners in equal measure. ("The guy removed the wall, and, so, you could, like, see the gallerist sitting there?") The photographs and the summaries do allow the work to speedily travel the world, but at the risk of transforming the artworks into caricatures of themselves.

134 Jennifer Allen, "Not So Black & White," *frieze*, December 2008, http://www.frieze.com/article/not-so-black-and-white.

Despite their cerebral reputation, the artists who criti-
cally use institutions as their medium are often deeply
invested in the somatic concerns of this chapter. At
best, their work is enmeshed with the venue as an ac-
tual, physical, architectural, psycho-professional, socio-
erotic space, and not merely as a symbol or a website.
The work becomes one with the materials it uses, and
with the visceral impressions, conversations, and at-
mospherics these materials spark. None of which is
done justice to by JPEGs and hearsay, as fascinating as
the miscommunications of such vessels might be.

In the worst case, the sheer speed at which the
JPEG simplifications circulate will foster a downright
folklore of post-critical misery. Not by vulgarizing the
artworks necessarily, but by speeding up their circula-
tion to the point of suggesting that institutional critique
is both easy, and absolutely everywhere. That the cri-
tique is pretty much as common as the institutions per
se. Consider the currency of the strange idea that insti-
tutions are routinely critiquing themselves. "You can't
do anything no more, it's all, like, totally co-opted."[135]
As explained in chapter 2, the latter is a superstition
that has nothing to do with existing confrontations
with existing institutions. Far from being a simple fact
of life, the raison d'être of all that *tristesse royale* lies else-
where. The advantage of a post-critical ambiance—of
critique being wielded by power itself, in some quasi-
automatic fashion—is that it compounds the notion of

135 See also: Vincent Bonin, "Here, Bad News Always Arrives
Too Late," *Red Hook Journal* (2012), http://www.bard.edu/ccs
/redhook/here-bad-news-always-arrives-too-late/.

contemporary art being something other to the institutional activities that surround it. Instead of theorizing the ways in which art itself dispenses, organizes, authorizes, and censors critique, you can assume it is the venue that enjoys this prerogative. As a result of which the critical virtue of contemporary art is preserved, even as the art is victimized once again.[136]

Working Example: "Monogamy"

"Monogamy" was an exhibition project at the CCS Bard Galleries in 2013, featuring Gerard Byrne and Sarah Pierce. The two artists had been coming and going from Dublin, both of them both teaching and exhibiting at CCS, for a number of years. I myself had been a member of the faculty for five years, most of them full-time, which allowed for an exceptional degree of calm, deep in the upstate countryside, even if my stint at the school

136 In fact, as argued in chapter 2, artworks are censored, watered down, and domesticated on a regular basis. For the sake of sponsors, audience numbers, politicians, and countless other constituencies. And this process of channeling, importantly, is undertaken by means of—and for the sake of—the codes and prerogatives of contemporary art. Not at the hands of some essence extrinsic to it.

was marked by an odd succession of directors noisily coming and going throughout.

CCS encompasses not only a school but also a museum, two institutions that are both typically associated with long-term thinking, with generational developments, geological time frames, and so on. And yet, both these institutions are typically beset with structural amnesia. There is a peculiar oblivion that marks even a latter-day museum, where it is easier to chase the zeitgeist than it is to foster a genius loci. It comes far more naturally, even here, to keep up with fleeting transnational fashions, than to develop your institutional sense of place. To see every show as another one of those preludes to a prelude, a vernissage to the rest of your career. As Boris Groys likes to suggest, you are indeed well advised to disremember as much as possible, because your successor will do the same to you.

It is all the more difficult to cultivate collective memory in a school. Students are eager to move on. Faculty are not only faced with a yearly tide of new faces, but, true to the laws of the post-Fordist labor market, they are prone to moving on quickly themselves. And so nothing comes easier than disremembering that constant stream of meetings and conversations. Moreover, the recurring disappointments that are the mark of any genuine educational experiment—such as CCS itself at its finer moments—make it easier to forgive and forget than to ponder a perplexing pedagogical record. "Monogamy" was my farewell kiss to CCS, my last hurrah. It sought to tap into the recent institutional memory of the place by relying on memory as an ac-

tual medium, and privileging those who had been around longer than others. Such degrees of separation were key to the project. The very title itself worked toward activating degrees of in- and exclusion. To some, the two artists and I were jocular frat boys, embarrassing ourselves in the eyes of the polyamorous queer community of Bard campus, so there was a lot of sneering and harrumphing. (As it happens, the vernissage coincided with the very day the United States Supreme Court accepted to deliberate on marriage rights for gay and lesbian citizens.) For those who cared to pay closer attention, however, "Monogamy" was a plea for taking seriously—beyond the comfort zone of critical virtue— the institutional ties that bind curator to artist, student to faculty, artist to oeuvre, and art to discourse. The artist's voice, in particular, is especially prone to pressures to disavow the pragmatic promiscuities that are always necessary behind the scenes. To highlight such bonds is to acknowledge them as a condition even as you push for other models.

"Monogamy" was also site-specifically grounded, or emplotted, rather, by means of our discussions with students; discussions addressing professional accountability, conditions of production, and conflicts of interest. When it comes to a school's art collection, and its pedagogical mission statement, what marks the difference between loyalty and laziness, between commitment on the one hand, corruption and incest on the other?

A key ingredient here was the lighting choreography devised by Sven Anderson, which activated some artworks at the very moment it deactivated others,

plunging the one room into darkness while bathing the other in chromatic tessellations. Byrne and Anderson had collaborated on similar strategies before (my own curatorial reference was chiefly "No Matter How Bright the Light, the Crossing Occurs at Night," curated by Anselm Franke, who took his own cues from similar setups before him—see previous section of this chapter). Anderson's itinerary imposed upon our viewers a heightened sense of institutional push and pull, proactively claiming the location, just as it claimed the public as its own. Thereby imbuing the viewing experience with a visceral friction that lingered, and that served to denaturalize the sense of time passing within an exhibitionary complex. As a matter of fact, the exhibition's overall aims were largely pursued without relying on language alone. The core concerns were conveyed by means of pacing, choreography, and curatorial gesture, very much along the lines of many a period room or Volksbühne production.

Monogamy, as the two artists liked to say, is something you endure. It is more of a sustained condition than a rational decision. As Byrne put it in an e-mail shortly before the exhibition opening:

> Monogamy has connotations that have become explicitly ideological since the Sexual Revolution—bearing a tone that, strangely, is not about personal freedom in the narcissistic sense, so pervasive in contemporary free-market thought. Rather, above all else, it's an opposition—a negative. It's not about freedom or pluralism. Accordingly, this project is

not a distinct curatorial composition. It's actually predicated on the aspirations of previous shows. Such is the mechanism of our concept: the tension between choice and no choice. A critique of the relationship between choosing and curating. Artists don't "choose" their practices, they endure them, if that's not too melodramatic.

Surely enough, the selection of the works was based more on the artists' respective exhibition histories than on personal preference alone. In fact, half the artworks had previously been installed within those very CCS spaces. Byrne's *New Sexual Lifestyles* (2002) was reinstalled as a perfect replication of its presence at the 2008 "Green Room" exhibition curated by Maria Lind. On the other hand, Pierce's *It's time man. It feels imminent.* (2009) was reconsidered from scratch, in terms of placement, setup, lighting, as well as tenor, marking a contrast to what it embodied in "Anti-Establishment," curated by Johanna Burton in 2012. Pierce's *Future Exhibitions* (2010) was equally part of "Anti-Establishment," and was left *tel quel*, except for an occasional nod to its new exhibitionary context.[137]

The mediation equally cross-referenced wall labels used in previous exhibitions. As I looked into my curatorial precedents for "Monogamy," the similarities

137 For example, *Future Exhibitions* usually has the artist reading from a "script," a set of instructions for a team that reorganizes or finalizes the install. In our case, instead of Pierce herself, it was CCS exhibitions manager Marcia Acita who read out the instructions, Acita being the one most committed member of the CCS team over the decades.

between them turned out to be many in number.[138] My long inventory of curatorial overlaps, which I eagerly shared with students and peers at the time, was occasionally misread as competitive griping, but was not meant as a criticism so much as a foregrounding of institutional seepage as a matter of routine—of the genius loci persisting, regardless of whether its theorized or historicized.

Theater served as a key reference here, in terms of scenography and object ontology alike. The stage is where scripts can be revisited without much loss in significance or value, offering a more supple relationship to an original template than art usually does. Thus the works in the show multitasked as time capsules, theatrical props, and auratic art objects. Thanks to which we could minimize the usual spectacle of reenactment, in favor of a déjà vu experience that was familiar, closer to home, maybe a bit claustrophobic at that.

At this point, it is worth disclosing the shocking fact that Byrne and Pierce are married. They even have a child. From their perspective, this was a rare opportunity for the family to travel and work together. From the school's perspective it was a rare opportunity to

138 Both "Green Room" and "Anti-Establishment" were curated by CCS directors within eighteen months of their boisterous arrivals. Both served as pedagogical foils for an entire semester. Both used the main seminar room as a black box. Both featured wordy work descriptions and extensive artist statements. Both addressed recent historical shifts (whether in terms of documentary strategies—Lind—or institutional critique—Burton). And both were more or less classic renditions of thematic group shows. I could go on.

invite two artists of this caliber in one fell swoop. "Monogamy," in other words, encapsulated working conditions in the arts that are sometimes hard to address. The show took advantage of the intimacy between Byrne and Pierce, building on their familiarity in favor of far more experimentation than is usually appropriate.

Our duo show was a conservative premise in that it set up a monogamous horizon of expectation. ("Comparisons between the work of two artists.") Like any institution, monogamy does imply a degree of depersonalization. Ideas bleed into each other over time. For better or for worse, our show wound up further de-differentiating between two practices, bringing to the fore the pedagogical overtones, the historiographic appetites, and the politicization of display that seems to permeate both oeuvres. Another mutual trope was the aforementioned artist's voice, plain to see and hear in Byrne's *A Thing Is a Hole in a Thing It Is Not* (2010) as well as Pierce's *The Artist Talks* (2012). As Pierce put it, in the booklet accompanying the show:

> Like the installation shot, a two-person show is a simple contrivance, but is also how artists and artworks substantiate institutional "ties." Although the artists are making a two-person show, it does not find them in collaboration. Instead, they find themselves in institution—together (yet again). We, as artists and curators, endure in relationships we feel secured by, even if we ideologically plead against them, in so far as they are institutional in their structure. Monogamy is the practice

of institution—we are not referring to particular buildings or even particular institutions. So while CCS is particular, it is also part of a larger system. Monogamy is what it is—more or less everywhere.

Working Example: "It's Not You, It's Me," the 1st UAE Pavilion, 53rd Venice Biennale

Not long after "No Matter How Bright the Light, the Crossing Occurs at Night" (Kunst-Werke, Berlin, 2006, see the "Territorialization" section of this chapter), Franke commissioned the architectural firm D'haeseleer & Kimpe & Poelaert to design his group exhibition "Mimétisme," at Extra City, Antwerp, in 2008. The firm devised a system of seating contraptions of brilliantly stylized character, with the back of each bench serving as the projection screen for the bench immediately behind it. In a remarkable feat of squaring the circle, the viewing possibilities were pragmatically maximized, even as the scenographic magic was maximized in turn. It was the lingering memory of that show which com-

pelled us to collaborate with Kris Kimpe of the same firm, in the context of the first UAE Pavilion at the 53rd Venice Biennale (2009).

The challenges of the pavilion were pretty obvious to see. First of all, we were offered a tremendous postindustrial Arsenale hallway, at the tail end of a biennial marathon, this in the sweltering summer heat of Venice. Secondly, there was the sheer eccentricity of national showcasing within the frame of contemporary art Thirdly, the staggering expectations of nearly one million visitors traveling far and wide. And, finally, the deep-seated, not to say hysterical suspicions regarding the UAE. The answers were not as obvious, but much fun to pursue.

To begin with, the pavilion featured a single new commission: a series of photographs of one-star hotels by artist Lamya Gargash (*Familial*, 2009). The pavilion also included a "showcase" featuring the eminent Hassan Sharif, alongside Ebtisam Abdulaziz, Tarek Al Ghoussein, Abdullah Al Saadi, Layla Juma, Mohammad Kazem, and Huda Saeed Saif.

As an overarching premise, meanwhile, we opted for a loud measure of self-reflexivity, as indicated by the show's subtitle "Pavilion as Pavilion." To be clear, we were not partaking in the grand tradition of problematic nation-states using Venice pavilions for self-critique, most prominently and consistently exemplified by the German presence in the Giardini. If anything, we were keen to ditch the mea culpa. Consider the main title. "It's Not You, It's Me," which is a cliché uttered in guilt and embarrassment. ("It's me who has issues not you.")

But you can sense the bad faith a mile away. Surely enough, at a time when the UAE was raising so many eyebrows, what the title subliminally aimed for was a belligerent sense of self-confidence. Anyone who paid attention to the pavilion as a physical space did realize that it was actually a case of "this hurts you much more than it hurts me." And, by implication, "It's not about Venice, not the Emirates." (Maybe even, "It's Not about a 'Dictatorship of the Audience,' It's about Us.")

Backstage at the Venice Biennale, the idea of pavilion artists posing as national exports—as opposed to the idea of artists posing as world citizens—is the object of much sarcasm at Harry's Bar on San Marco. Over Bellinis, we can agree on how propagandistic and silly it all is. When in point of fact, though it may not jive with our cosmopolitan self-image, nation-states continue to define art careers in myriad ways, from the infrastructure to the funding to the distinctions that come with any given passport, language, or cultural cachet.

A second problem with harrumphing at national pavilions, and leaving it at that, is that lazy sarcasm allows people to get away with murder. Venice pavilions regularly indulge in the most insane representational excesses. With the most effective examples of such representational excesses engaging in a reflexive signposting thereof, as reassurance that the pavilion team is well aware of all the monkey business going on. As argued earlier in this chapter, reality effects are deployed with more efficiency through the back door these days. In other words, the more we would have deconstructed or problematized our own privileges, the more we would

have been credited as producing a truthful representation of the UAE.

What we ultimately aimed for was a blunt sense of self-reflexivity, albeit without the halo of critical virtue. A tenor that suggested a national platform be a national platform, without resorting to an apologetic display of timely criticality. A national pavilion should look national in the way a period room is inalienably pedantic, or in the way Hauser & Wirth could and should look like a "concept store" (see chapter 6). To achieve this effect, the world's-fair prehistory and subtext of Venice, Mother of All Biennials, was highlighted in obtrusive fashion. By means of exhibition didactics on overbearing text panels, but also by way of eye-catching models of UAE museum projects, displayed alongside the art in the showroom. Along similar lines, the pavilion also included an elaborate discursive "Kiosk"—a display format devised by artist and curator Hannah Hurtzig, which featured filmic dialogues between eminences grises of UAE cultural policy.[139]

Most importantly, it was the architecture that was mobilized in the above spirit of reflexive bluster and plump legibility. After much to-ing and fro-ing—and much soft-spoken insistence on Kimpe's part—we came to the agreement that an intelligent organization of the

139 World's-fair subtexts aside, a collaboration with the Jackson Pollock Bar led to a series of reenactments of our pavilion press conference (the reenactments were an example of the collective's signature "playback installations"). Finally, a surprisingly popular audio guide was devised by writer Shumon Basar, and voiced by our dazzling commissioner Lamees Hamdan, offering "subtitles to the show's subtitles."

room need not be linked to maximizing surface space. On the contrary. The uncompromising spatial envelope that was devised in due course by Kimpe and his team cut the exhibition space in half, effectively squandering gallons of space.

So, from the visitor's perspective, the first thing you noticed, as you entered the tail end of the Arsenale, was a colossal wall that drew an absurd amount of attention to itself. It was something of a hyperwall, perhaps, a wall-as-Wall, not just in terms of its dimensions, but also in that it was nothing more than a plain old slab, in the midst of all the *biennale tutti crazy*. If you paid a modicum of attention, you noticed an entrance to the left of said wall. If you did not, you zipped right through, along the blank side of the wall, as many visitors did, and were probably grateful for that ninety-second art-free promenade, guided gently along through a weirdly empty corridor, featuring only a few benches here and there. This is where you could take a break, resting your eyes on the soothing white surface—oblivious to the Emirat-o-rama going on behind it—before moving on to the next exercise in look-at-me-look-at-me.

The imposing dimensions actually encouraged the public, mostly coming from the Chilean Pavilion, and on their way to China, to miss the show. (As a small concession, after zipping through our section of the Arsenale, you did have the opportunity of looking back as you exited the hallway, to notice the show and retrace your steps.) Certain pavilion precedents, similar in architectural temperament, come to mind: from Santiago Sierra's Spanish Pavilion in 2003 to the late Hüseyin

Bahri Alptekin's Turkish Pavilion in 2007. But not one, to my knowledge, went to comparable lengths to emphasize the somatic potentials at play. Kimpe's partitions both liberated us from quantitative considerations, and allowed for a quiet tribute to the pleasures—and the didactics—of modulated access. An exclusivity not of VIPs but of a public that is willing to take the time. If you were ticking boxes in a sweaty rush, you were not our audience to begin with.

– 9 –

SCHOOLING

Working Example:
Student Shows

Whether you consider it the beginning of the end, or the end of the beginning, the École du Magasin is where formal curatorial training first started. The first curatorial student exhibition, at the very first curatorial program in Grenoble, was in some ways a game-changer. Its first graduation show, "19&&," opened on February 27, 1988, featured eleven artists curated by six students,[140] and was to influence the field for generations to come;

140 The curatorial team also included artist Dominique Gonzalez-Foerster, then a student from the École supérieure

both in terms of production and training, and in terms of creating a tight network of remarkable longevity. The show even confirmed people's deepest fears regarding curatorial programs as mafias in the making. Many a collaboration soon followed, between Magasin student Esther Schipper and artists Philippe Parreno, Pierre Joseph, Bernard Joisten, and Dominique Gonzalez-Foerster, to name only the more eminent examples. And we must not forget a lanky young intern by the name of Nicolas Bourriaud who dropped by for the opening. In other words, Relational Aesthetics demonstrates what a school can offer at its best: a form of social knowledge production that allows material and discursive practices to interact in ways that are less cookie-cutter than usual.

In retrospect, the stroppy impatience of the title—&&, etc. etc.—both reflected and consolidated a zeitgeist. 1988 marked the last gasp of the Cold War, as well as the last moments of the predigital era, and was characterized by a hunger for new vehicles, new terms, new networks. Powerful ideas reconsidering the exhibition as a medium were in the air, and the market was booming as never before, innocently unfettered by the boom/bust experiences that were soon to follow. In France, the provinces were becoming attractive as the *centre d'art* (Kunsthalle) model was gaining ground across the countryside. In nearby Frankfurt, too, a promising Kunsthalle by the name of Portikus was now at the disposal of the Städelschule.

—— d'art de Grenoble who was spending a year at the newly founded program instead.

Much of what we take for granted is negotiated at such moments, to then be renegotiated from one student generation to the next. Together these events form an underexamined heritage that discreetly defines the field at large. It is obvious to anyone who has seen curatorial student shows from up close, that more rigorous discussion, more heartfelt research, and more dogged negotiation is invested in a student show than in many professional ones put together. So why would their effects not be more deep-seated and long-lasting? Indeed, the example of "19&&" bears witness to complex microhistories as well as the institutional landscapes that crystallized around them. Curatorial training itself has succeeded in moving from an annoying idea to one of the defining vectors within contemporary art.

But events of this type remain a minor genre, rarely taken seriously beyond a semester's worth of accreditation—and a history of curatorial student shows is simply twice the pain of a history of student shows. Like studio visits, student exhibitions remain beyond the reach of history, and we have no way of knowing whether they have remained unchanged since the days of Queen Berenice of Benghazi. Recently, calls have been growing for a curatorial canon, which, in light of the crises described in this book, is an idea worth pursuing undeniably (see also this book's conclusion). But what is just as pressing is a canonization and historicization of student exhibitions, curatorial and otherwise. Here, as elsewhere, a canon would lead to a theorization of exactly what forms of knowledge are being pro-

duced, de facto, and what exactly, *de iure*, the best-case scenario would be.

Working Example: unitednationsplaza

The informal educational experiment unitednations-plaza (unp), Berlin was borne of the ashes of the canceled Manifesta 6 (M6), Cyprus, in 2006. The M6 event and its cancellation have been plenty hyped. But as long as biennials continue to be as unsurprising as they are, M6 should be commended still. Curators Mai Abu El-Dahab, Anton Vidokle, and Florian Waldvogel vied for a process-based structure focused not on a wider audience but a small number of artists and their immediate interlocutors. The idea had experimental precursors (e.g., Gwangju, 2002), and several examples have since attempted comparable redefinitions in format (e.g., São Paulo, 2009), but we have yet to see something quite as uncompromising.

When the event was canceled at the eleventh hour, Vidokle, with e-flux under his wing, wasted no time in reconfiguring M6 into a "one-year-exhibition-as-school," where I became one of a good dozen advisors/tutors/

collaborators. Here, you could find the perfect conflu-
ence of factors that make informal art schools so irre-
sistible; no official hierarchies, no visible curriculum,
artists big and small socializing together, and their art-
works doubling as infrastructure—including a formi-
dable bar-as-sculpture by Ethan Breckenridge, where
the odd superstar intellectual was treated to relaxed
irreverence in smoky barroom colloquia. All of which
fostered a complex socio-professional dynamic, further
complicated by the high visibility of the e-flux project
at large, the effect of which can be promotional, elec-
trifying, and intimidating all at once. By virtue of unp
being part of the artwork that e-flux already embodies
(see chapter 3), things were made even more intense
and complicated yet.

As far as the content was concerned, the range of
outstanding practitioners inevitably made some excel-
lent contributions. Including twists and turns like the
unp symposium at the ARCO art fair, Madrid, which
was reconfigured into *Madrid Trial,* a court trial accus-
ing Vidokle and myself of "collusion with the bourgeoi-
sie" (it now circulates as *A Crime against Art,* 2007, an
award-winning documentary by Hila Peleg). Another
highlight was undoubtedly *I Don't Know If I've Explained
Myself* (2007–ongoing), a willfully convoluted artwork
by Chris Evans.

Evans took his lead from a 1970 conference held at
the legendary Nova Scotia College of Art in Halifax,
Canada. Artists participated in a discussion on the sixth
floor, while students watched on monitors from the can-
teen. Evans's *I Don't Know If I've Explained Myself* is at

this point an extensive series of roundtable discussions, equally separated from the audience. The latter follows the conversation via live feed, just like the students back in the day. (Sometimes the topic of conversation is a given artwork, which is removed from the speakers discussing it, and hung near the audience instead.) The resulting segregation between the discussants, on the one hand, and the audience, on the other, is almost Schlingensiefian in impact. An odd sense of separation anxiety and group envy emerges, even a taste of symbolic violence unfolding. This without any real understanding of what is being violated exactly. Let alone any real sense what you should be anxious about, or envious of. (Four panelists locked in a room, perhaps?)

The first rendition of Evans's project was held in the communal unp kitchen, during my two-week seminar "That's Why You'll Always Find Me in the Kitchen at Parties." The unp kitchen was open to all, or, more precisely, to anyone who felt entitled to enter. This simple, tacit premise of self-regulation usually controls entry more effectively than barbed wire ever could. Having the confidence to cross the kitchen threshold indicated a very strong likelihood of your indeed being entitled to doing so. (As theorist Tan Wälchli once argued in a barroom analysis of Paris Hilton, sometimes the content of your success is simply your success in and of itself.)

Soon after we began our own roundtable, however, the audience decided to quietly barricade us into the kitchen. Unbeknownst to us speakers, they switched off the live transmission, bought some beer, and proceeded to discuss exactly what was wrong with unp in general,

and with Zolghadr in particular. Meanwhile, we kitchen panelists, oblivious to all of this, continued our endearing attempts to sound clever, for a full hour or more. When the door was finally opened, I was summoned to a kind of improvised hearing in the seminar room. This time, the tone was a bit harsher than the *Madrid Trial.* The charges being that the "experimental" promise of unp stood in contradiction to the "elitist" kitchen experiment, but also that the style of the entire exhibition-as-school was "arrogant" through and through. It is hardly a coincidence that Vidokle was not in town that night—we were all home alone—which confirms that an artist's charismatic authority does hold plenty of sway in such informal settings.

My loudest, angriest prosecutor exclaimed that the only "truly experimental educator at unp" was Martha Rosler. Which is telling, in that Rosler, a classic professorial authority, is not exactly known for a cross-legged, funky teacher style. Another member of the audience turned out to be an alumna of the Nova Scotia College of Art. She did not remember the 1970 canteen conference. But she did remember chilling stories of sexual exploitation at the hands of artist faculty, all in the name of "experimental teaching." She also shared the paradox of her graduation ceremony, presided over by Joseph Beuys. Much as she was aching to meet him, she boycotted the event, in the aim of becoming the anti-institutional "good student."

The following year, Evans's event was mentioned in the *Artforum* coverage, in terms of just another night of boozy Berlin anarchy at unp. No mention of a tightly

structured experiment, let alone an artwork. In point of fact, cases of crazy mayhem, boozy or otherwise, were few and far between at unp. It is ironic that on the rare occasion when that holy grail of indeterminacy did finally materialize, it was barely noticed as such. Maybe on account of being incommensurable—it is hard to record what is incommensurable—or maybe for other reasons too.

It took a deeply artificial, highly stilted, hyperformalized structure-within-a-structure to create a few minutes of genuine indeterminacy, or genuinely open-ended political tension. To have the unresolved intellectual folklore and the emotional contradictions of informal schooling come to the fore in one angry crescendo. If the usual idea is that open-ended structures create structural open-endedness, Evans proves that it takes a crassly premeditated closure—one that builds a location as well as an audience—for any genuine antithesis to unfold. I have to say that I learned a good deal from unp in general, and from the superbly perceptive Vidokle in particular, but that one night, though painful, was a night to remember.

The Presumptuous Schoolmaster

Whether in an informal exhibition-as-school, or a degree-giving setting, the moral economy of indeterminacy finds its most punchy articulation, its loudest devotee, in Jacques Rancière's figure of Joseph Jacotot, the "ignorant schoolmaster."[141] The teacher who does not know is the pendant of the curator who is not an authority. "You cannot really teach art," one is told, "you can only create a space where art might happen." Tutor after tutor will uphold John Baldessari's mystical truism in a classroom setting. Even when student fees are crippling, the institutional agenda is obvious, and the teaching methods unilateral, the stated moral horizon needs to be one of open-ended questions, of unknowing and unlearning, usually peppered with ample references to Paulo Freire's "theater of the oppressed."

The advantages are plain to see. If teaching art is impossible, you are never really to blame. And if art has no answers, you can avoid tough questions. So it should

141 Jacques Rancière, *Le maître ignorant* (Paris: Librairie Arthème Fayard, 1987).

not come as a surprise that the master tropes of this master narrative have persisted for an extensive period of time. The idea that art education should not be institutional or instrumentalized, but open-ended and antielitist, can be traced all the way back to the German Romantics, who already insisted that artists should learn to be unique individuals, critically independent of the state, who scoff at any pursuit of clear meaning and so forth.

Yet the evacuation of accountability runs into the very same contradictions here as it does in an exhibition setting. Whether in a white cube or a seminar room, complete openness is always already premised on the powers of persuasion of whoever proposes it. Once this individual's authority has been transfigured into innocuous ignorance and critical virtue, it is pretty much unfettered.[142] And given the cult of individual self-reliance in our voraciously post-Fordist context, "teaching to unlearn" cannot amount to more than an imitation of rebelliousness, at best. More often than not, Rancière's "radical perhaps"—a politics devoid of particularity or predetermined content, tends to seamlessly reiterate latter-day forms of governmentality. All the while suggesting it is doing the very opposite.

The resulting confusions and delusions are endearing to behold. Notice the peacockery of every "self-taught" curator these days. Among my own middle-aged generation, the self-image of fierce curator-mavericks in a brave new world is quite something. "I never needed

142 See also: Malik, "Vindicating Didacticism."

no training. I learned from the code of the streets." Philosophers and historians, it seems, do need teaching, but writers and curators, well they emerge from a mysterious process of autogenesis. Like gangsters. Or amoeba. During the CCS lectures described in chapter 1, you had Roger Buergel, Charles Esche, Anselm Franke, Maria Lind, and Dieter Roelstraete voicing the same concern that curatorial training will lead to "bureaucrats," or "greenhouse tomatoes," all pruned and domesticated. If only there were some autodidactic curators out there who could prove them right. Some lush, green pasture of political courage, intellectual risk, and aesthetic innovation. Show me these heroes, and I will disavow formal training in a heartbeat.

For now, it is precisely the formality of a school that can potentially upend the orthodoxies. Orthodoxies including those very forms of social bonding through which autodidacticism has unfolded for decades now. If anything, the typical insecurities of "finding your own way" do not challenge but actually encourage the stereotypical groupthink of servile virtuosity. In my experience, the most exhausting clichés—and the most tedious teaching on my own part—arose whenever people were encouraged to make up the rules as they went along. While the best pedagogy has resulted from straightforward assignments.[143]

143 Two cases in point. When I arrived at the Funen Art Academy to conduct a workshop, in the summer of 2006, the school had just hired star artist Jens Haaning. I responded by asking students to collectively produce a Haaning artwork of their own. The resulting mindfuck remains a cherished memory and a mark of pedagogical pride. And several years thereafter, at CCS, our

Full disclosure: my own coaches were not degree-giving faculty, but artist friends. Whether from my student days (Martine Anderfuhren, Solvej Dufour Andersen, Dirk Herzog, Andrew Hieronymi, Patricia Nydegger, Peter Stoffel) or later collaborations (Hassan Khan, Natascha Sadr Haghighian, Shirana Shahbazi, Solmaz Shahbazi, Anton Vidokle, Marion von Osten). They include the odd designer (Manuel Krebs), writer (Bruce Hainley), and curator (Maria Lind). What I learned from these people was a grammar, an intellectual sensibility, and a realistic sense of the possibilities at hand—what sociologists call an "objective future"—all of which dovetailed well with a university education in comparative literature and critical theory. And very early on, in this sentimental education of mine, I was accorded some disproportionately XL responsibilities.

And I handled them with a self-important gaucherie that still has me waking up at night screaming. Looking back, I would have much preferred to make those painful mistakes within the confines of a school, instead of growing up in public like some Britney Spears. Blinking in the limelight of *frieze* magazine and the Sharjah Biennial. Very often, schooling is necessary to even acknowledge the mistakes you make, precisely as mistakes. The pressure of a public setting—amplified by all the screeching bungee jumps of professional trial

—— "Solo Hang" series (2011–13) required students to concoct a mini-exhibition using the in-house Marieluise Hessel Collection. What was a potentially dreary exercise—mildly corrupt, even, in that it showcased a patron's collection in an educational setting—sparked several shrewd responses that amounted to curating at its finest.

and error—only induces a state of breathless denial, and has you repeating your mistakes. Until you replace them with new ones. Which you will then screechingly deny all over again.

Disruption[144]

In view of the ongoing explosion of massive open online courses (MOOCs), some say the ignorant schoolmaster will soon be out of a job. As curator Doreen Mende has suggested, students will turn to avatars instead. The numbers are indeed overwhelming, and MOOCs are creating facts on the ground that will soon leave our bankrupt students little choice in the matter. The trailblazing platform coursera.org, for example, beat the expansion rate of Twitter and Facebook by attracting one million users within only four months. MOOCs, so goes one company catchphrase, "will be to education what cinema was to storytelling." It is already where internationalism, self-administered peer-to-peer education, class mobility, and experimental teaching are tackled with game-changing verve.

But it is not easy to tap into the MOOC dynamic from an art-pedagogical perspective. The issue of "em-

144 My thanks to artist A. L. Steiner for the terms and the references in this section.

plotting" movements through space (see chapter 8) is just as decisive in a classroom setting as it is in an exhibition venue. For all its novelty, there is something about an online course that seems weirdly lackluster and out of place here. For better or for worse, art still thrives on the aura of complicity among a given number of bodies in a room. More importantly, even avatars need pedagogical programming. And the ignorant-school-master-as-program is too useful—to too many of us—to evaporate anytime soon. If anything, the increasing precariousness has strengthened Maître Jacotot's hand. For now, Rancière's funky teacher has survived the hike in student fees, the Bologna Accords, all-out globalization, the triumph of curatorial training, even the transmogrification of Beuysian revolutionaries into potbellied fossils. As the next section will argue, its use value remains undisputable regardless.

Over the course of nearly half a century, Los Angeles was a trailblazing high ground of art education. In the fall of 2007, I was delighted to be teaching at the Otis College of Art and Design in Santa Monica, as critic in residence, but also at the Criticism and Theory program of the ArtCenter College of Design, Pasadena. It came to be a bittersweet experience, however, since that very semester, ArtCenter "restructured" the Criticism and Theory program out of existence. My disgruntled students responded by inviting the school's decision makers to explain themselves in our seminar room. So they came, and did a PowerPoint.

As the director looked on, murmuring soft reassur-
ances—"you know, some of my best friends are artists"—
the dean did a presentation on "global transdisciplinary
innovation." Insisting, all the while, that art and design
had "the same prerogatives." He proceeded to share
some industrial design novelties at ArtCenter, and one
PowerPoint slide featured a black woman in traditional
African dress, leaning over to suck muddy water from
a puddle, through a slender tube. "No more worrying
about desalination plants! Or water refineries!" the di-
rector exclaimed. "Now everyone in Africa can have a
LifeStraw." It was the buoyancy that took your breath
away. LifeStraws not as an emergency measure, for peo-
ple desperate enough to suck spillage from the floor. But
a case of design + deindustrialization = awesome. Some
of my best friends are Africans.

I am not saying art and design necessarily have
different prerogatives, but that maybe they should. If
you believe in art education, especially in light of the
slowly imploding investigational promise of museums
and biennials, then ArtCenter sets a terrifying prece-
dent. Surely enough, Otis College shut the doors of its
Theory in Practice department only a few months later.
And, most recently, the University of San Diego has
thoroughly restructured its once exceptional MFA pro-
gram: an unholy alliance of Dr. Dre and *Wired* magazine
is taking over, with a swaggering rhetoric of "disrup-
tion" and "interdisciplinarity." As *Wired* magazine put it:
"Taking the best from USC and WIRED, we can teach

discipline and disruption, business fundamentals, and the very latest innovation models from Silicon Valley."[145]

The odd thing about the "disruptive" conspiracy of Dr. Dre and *Wired* is that, ideologically and discursively speaking, we do not have much of an alternative leg to stand on. In terms of a modus operandi and a best-case scenario, creative "disruption" is something of a conceptual and pedagogical evergreen in contemporary art. The student is to undermine any determinacies in sight, and make up her own rules, but remember to disrupt those too as she goes along. As is the case with other key ingredients discussed in this book, disruption is a more conservative, system-affirming creature than one might assume.

The recent genealogy of the term is telling. Economic historian Jill Lepore has been tracing ideas of "disruptive innovation" reaching back to the late 1990s. Disruption is widely considered a prerequisite to economic progress, best achieved by the cyclical introduction of "a 'cheaper, poorer-quality' product or service, typically by a smaller, hyperaggressive and more nimble company, which 'eventually takes over and devours an entire industry,' leaving its competitors in ruins."[146] All things considered, Lepore concludes, disruption proves to be a theory of change founded less on evidence than

145 Marcus Wohlsen, "Come Learn at USC and WIRED's New Degree Program," *Wired*, October 1, 2014, https://www.wired.com/2014/10/wired-u-usc/.

146 Alexander Reed Kelly, "Truthdigger of the Week: Jill Lepore," *Truthdig*, July 6, 2014, http://www.truthdig.com/report/item/truthdigger_of_the_week_jill_lepore_20140706.

on "panic and anxiety."[147] The thing is: disruption is bloody hard to compete with. After all, what sounds better to contemporary ears: a studious, specialized, sustainable sense of focus, or a whirling *Wundertrommel* of international names and interdisciplinary visitors, all colorfully disrupting you and me and one another?

Though disruption is rarely disruptive to anything but the steady continuity pedagogy necessitates, even the informal, non degree-giving alternatives I have had the privilege of coming to know—whether in Los Angeles, New York City, Berlin, Budapest, Istanbul, Beirut, Bethlehem, or Taipei—are all the more informed by an ethos of quasi auto-disruption, channeled, explicitly or implicitly, by the conceptual parameters of the glossary in chapter 1. It is fascinating to see such a variety of voices come up with such similar results, whether in terms of politics, language, or atmosphere.

If public facilities are overpopulated and under-staffed, informal projects can replace the stuffy claustrophobia with a list of freedoms.[148] Freedoms from syllabi, grades, and access regulations, with the sole definition of success being channeled by the charisma and willpower of the ostensibly ignorant schoolmaster. Dieter Lesage of Brussels University sums it up as follows: "The suggestion seems clear: we don't need the academy. With the desire to reinvent the art academy

147 Jill Lepore quoted by Alexander Reed Kelly, ibid.
148 David Batty, "Alternative Art Schools: A Threat to Universities?," *Guardian*, October 21, 2013, http://www.theguardian.com/education/2013/oct/21/alternative-art-schools-threaten-universities.

routinely premised on the idea of breaking down its barriers, the criteria for artist's discourse, and the specific contribution of the art academy to that discussion, are habitually left to chance or intuition."[149] What is more, the short-lived, ephemeral nature of informal structures only leaves them doubly disrupted—but also doubly romantic, and doubly attractive—"events called schools," as artist Oraib Toukan puts it.[150]

It is not that the self-teaching, informal varieties are unproductive or pointless. Far from it. Some examples I know firsthand, in Tehran especially, are the only intelligent options available within the local landscape, and will remain so until the public sector gets its act together. What such organizations lack in terms of the hard currency of an art degree, they make up for in other ways, including the sociocultural references any contemporary art trajectory requires. But it is important to emphasize that, rather than brazen alternatives to hegemonic values, auto-disruptive and otherwise, uncertified schools are streamlined, upgraded versions thereof. If most certified institutions have flimsy benchmarks, informal schools have none at all.

149 Dieter Lesage, "The Academy Is Back: On Education, the Bologna Process, and the Doctorate in the Arts," *e-flux journal*, no. 4 (March 2009), http://www.e-flux.com/journal/the-academy-is-back-on-education-the-bologna-process-and-the-doctorate-in-the-arts/.

150 Oraib Toukan, "Transcript from the International Academy of Art Palestine," *Red Hook Journal* (January 2013), http://www.bard.edu/ccs/redhook/events-called-schools/.

Mission
Statements

Despite all the harmony and common ground, among art schools big and small, formal and informal, I have never read a mission statement I would proudly subscribe to.[151] If statements of the kind were once buried deep within flimsy brochures and pompous school catalogues, they are now consulted on a planetary scale, at the click of a button. But in the aim of maintaining maximum leeway, and allowing the school to be as broad a net as possible, our statements usually stick to the catchall puree of "variety" and "criticality."

Mission statements allow for yardsticks. And yardsticks are hardly conducive to fostering the unique artistic identity of the student, and the incommensurable nature of her work. As it presently stands, a liturgy of individualism holds sway in the MFA seminar room.

151 Concerning common ground, see, for example, the surprising consistency of the CCS lecture series in chapter 1. Terminologies and discourses aside, the range of our artistic references at CCS was hardly overwhelming in scope, and even our politics were staunchly contemporary art, only just, just left of center ...

Faculty train their students to fetishize their private likings as unique sparkles of artistic truth. To the point of then having to play expert-on-demand to an impossible range of approaches. On any given day of tutorials, faculty must respond, with a modicum of intelligence, of course, to supposedly unique takes on depression, angst, jealousy, Gerhard Richter, Singapore, accelerationism, monochromes, the idea of calligraphy, and maybe more. Choose your own adventure. It is this gentle group-think, channeled by charismatic assurances of consumer democracy, that lead to such an amazing degree of peace and harmony in our schools, and in our boardrooms to boot.

In other words, it is not so much that an educational vision might deindividualize student practices. It is that it would do so with more matter-of-fact transparency than is presently the case. The good thing about a mission statement, and the didactic yardsticks that come with it, is that it creates the possibility of dissent on behalf of the student. To forcefully advocate a position as faculty, even a larger ideological proposal, without guilt or fear of treading on those fragile eggshell minds, is the only way to allow for genuine disagreement in the classroom.

After all, Rancière's insistence on the wisdom of the student can just as well lead you to the polar opposite of the pedagogical conclusions commonly drawn. You could say the student is smart enough to think for herself, so stop trying to brainwash her with your ideas. Or you could say that if the student is so damn smart, then brainwashing is hardly an issue. Indeed, given the

vicissitudes of language in general, and modern-day teaching in particular, how violent must a didactic gesture really be to truly crush all intellectual opposition? You do not need to be a stark raving Marxist to realize that all hypotheses inevitably spawn antitheses, and a clear proposition allows for a stronger antithesis to unfold. In this sense, aggressively defining pedagogical benchmarks not only protects the student from arbitrary judgment, but also liberates the teacher from the role of investment broker or inspirational shaman.

All of which becomes even more pressing in the face of mounting tuition fees, a situation which is currently serving to intensify a scary blend of frustration and servile virtuosity among students. There were many cases of productive student pushback at CCS, for instance. But other examples were shockingly monetarist ("your course is a waste of my money") or weirdly personal ("you're a high-flying cosmopolitan who would not understand"). What is more, an institutional vision is what explains and legitimizes your admissions procedures. The moment you stop claiming your school is about "critical thinking," and go for something more credible, is the moment regulated access can make structural sense. It is when regulation becomes politically legible as such, whether along the lines of Hans Abbing (chapter 7) or otherwise.

Finally, it is only from a strong sense of specificity that a strong sense of interdisciplinarity can eventually emerge. When working with scholars and activists of various stripes, it is easy to spot the yardsticks by which they wish to be judged. While our own lack of bench-

marks makes interdisciplinary matchmaking an awkward, lopsided affair. Notice how our guests from other disciplines are always flattered to accept our invitations to the artscape, but rarely invite us back.[152] To most of these visitors, indeterminacy looks great for a holiday, but a terrible place to settle down.

This is why art and scholarship, not unlike art and activism, is an awkward combo, too unwieldy to offer a decent, well-crafted sandwich. In the best of cases, it forms an open-faced tartine: a single slice of bread with toppings. The metaphor is worth dwelling on. During much of European history, the tartine was a staple item. Stale bread was used as a plate, until it soaked up enough juices to be eaten in turn. The symmetry of a sandwich is unnecessary; the one side offers the foundation, the other a squelchy topping. Between human rights scholarship and curating, for example, you can guess who has been doing the squelching, time and again. Squelch squelch. But at least there is a choice in the matter. We can offer ourselves as soggy toppings, without apology, and accept the foundational authority of any outside partner in conversation. Or we can aim for that perfect sandwich of interdisciplinary symmetry, with both sides meeting halfway. In which case something more foundational, more doughy, would be needed on this side of the equation.

152 My thanks to art historian Thomas Crow for this point.

CONCLUSION

Denon

"No one will visit the grave of a curator," as curator Tom Eccles likes to say. In other words, keep your head down kiddo, you are not exactly an artist. In fact, by keeping it down, nice and humble, you will get a lot more done. There is only one grave out there that is an important exception to the rule: the monument of Dominique de Vivant Denon, at the Père Lachaise Cemetery in Paris. For reasons that should soon become apparent, I would like ur-curator Denon to personally preside over the book's outro.

In 1804, Denon, artist and diplomat, was appointed director of the Louvre. This mythical moment allowed for the very invention of a profession, largely thanks to Denon's social skills. Various biographers suggest that he knew how to disagree with such grace that, "no one ever left dissatisfied from a meeting with him" (Augustin Jal), and, although Denon did not have the training to expertly separate any wheat from any chaff, he knew how to convince others of which was which.

Before his appointment, Denon was known for pornographic etchings, Rembrandt forgeries, embassy espionage, slanderous novels, and escape carriages waiting beneath the windows of lady prisoners. Not exactly a man of the institution. And his political views were no less imaginative. (Denon expressed support for the revolution only intermittently.) Napoleon eventually made the spritely Denon responsible for editing bite-sized chunks of information from his imperial briefings, after which he promoted Denon to an advisory role in the imperial plundering of Egypt.

His comments on the pyramids speak to Denon's signature eloquence. "I do not know which factor I find more astonishing—the tyrannical madness that dared order the execution of the pyramids, or the stupid obedience of those who were willing to help build such structures." And: "The mountains neighboring the audacious monuments are presently less steep in comparison and even less well preserved."[153] At some point, Denon denounced the Egypt excursion as "absurd,"

153 Judith Nowinski, *Baron Dominique Vivant Denon* (Cranbury, NJ: Farleigh Dickinson University Press, 1970), 222–23.

shedding tears over the dead, even as he supported the campaign, mediating it so glamorously, it led straight to his directorial position at the Louvre.

The museum was already long planned by the ancien régime, and its much-delayed opening in 1793 made it the logo of the new public sphere, semi-democratic and quasi-inclusive. The European culturati, however, were not convinced. The new institution, after all, coincided with Napoleon's marauding conquests, and Goethe and his colleagues feared a *Zerstückelung des Kunstkörpers*, a fragmentation of the *Kunst*-body. But the Parisian proponents of European Zerstückelung would quote the likes of Winckelmann, arguing that art was born of the spirit of freedom, and that, with France being the new Greece, it was the Louvre which was predestined to be our new Kunstkörper. In the words of Lieutenant Luc Barbier, "it is in the bosom of a free people that the legacy of great men must come to rest."[154]

Many, such as the Swiss writer Jacques-Henri Meister, wondered whether, back in the day, the museum, "completed to perfection, might not have saved the monarchy by providing a more imposing idea of its power and vision, by calming anxious spirits, and by dramatizing the benefits of the old regime."[155] This is very much what Denon set out to do, first at the service of Bonaparte, then at the service of the Louvre as a Kunstkörper in and of itself.

154 Quoted in: Andrew McClellan, *Inventing the Louvre* (Berkeley: University of California Press, 1994), 116.
155 Quoted in: ibid., 8.

When Denon took over, one of his more famous formal innovations was a chronological layout that replaced the ramshackle hangs of before. But what is at least as significant is the long-term, signaling effect of the institution he ran. The day Napoleonism crumbled, former subjects showed up to reclaim their patrimony, and Denon defended the Louvre against its own Zerstücke-lung, using stalling tactics, backroom deals, even risky, drama-queen confrontations with soldiers at the gates. As we see today, he did so with considerable success.

This institutional zeal is remarkable, given that Denon spent most of his life being so badass. But it is through the prism of the institution that Denon's raunchy youth shines through to begin with. If he had been badass in a bistro, we would not be talking about him. (A reputational flickering between the impish and the genteel has remained the stuff of curators to this day, alongside many other traits of the ur-curators.)

Long after Denon, as artist Hito Steyerl recounts, the Louvre remained an arena of struggle for art as a public good: "In 1792, about 600 Swiss mercenaries got massacred in the courtyard. This may also be the reason why they refused to defend it in 1830 and ran away. The Louvre was stormed again in 1832, 1848, and 1871, when it was burned down. It had to be stormed at least five times in order to become or remain a public art space. Up to this day entrance is free for students for fear they could burn it down again."[156]

156 Hito Steyerl, *Is the Museum a Battlefield?*, lecture-perfor-mance, first shown at the 13th Istanbul Biennial, 2013, available at: Vimeo, 36:47, posted by "Museum Battlefield," October 2,

Today, at the time of writing, Louvre Abu Dhabi is scheduled to open its doors at any moment. The stakes are enormous; the use of the Louvre name alone has cost the UAE over half a billion USD. And the voices raised in protest are many. The Louvre, critics moan, was once a departure from royalist humbug. Now look.

Politically speaking, the Louvre has always been humbug. It never once offered a clear departure from the sludge it emerged from. What makes even a colonialist, royalist institution such as this so significant, is not its critical virtue, but the way it amplifies and intensifies the stakes of any given political situation, from Denon's war of words at the gates, to Abu Dhabi's struggle for a postcolonial seat at some fantastical table of nations, to the Gulf Art Artist Coalition's fight to impose conditions on Abu Dhabi, by means of an international artist boycott (see chapter 6). There is a big difference between the idea of a museum sheltering a spirit of freedom deep within its bosom—an embattled refuge for art, safe from the humbug of realpolitik—and the idea of an arena through which art and culture stake their claims, some heroic, some unsavory.

Of course we would prefer to see Denon betray his own class, and abandon all that creepy Napoleonic baggage. As it stands, the man is hardly useful as a shining example. But whether monsieur Denon was an imperialist, or whether Paris should keep its mummies, is another conversation entirely. Even if Denon's spirited defense of empire makes his rendezvous with history

—— 2013, https://vimeo.com/76011774.

pretty sinister, to paraphrase Meister, it did provide "an imposing idea of power and vision" of the Louvre, and "dramatized its benefits" by means of a dogged sense of accountability. In terms of a spirited defense, it is not exactly what we curators are known for today, in a context half as intimidating as Denon's, if that.

Nowadays, curators are considered successful as long as they scuttle creatively between audiences, critics, directors, funders, and artists, introducing a curatorial agenda with such discretion that they are barely aware of it themselves. Curator Jan Debbaut has pointed out that everyone is doing their job: artists produce art, administrators administer, sponsors sponsor, and politicians politick. Meanwhile, curators have left the building.[157] Instead of backing art's entitlement to a location of its own, we allow James Franco, flower festivals, concept stores, and Marina Abramović to take center stage, in a lurid, capitalist-realist pantomime.

157 Quoted from discussion following Jan Debbaut's "Transformed Power Relations" (lecture as part of the symposium "Mountains of Butter, Lakes of Wine: The Effects of Changing Funding Conditions for Contemporary Art," curated by Maria Lind, Stockholms Stadsteater, Stockholm, November 7–8, 2009).

Realism

The disidentification with power discussed in these pages precludes a more accurate idea of the traction art wields. Both in the micropolitical sense of creating a viewing and listening subject, and in the broader sense of impacting the world around itself. The Paris Louvre is one thing. But it is easy to forget that, every now and then, a single exhibition has sparked and consolidated entire schools of thought, including the self-understanding of entire nations. In 1936, Alfred Barr's "Cubism and Abstract Art," at MoMA, New York, offered a confused Europe a new transcontinental identity it continues to embrace today.[158] Meanwhile, Adolf Ziegler's concurrent "Entartete Kunst" generated record audiences across Nazi Germany, to much sinister effect. Later, in 1955, Edward Steichen's "The Family of Man" was seen by nine million viewers on six continents, and catalyzed schools of humanist and antihumanist thinking alike (chapter 4). More recently, you could point to Damien Hirst's "Freeze" (1988), thanks to which the YBAs au-

158 My thanks to Goran Đorđević, doyen of the Museum of American Art in Berlin, for this point.

thored a potent sense of Cool Britannica. While Michael Levine's 1984 exhibition "White City" offered Tel Aviv a whitewashed, phantasmagoric identity that made its way into the UNESCO World Heritage List (see chapter 5).[159]

Exhibitions aside, the apparatus of contemporary art is presently enjoying a sweeping effect on the visual cultures of entertainment, fashion, and advertising, but also on job markets, student loans, real estate, urban planning, finance capital flows, and geostrategic maneuvers at the highest levels, not to mention on the conceptual prerequisites of free market ideology. We art-contemporaries are not alone in this macropolitical dispensation; for historical precedents, consider the Soviet-era avant-gardes that were invested in breeding a New Man, in a manner that dovetailed well with the messianism of the politburo.[160] Consider also the "artistic critique" of the 1960s generation in Europe and the United States, which spawned a formidable update of capitalism as we now know it (see chapter 4).[161]

A power nexus is a claustrophobic place to be, but it is brimming with bizarre possibilities. If today's MFAs are more and more consequential in nature, if art

159 At the risk of sounding pat, our clout is further illustrated by sponsorship deals—concluded not only by artists but curators too. Notice Jens Hoffmann's ads for Lexus cars, or Karl Holmqvist's and Hans Ulrich Obrist's contracts with Brioni menswear (the artist and the curator now figure alongside Harvey Keitel). Firms of such dimensions do not invest in people with little say and nothing to lose.

160 Boris Groys, *Gesamtkunstwerk Stalin* (Munich: Carl Hander Verlag, 1988).

161 See: Boltanski and Chiapello, *Le nouvel esprit.*

boycotts have long made a mark, and if certain artists are proactively formulating their interests as members of a professional class, then other steps seem equally feasible. Why would art venues not learn to push back against gentrification, for example, by emulating—as opposed to alienating—existing neighborhood campaigns. Perhaps they could even—shudder to think—become neighborhood campaigns in their own right.

A great example is the artist initiative Kampung Kreatif in Bandung, the Indonesian city marked as the upcoming creative hub of the nation. Kampung Kreatif reinvents what terms such as "urban regeneration" or "creativity" can mean, from the bottom-up. In order to weather the social cleansing that threatens an impoverished part of Dago, in north Bandung, art has become a vehicle for neighborhood solidarity, literacy drives, confidence building, and hands-on workshops for anything from painting to dance to carpentry. Instead of fetishizing a subaltern status, the artist project seeks nothing less than self-empowerment—nothing less ambitious, in other words, than doing away with a subaltern existence altogether. And in order to get there, Kampung Kreatif performs a dialectical backflip, rechanneling the momentum of an international trend to its own benefit.

It is in this sense that it offers an attractive case in point. In crudely dialectical terms, all those items which were once widely considered contemporary art's solution—placelessness, voluntary self-marginalization, indefinite postponement, opacity—have together become its weakness. While what was once defined as art's weaknesses—the intellectual overconfidence, the pro-

fessional specificity, the institutional contours, the didacticism and unilateralism—could gradually become its forte.

At the end of the day, the assumption that contemporary art is indeterminate, in essence and consequence alike, is a case of realism of the most naive variety. Not only does it focus on a sliver of reality in a misleading, myopic, selective fashion, it is the kind of true-to-life attitude that assumes it is mirroring the world, as opposed to proactively inscribing it. Although art does claim to reflect, double, problematize, and/or critique the world, very rarely does it acknowledge the act of coproducing it. Contemporary art is to globalization what Napoleon, Denon, and Delacroix once were to the Orient. With all of them helping to organize, institutionalize, and legitimize a geopolitical future.

As argued repeatedly by Suhail Malik, the notion of art's indeterminacy is tied to the assumption that the global condition is in itself indeterminate. That the contemporary moment at large is intrinsically too complex to pin down. It is this complexity of globalization that leaves art no choice but to become a cosmic mystery in its own right. And in doing so, as seamlessly and radically as it does, contemporary art has become an absolute hallmark of the contemporary tout court. The dynamic exemplifies what writer Mark Fisher sees as the shared strength of all different forms of "capitalist realism": it naturalizes globalization to the point of suggesting that the idea of any possible alternative is delusional at best, reactionary at worst.

Nevertheless, to reiterate a key argument of chapter 1, no ideology or moral economy holds total sway, which is why every practice, whether curatorial or artistic, is replete with opportunities that transcend orthodoxy in manners undeclared and unintended. Sometimes only momentarily, sometimes with unsuspected consistency. For example, in its celebration of all things mediatory, Søren Andreasen and Lars Bang Larsen's *The Critical Mass of Mediation* is a case of unintended conservatism.[162] But in its intermittent focus on the tipping point suggested in the title—that moment when curators do indeed move beyond the role of institutional lubricant—it is no less than a milestone.

Really-ism

"Realism? Really?"
—Bruce Hainley

If tipping points do materialize, they do so mainly behind closed doors. Like boycotts, they are considered nuclear options, dramatic and freakish. But consider, if you will, the option of "Really-ism." If contemporary art's realism is a case of porous, quietist acceptance,

162 Andreasen and Larsen, *Critical Mass.*

sometimes melancholic, sometimes smug, Really-ism insists on a belletristics of lines in the sand. Not only does it propose to draw those lines, it celebrates, institutionalizes, and eroticizes the act of drawing them. It prefers the lurch of a full stop to the slip of a comma. Instead of preludes to preludes, stepping-stones to ever more stepping-stones, Really-ism enforces the *plumpes Denken* of a boycott, it is spite specificity, a libidinal reappraisal of partisanship over limbo. One that frames indeterminacy as an economic banality, not as some epistemic Eldorado.

Really-ism is by no means unrelated to the recent speculative-realist writing that marks ongoing art-ontological conversations (see introductory chapter), but is perhaps best described as a distant friend of the family. On the one hand, it suggests precious few overlaps with the accelerationist agenda, and it harbors no quarrels with post-structuralist ancestors; striving instead to stand on their shoulders, and to bring their political appetites to their own logical conclusions. On the other hand, by virtue of being slightly ridiculous, the term draws attention to a spirit of secular, plump, and pushy expediency.

Admittedly, what some recent philosophy and Really-ism do share is a polemical whiff of that preposterous, old-school "here I stand and cannot do otherwise." (As opposed to the more contemporary "somewhere I float, but could also do otherwise.") And yet, this is not about Martin Luther heroics. In the longer term, Really-ism's insistence on mission statements, and didactic yardsticks, can only serve to deindi-

vidualize. Taste, whim, affect, and personal judgment can never be evacuated from the equation entirely, but a Really-ist mentality does not wallow in the egotism of "Like." Instead, it answers to broader factors that are procedural, collective, and systemic in nature. Macro-politically speaking, this translates into a demand for support systems that allow for depersonalization, but also for the occasional privilege to decelerate, decline, refute, to beg to be excused. Support systems that may take the shape of post-post-Fordist contracts, infrastructures-as-artworks, job regulations à la Hans Abbing, neighborhood coalitions, or top-down experiments such as a guaranteed basic income.

The temperament in question is an investment in a given habitus, and a polite dismissal of all shades of utopianism, escapism, and plausible deniability. Over recent years, exiting contemporary art has been evolving into a prominent narrative in its own right. The different political ideas and aesthetic horizons that inform this narrative are formidable in scope, ranging from the escapism of post-Internet aficionados, to the hard-line ultramodernism of Suhail Malik himself. Really-ism, meanwhile, is a more reformist, humdrum path altogether. It aims to think through structures, as opposed to beyond or against them. The newfound traction of art, as is, here and now, can just as well be used to better effect—as is, here and now. Surely the worst way to rethink indeterminacy is to point to that hole in the fence, and to hint at unnamable horizons, time and again. To unground, re- and deterritorialize, re- and dislocate once more. What you Really want is entrench-

however flat comes
w/its pre-existing
privileges

ment, investment, location. To anchor yourself squarely among the sites you are creating de facto. A modicum of professional pride of place is key to any contemporary art agenda worth its salt.

Anyone who has seen the series *House of Cards* will remember the dramatic opening episode, when Congressman Frank Underwood addresses the camera and purrs, "Power is a lot like real estate. It's all about location, location, location."[163] What makes Underwood's motto so eerily refreshing is the contrast to our own claim to be airy and everywhere. His bullish choice of words, incidentally, is a threefold repetition that, in rhetoric, you would refer to as an "epizeuxis" (see "words, words, words" or "rain, rain, rain"). In Underwood's case, the triad points to a threefold denotation in turn. First of all, "location, location, location" is a phrasing often used in real estate (compare "prime location"); secondly, location implies a sense of spectacle and display (as in a "film location"); and thirdly, the term also denotes a deliberate act of positioning, finding, placing ("the act of locating").

Spectacle, property, and positioning share a common ground in that they all underline the privileges involved in creating a site, in a more obvious fashion than the term "site" itself, or its artistic correlate "site

163 See also Frederic Jameson's "The Aesthetics of Singularity: Time and Event in Postmodernity" (Georg Forster Lecture, SoCuM, Mainz, May 7, 2012), https://www.youtube.com/watch?v=qh79_zwNI_s. Jameson suggests that nowadays, "all politics is about real estate." Whether in terms of privatization, gentrification, colonialism, settlements, ecology, or national boundaries, it all boils down to the commodification of land.

specificity," can allow for. In terms of thinking through the ontological here and now of contemporary art, location is even more helpful than the term "plot" (which is extensively put to use in chapter 8). A plot is a terrific device through which to discuss the experience of seeing an exhibition in the flesh, as opposed to flicking through a browser or magazine. But as a master trope for the overall proposal, it does smack of the impish, conspiratorial allure I am hoping to demystify in these pages. Location at its best is stripped of the innocence of site, just as it avoids the potential mythopoeia of plot.

As Denon, Really-ist avant la lettre, single-handedly revealed, it is only thanks to the located belligerence of institutional contours that art can resonate mnemonically, somatically, and didactically. And it is artists and curators, of all people, who are in a position to make that happen. Who else would be in such a formidable position to produce the "new forms of publics" Paolo Virno and so many others are stipulating?[164] This with the backhanded elegance of a tear catcher at that.

My insistence on the punny term "Really-ism," and on topographic figures of speech, may look a little silly to some readers. But as argued more extensively in chapter 4, language and discourse have an indisputable role to play here. Within the prevailing moral economy, what a curator announces, what a school envisions, what audience is interpellated, even how a given work

164 In Paolo Virno, *The Grammar of the Multitude* (Los Angeles: Semiotext(e), 2004), and elsewhere.

is framed, will go an awful long way. The fact that Anton Vidokle calls e-flux an artwork, for example, never fails to prompt emotional, self-righteous accusations. ("Hypocrites! They should admit it's just a business!") But an artwork can indeed allow for a clear-cut financial rationale, as well as a politico-professional appetite, and an aesthetic agenda to boot. Once again, indeterminacy-as-ultimatum proves an obstacle to rethinking the workings of art per se.

Vidokle rightly places e-flux within a long lineage of art-infrastructural crossbreeds that empower the artists even as they remain doggedly invested in format and form. Ramallah-based artist Khalil Rabah, for his part, equally sees the Riwaq Biennale (RB) as his artwork, no less.[165] When it comes to the Riwaq Centre for Architectural Conservation, after which RB is named, the agenda is so ambitious, and so concrete, that dubbing its biennial an artwork fundamentally reorganizes the possibilities as we know them today. To be clear, neither of these two artworks is a case of the aesthetic dimension being downgraded, to the benefit of administration or institution building. E-flux and RB's success will always hinge on the visual and communicational skills of artists invested in the minutiae of form. And yet, both are cases of framing the projects' leverage as an instance of art, rather than a means to art alone.

Rebuilding the language is also key to addressing the decisive but convoluted issue of time. Many, if not most of the measures suggested in this book are ulti-

165 Khalil Rabah cofounded the Riwaq Biennale in 2005.

mately chronopolitical in character. And amount to decelerating the speed of the apparatus in some fashion or other. As it presently stands, we deal with our crises so poorly because the culture and velocity of overproduction leave no choice in the matter. If anything, we are secretly proud of the jet lag, badass heroes of the urban jungle that we are. We may be economically exploited, intellectually exhausted, and aesthetically predictable, but we all raise our Bellinis in a defiant toast. Overproduction is so normalized, at this point, that many of us spend more time promoting the work than we ever spend working on anything.[166]

When a project is allowed to take a decade as opposed to a year, when a boycott seeks results as opposed to a plausibly deniable utopia, when a seminar becomes a realistic but future-oriented operation as opposed to a xeno-epistemic playground, or when a public is deliberately shaped and moved through space, as opposed to bathed in hermeneutic limbo; this is when a Really-ist timeline comes into play. The distinction is a chronopolitical one, between art as an embodied, located act with immediate ramifications, however small, pragmatic or symbolic, and art as an eschatological signpost, wistfully foreshadowing some future moment of redemption. In other words, Really-ism finds its perfect chronopolitical Other in Theodor Adorno, who forever

166 My pedantic requests to be taken off promotional mailing lists are presumably amounting to little more than slow-burn professional suicide.

saw art as the "unalleviated consciousness of negativity holding fast to the possibility of what is better."[167]

As theorists Danny Butt and Rachel O'Reilly put it when discussing the boycott of the 19th Biennale of Sydney, the artists' most decisive move was to avoid framing the biennial as an "aesthetic situation" or "performance of placemaking" while the real boycott was in play elsewhere. Butt and O'Reilly find echoes of the distinction in the age-old tension between Marxism and social democracy: "In the idea of classless society, Marx secularized the idea of messianic time. And that was a good thing. It was only when the Social Democrats elevated this idea to an 'ideal' that the trouble began. [Once] the classless society had been defined as an infinite task, the empty and homogeneous time was transformed into an anteroom, so to speak, in which one could wait for the emergence of the revolutionary situation with more or less equanimity."[168]

At moments of private contemplation, or of institutional confessionalism, we like to remind ourselves that "art is always political." And that the agency of art is just not what it could be or should be. But we say these things in the same way we tell ourselves "life's a bitch," or "time heals all wounds." It is not something you dwell on.

167 Theodor Adorno, *Minima Moralia*, trans. E. F. N. Jephcott (London: Verso, 2005), 25.
168 Danny Butt and Rachel O'Reilly, "Artistic Autonomy and the Contract as Form in Settler Colonial Space" (conference paper, Art Association of Australia and New Zealand Conference, Launceston and Hobart, Tasmania, December 5–8, 2014).

Though my five years at CCS coincided with a period of all-out war, I never addressed my wartime context. Nor did any of my students or colleagues. One day, people will say Iraq and Afghanistan haunted our exhibitions like empire haunted the novels of Charlotte Brontë. It is tempting to blame it all on East Coast Zionist trustees breathing down our necks. But if that were the real problem, there would be more people—students especially—willing to be heroes and martyrs every now and then. What is more likely is that, one and all, we intuitively did not trust ourselves to do what a novelist, journalist, or filmmaker could.

Contemporary art is political in that all cultural production strives to be a future-oriented operation. Organizational and persuasive, imaginative and administrative, representational and demonstrational. It seeks to sway, to mobilize, to win assent, and to establish itself as legitimate, valid, and true.[169] To think this premise through to its logical conclusion is to move beyond the disingenuous idea of mirroring, dialoguing, and flattering your audiences and locations, as opposed to manufacturing them. Such, in a nutshell, is the fine line between realism and Really-ism.

The ultimate idea of this publication is not to depict the power of art, but to generate more of it. To not only clarify but also strengthen contemporary art's institutional standing. Some readers will object that imbuing art with even more authority than it already enjoys is to court disaster. Which is a compelling point. That

169 My thanks to artist Amanda Beech for these formulations.